SAVED

Dedicated to John Randolf Hall

SAVED
MY PICTURE WORLD
BY DIANE KEATON

RIZZOLI
NEW YORK

New York · Paris · London · Milan

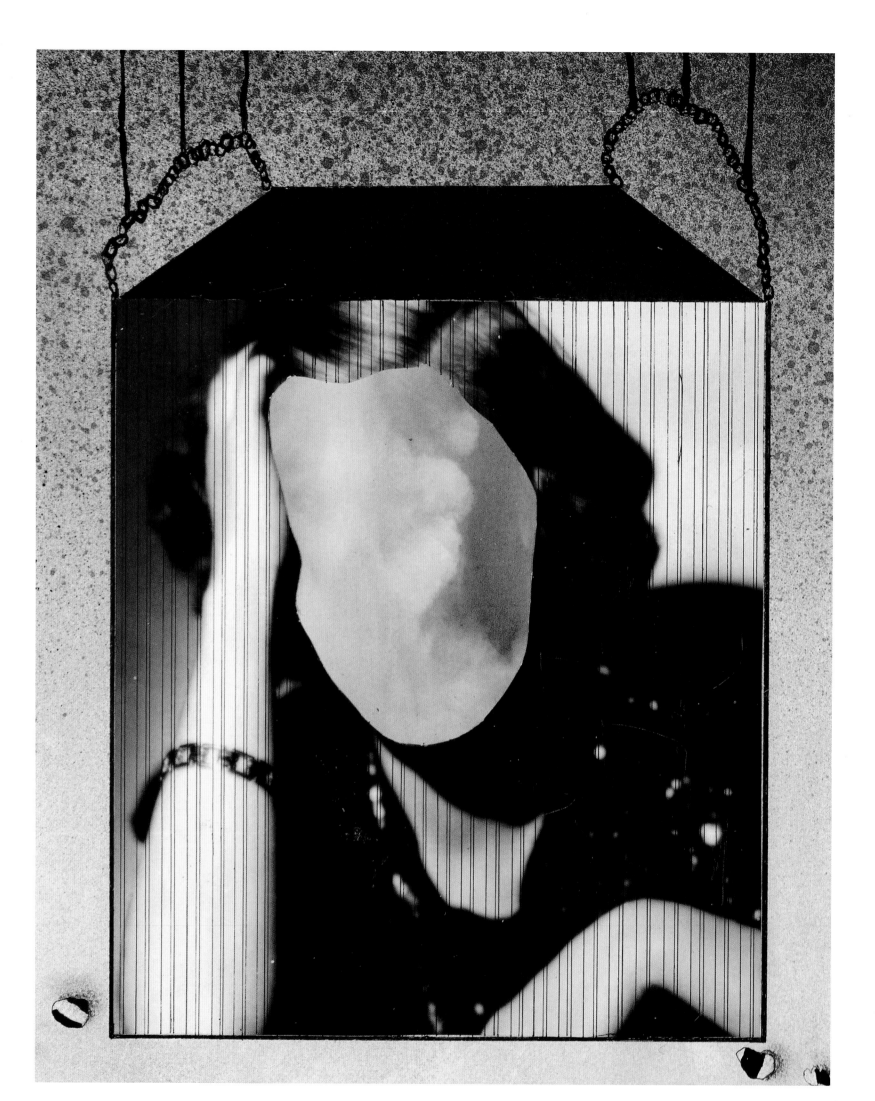

You are about to turn the page to see my so-called Cherished Treasures. Most will not pass your test. I understand. Small, Undervalued, Medium and Ordinary aren't frequently at the top of anyone's list of fascinating objects. For example, I don't remember buying the tiny gray dolls' couch. I don't remember where I found the yellowing metal ring resting in my jewelry box. Did my sister Dorrie give me the tiny black and white wooden dog she may have named Lucille with the frowning red lips? Inside the antique metal frame resting on my office table is a black and white planet I cut out of an ancient astronomy book I bought at a swap meet forty years ago.

Am I crazy? Not as crazy as I was when I bought a metal First Aid Kit. Yet when I opened it I reminded myself that someone somewhere was taking care of a dangerous, even life-threatening, situation. If I put my large Nautical Antique Warehouse Hook upside down it becomes a question mark. Frames are misunderstood when empty. To me they say look at nothing and reflect on what nothing indicates.

I can't help marvel at the ominous Indian woman who wove a rug illustrating a big mama bear hovering over a tiny baby bear. To this day her artistry still moves me to tears. The collection of objects we live with is a passion filled with memories. Large, small, strange, and especially cherished items help remind us of a world filled with wonder, grace, and most of all, expression. These nonentities continually remind me not to take myself too seriously.

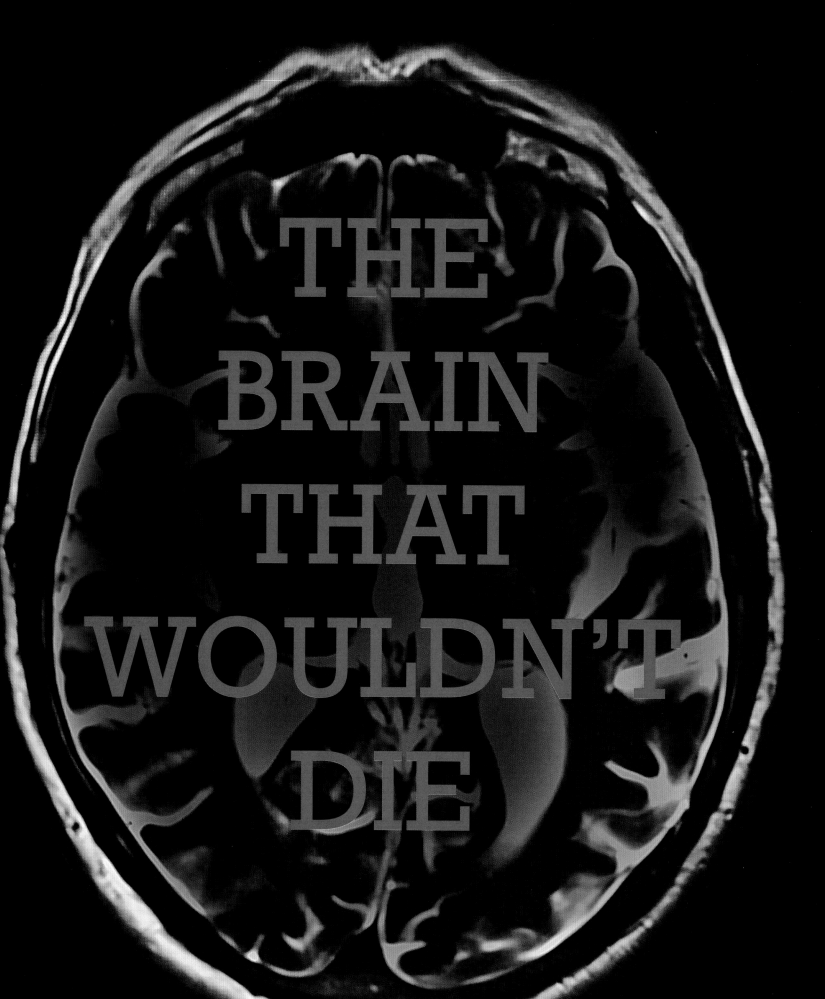

My brother Randy
loved horror films. Mom would
drop us off at the old movie theater in
Orange. In those days you could see two movies
for the price of one, but only if you went to the matinee. I
liked movies for girls, particularly *Gidget* starring Sandra Dee.
Randy's picks were creepy. There was *Attack of The Puppet People*
(1958). Deranged doll-maker Mr. Franz is deathly afraid of being left
alone, so he creates a machine that can shrink humans down to only a few
inches tall. He soon accumulates a troupe of shrunken prisoners whom he
forces to perform for him and also keep him company. When he shrinks his
secretary Sally and her fiancé Bob, the pair decide to stop spending their days as
pint-sized playthings and try to find a way to escape and re-enlarge themselves. To
my brother Randy it was sheer genius. And finally, *The Brain That Wouldn't Die*. Dr.
Bill Cortner saves a patient who had been pronounced dead, but the senior surgeon,
Cortner's father, condemns his son's unorthodox transplant methods. While driving
to his family's country house, Cortner and his beautiful fiancée Jan become involved
in a car accident that decapitates her. Cortner recovers the severed head and rushes to
his basement laboratory and revives the head in a liquid-filled tray. Jan's new existence
is agony. She begs Cortner to let her die. He ignores her. Cortner decides to commit
murder to obtain a body for Jan. He hunts for a woman in a burlesque nightclub.
Meanwhile, Jan begins communicating telepathically with a hideous mutant locked
in a laboratory cell. When Kurt, the doctor's assistant, leaves a latch in the cell door
unlocked, the monster grabs and tears off Kurt's arm. Kurt dies from his injuries.
Cortner lures his old girlfriend Doris to his house, promising to study her scarred
face for plastic surgery. He drugs her and carries her to the laboratory. When
Cortner goes to quiet the monster, it grabs him and breaks the door from its
hinges and sets the laboratory ablaze. The monster, a seven-foot giant with
a horribly deformed head, bites a chunk from Cortner's neck. Cortner
dies, and the monster carries the unconscious Doris to safety. As the
lab goes up in flames, Jan says, "I told you to let me die." The screen
goes black, followed by a maniacal cackle. My brother Randy
loved these movies. Fifty years later I have to say Randy's
choices were bizarre, but in retrospect they were
definitely better than *Gidget*. At least the plots
were imaginative tales of insanity.

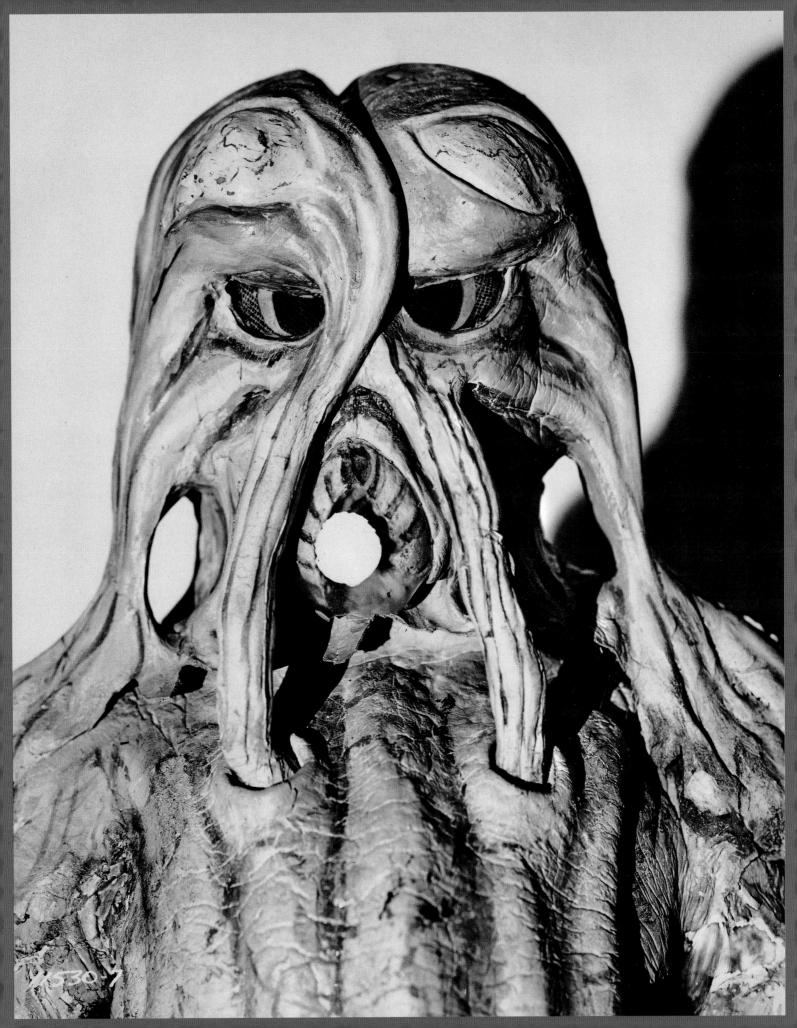

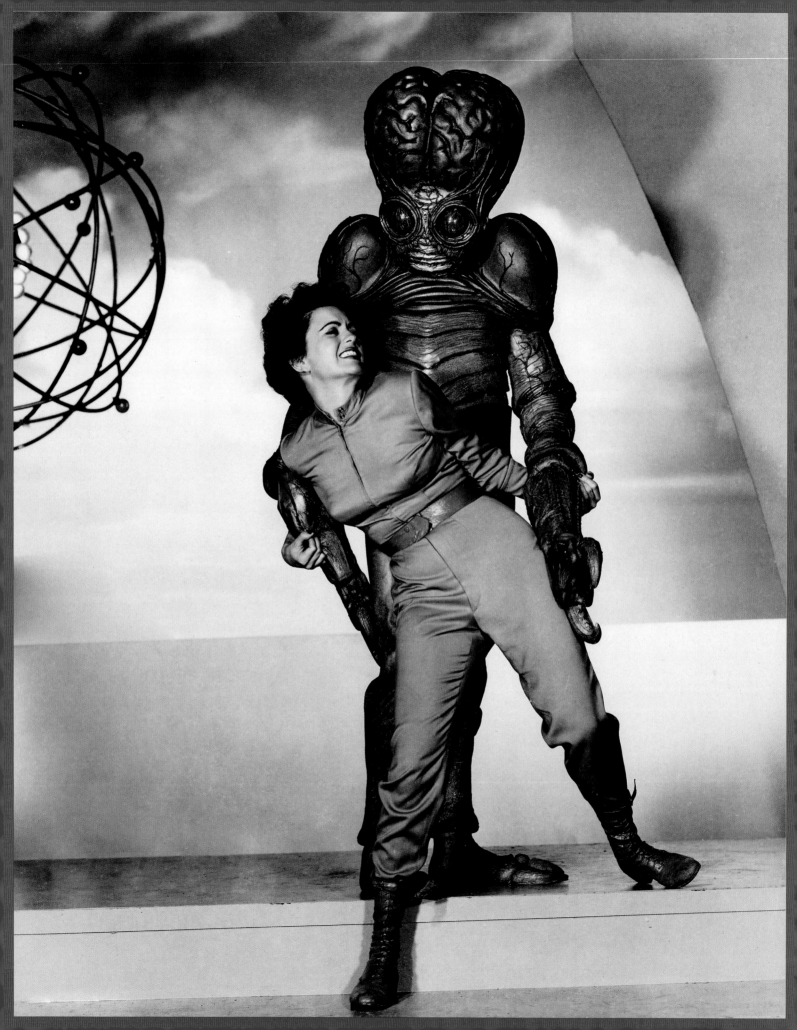

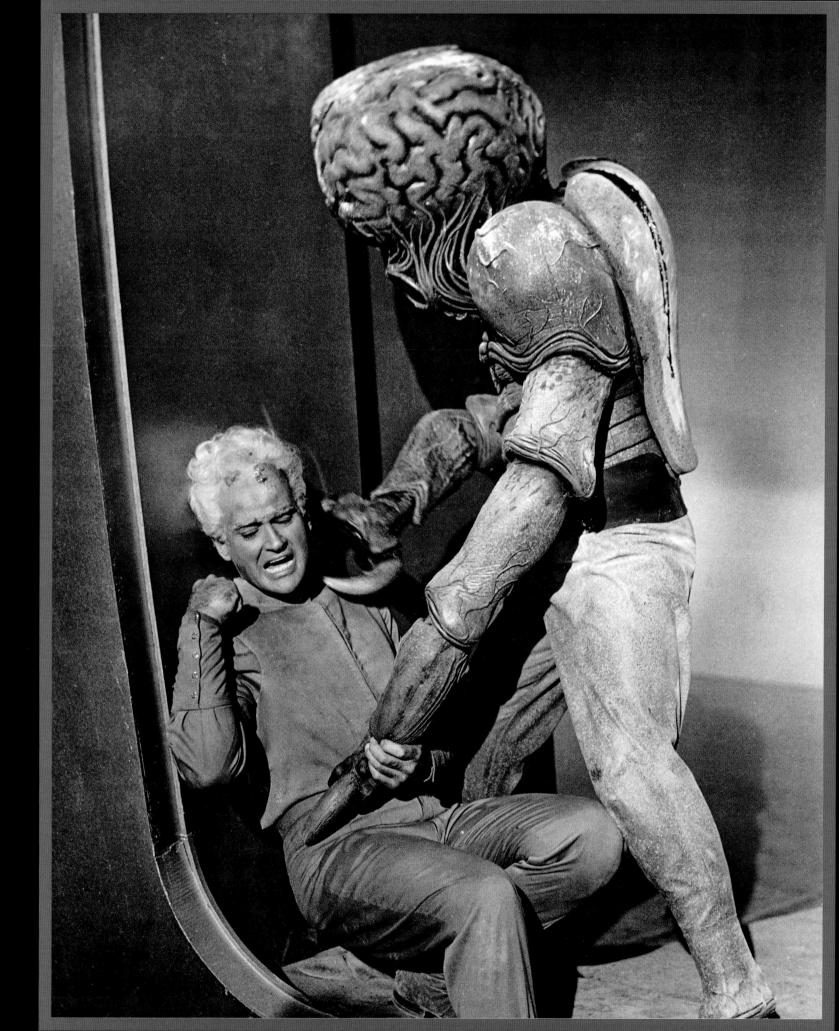

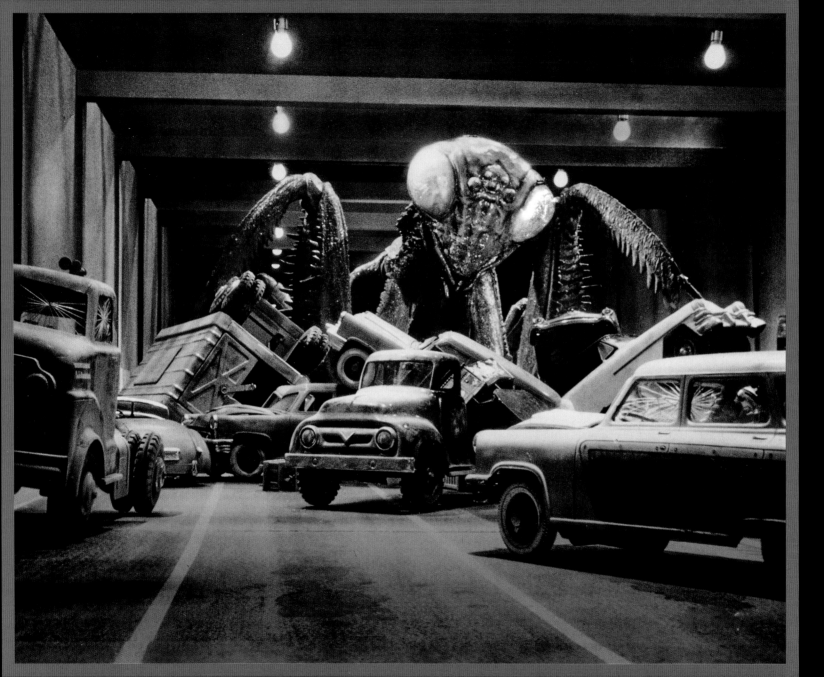

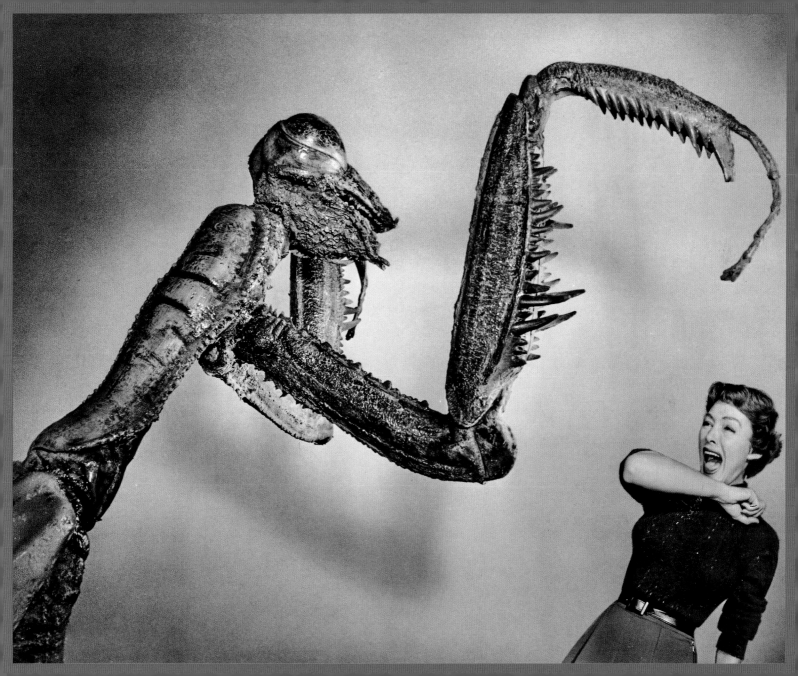

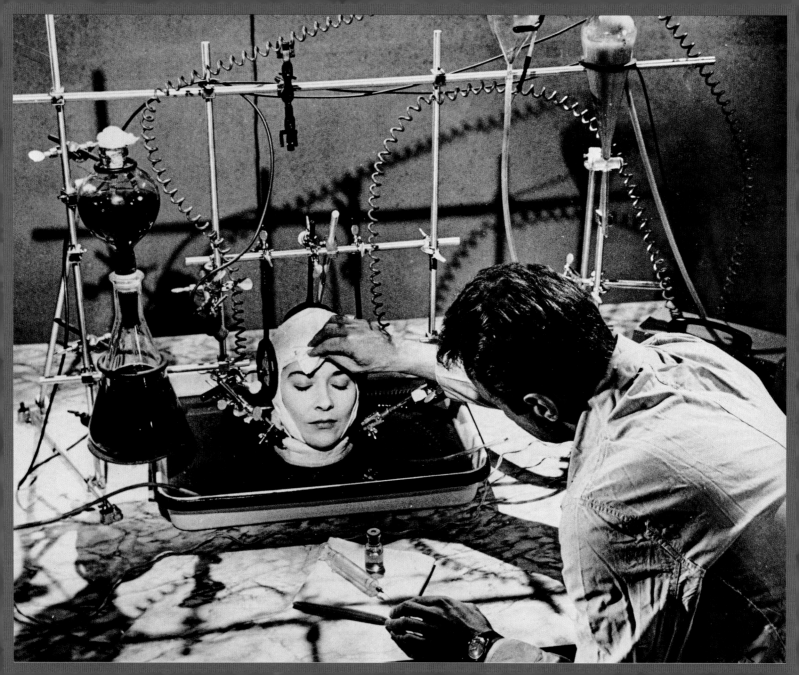

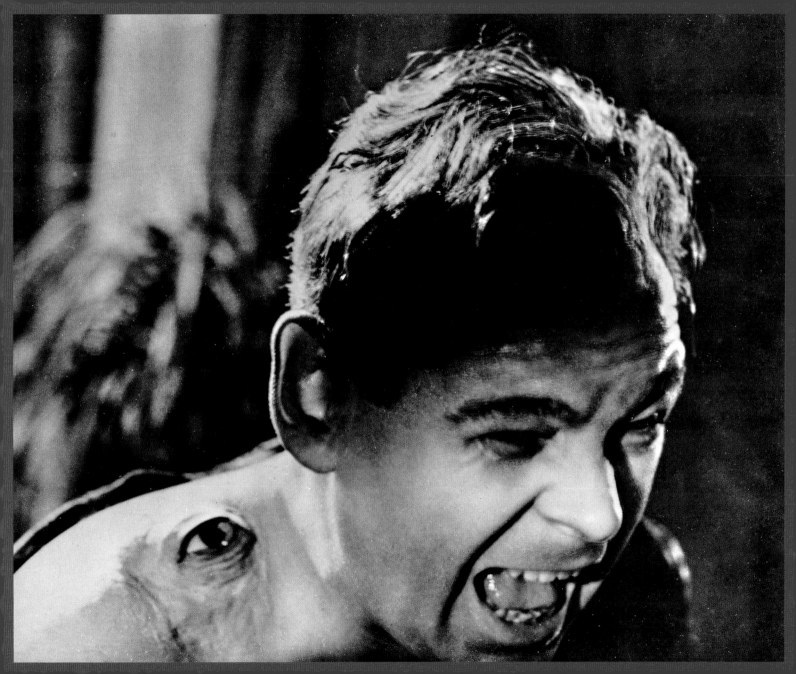

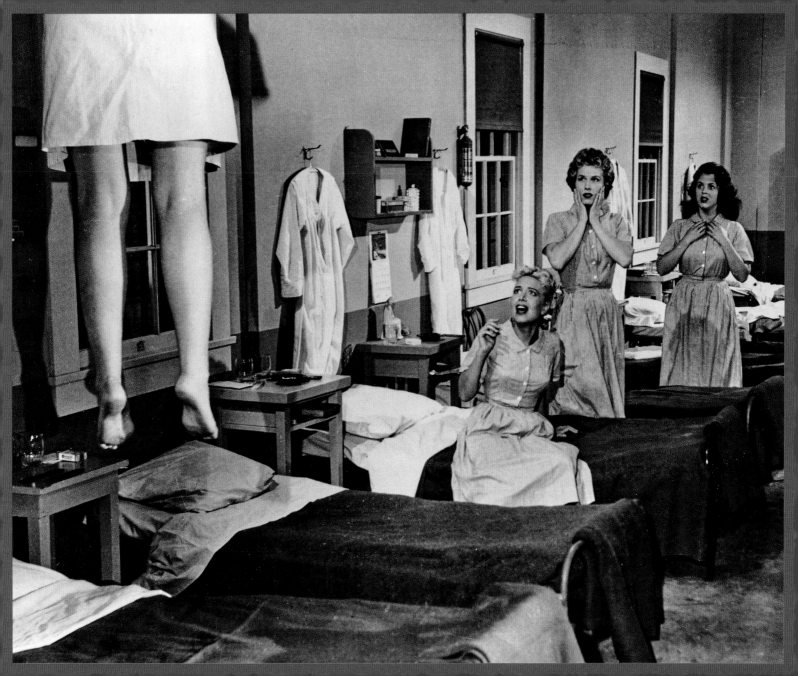

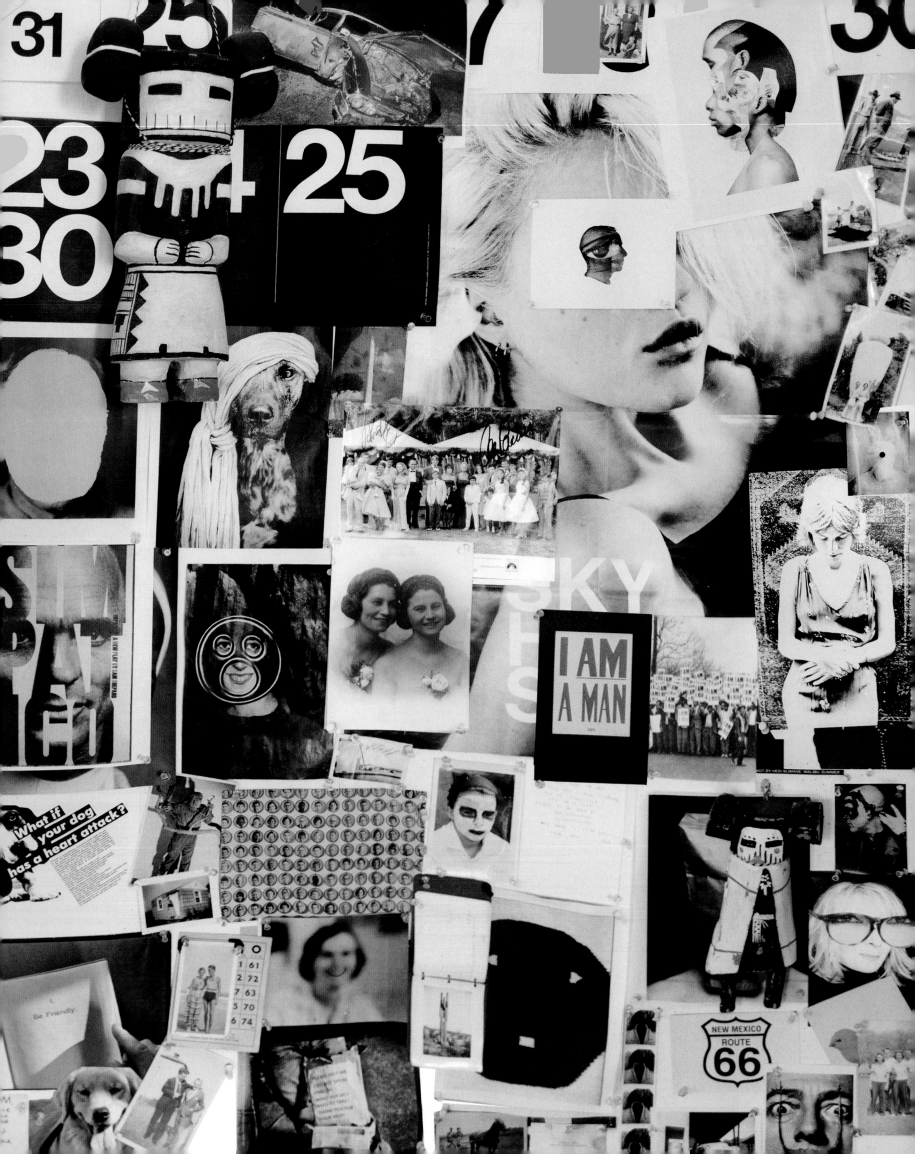

CRACKED

Many years ago I bought a large photographic archive. Recently I went through my storage space and found several boxes with hundreds of damaged negatives. Most of them were portraits rumpled from neglect. Not only did the 1,255 four-by-six inch unclaimed portraits lay unseen and untouched for over 20 years in Compton, they've also become smelly, cracked, and crunchy orphans. As with a host of other abandoned items, I neglected to explore what I had. I had picked up a box of Mr. Roy Hirshburg's negatives from Richmond, Indiana, and one pretty woman's face is cracked in half with white lines, giving the appearance of a giant spiderweb cutting her nose in half. Another network of faded lines almost succeeds in blocking out a young man's entire face with the exception of his smile and an engagingly large proboscis. Examining dozens and dozens of these portraits brought back the memory of my own first professional studio portrait taken by the photographer Guy Gillette. I remember feeling very special in front of the white seamless background under the light he framed me in. I smiled in hopes of being seen as beautiful. Somtimes I wonder what Mr. Hirshburg would think if he saw the damage that has been done to a large part of his work. Obviously I have to take blame for the years of neglect that led to such strange effigys. I only hope many of the negatives were printed into black and white portraits resting on relatives' tabletops, or framed on walls, or even saved inside scrapbooks on family loved ones. It's intersting to note that Mr. Hirshburg achieved international fame for his photography and was often called upon to judge photo shows. In 1955 he was named as one of the top twenty photographers in the United States. Widely known for his wit and humor, it's sad such a renowned portrait photographer was shot to death in Richmond, Indiana, by a certain Ethel Mae Wise, who got out of the driver's side of her car, picked up an automatic .22 gauge rifle and shot Hirshburg as he stood in the street. He was 57 years old.

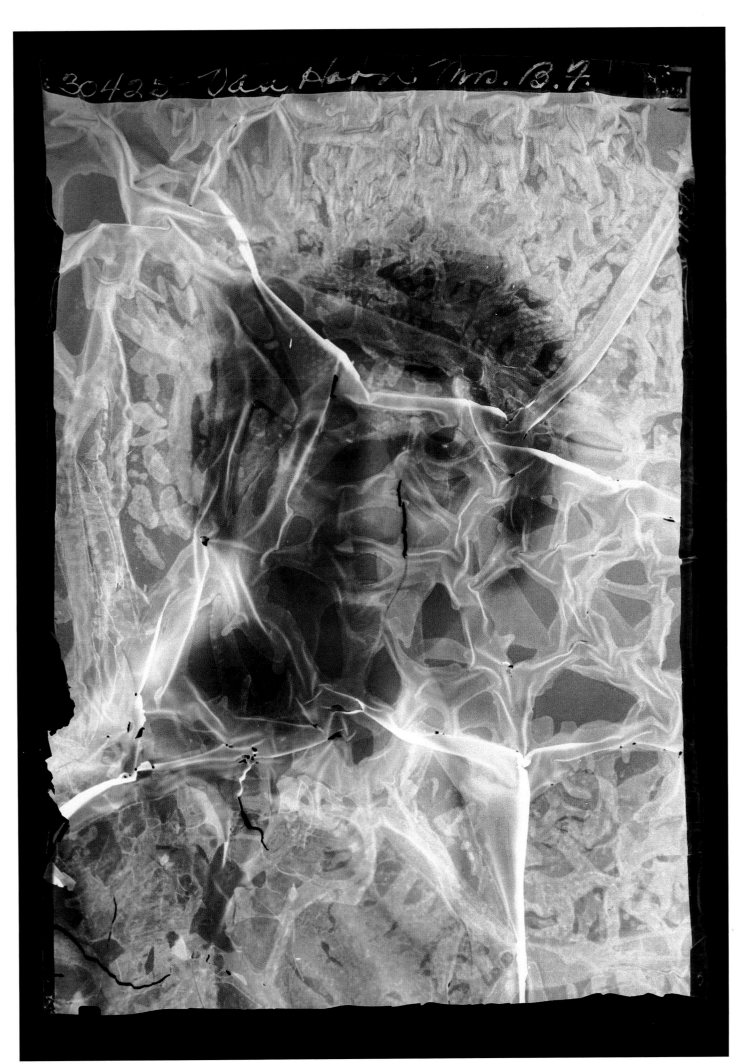

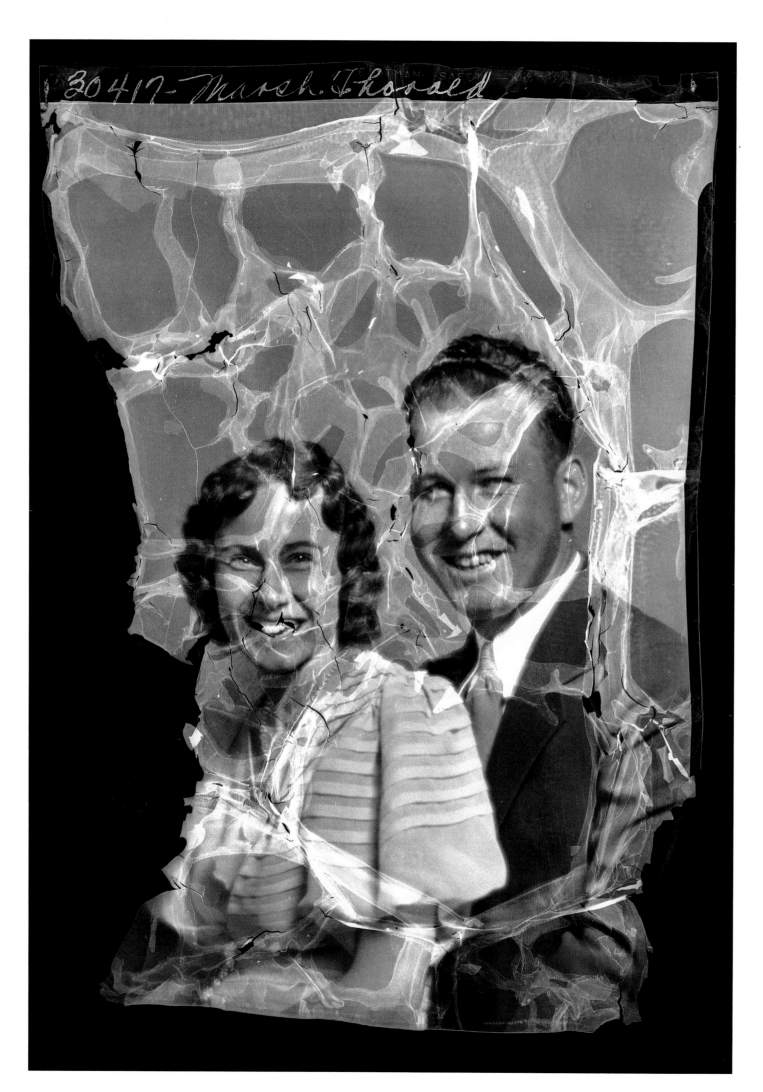

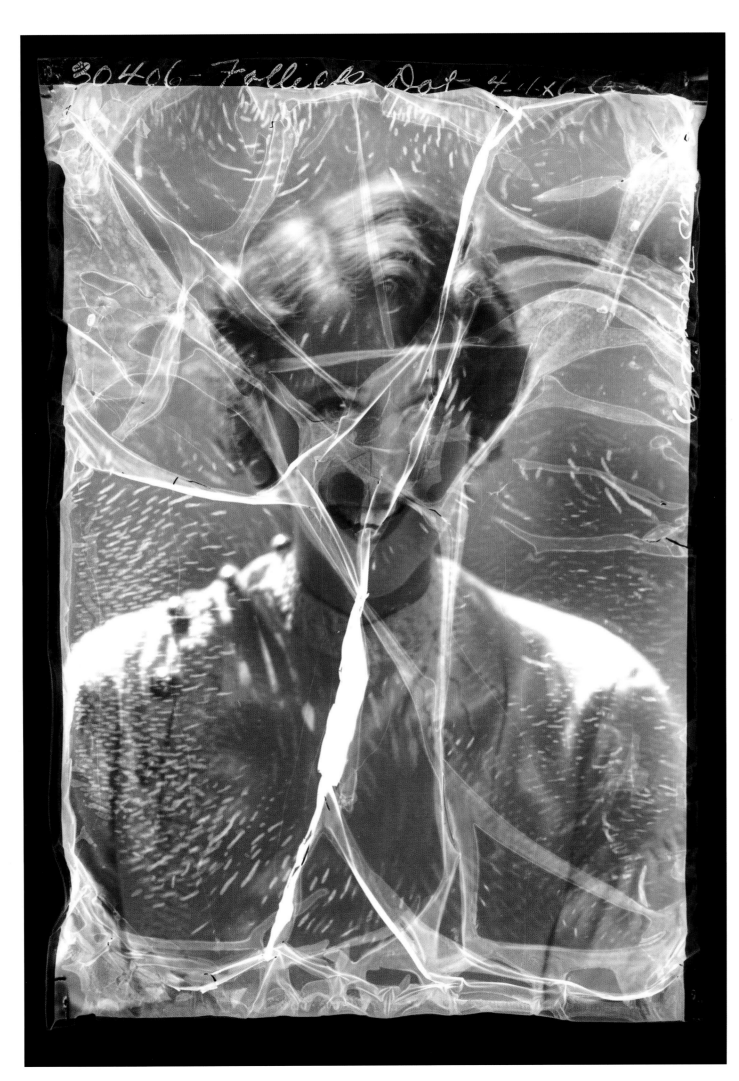

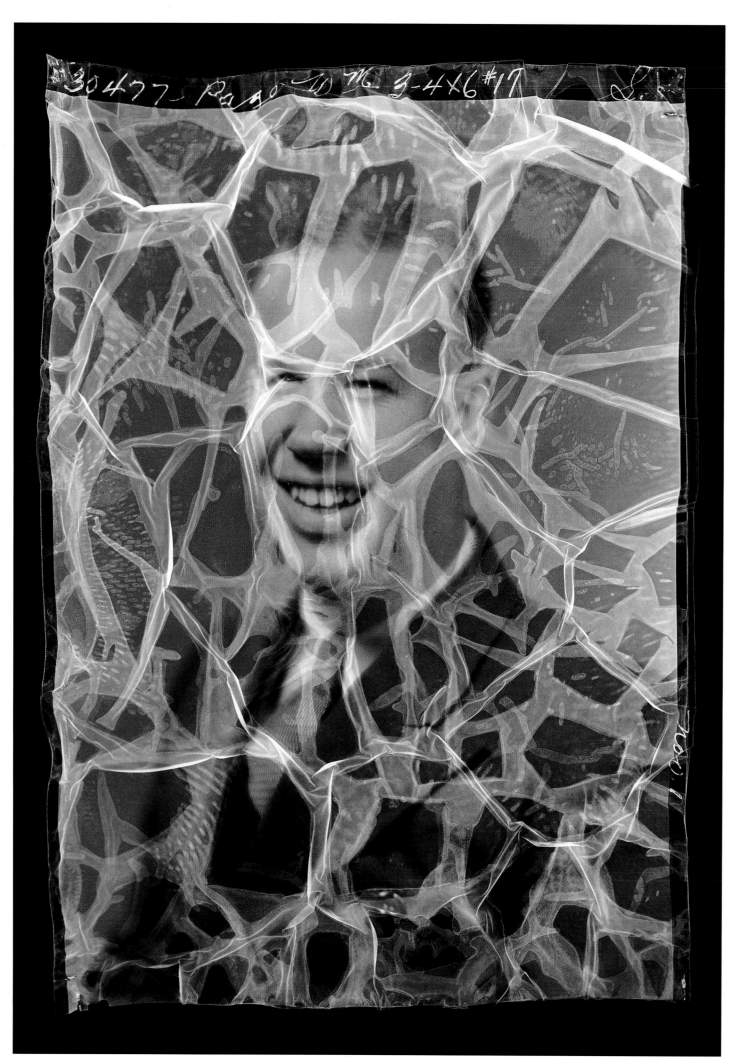

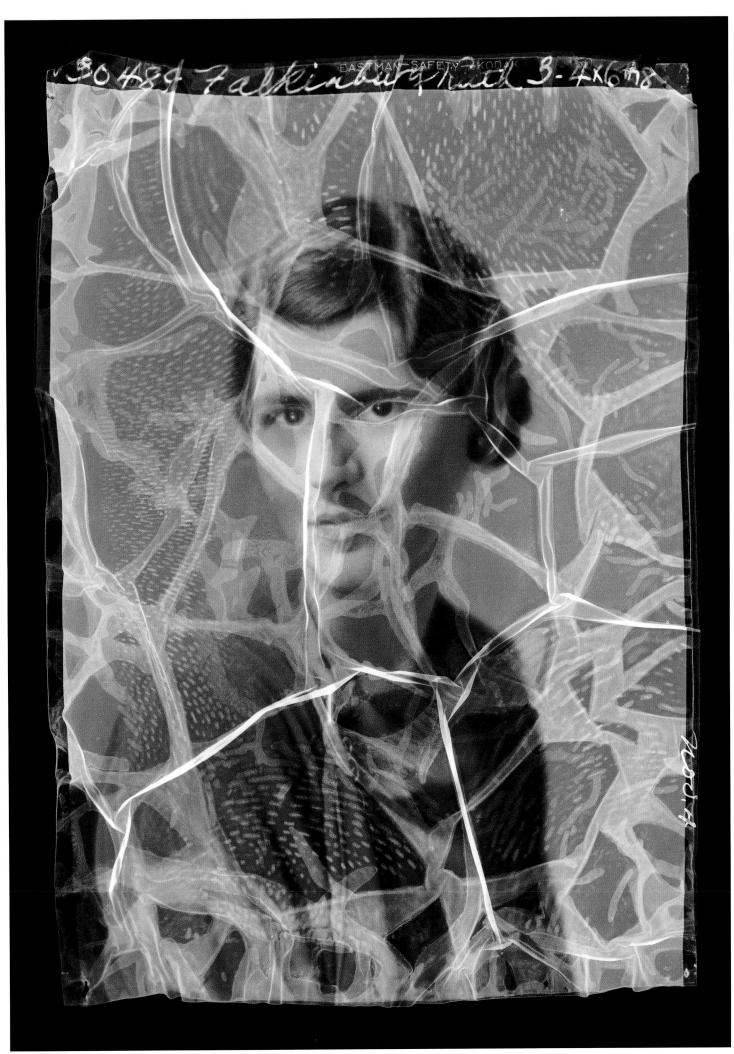

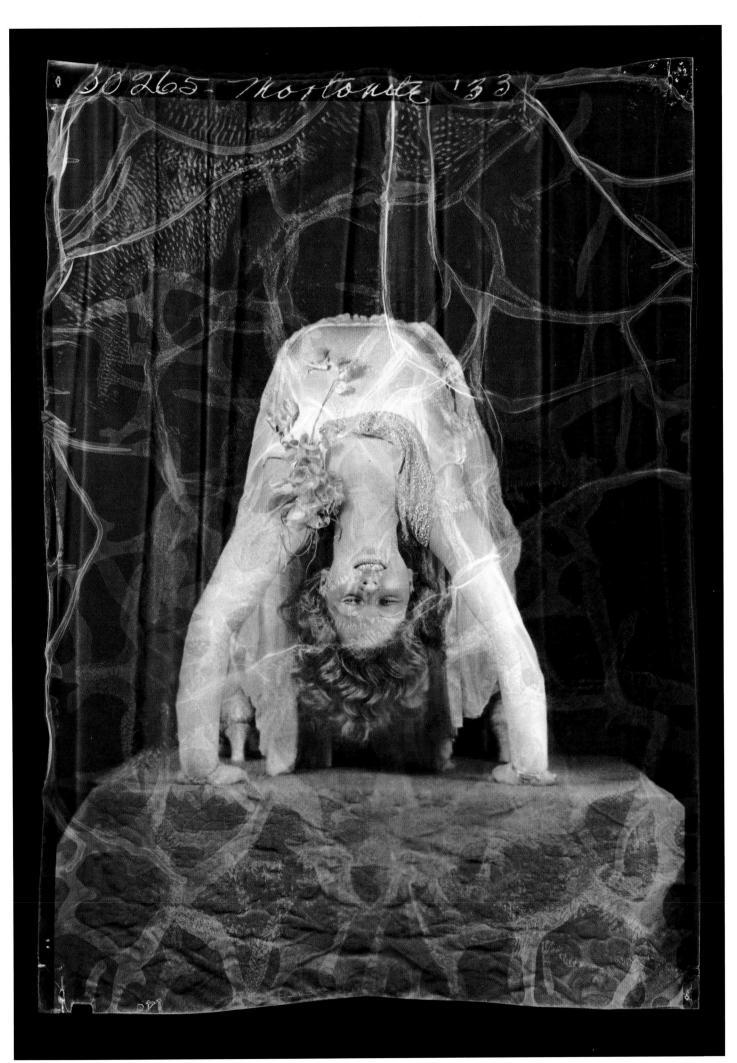

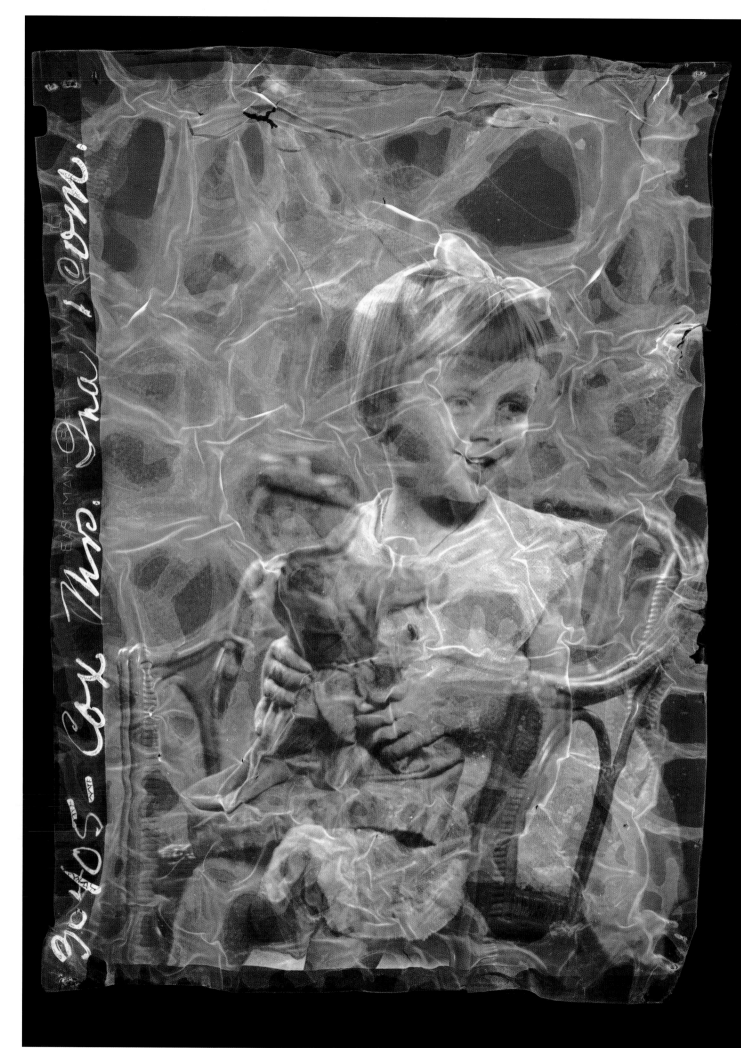

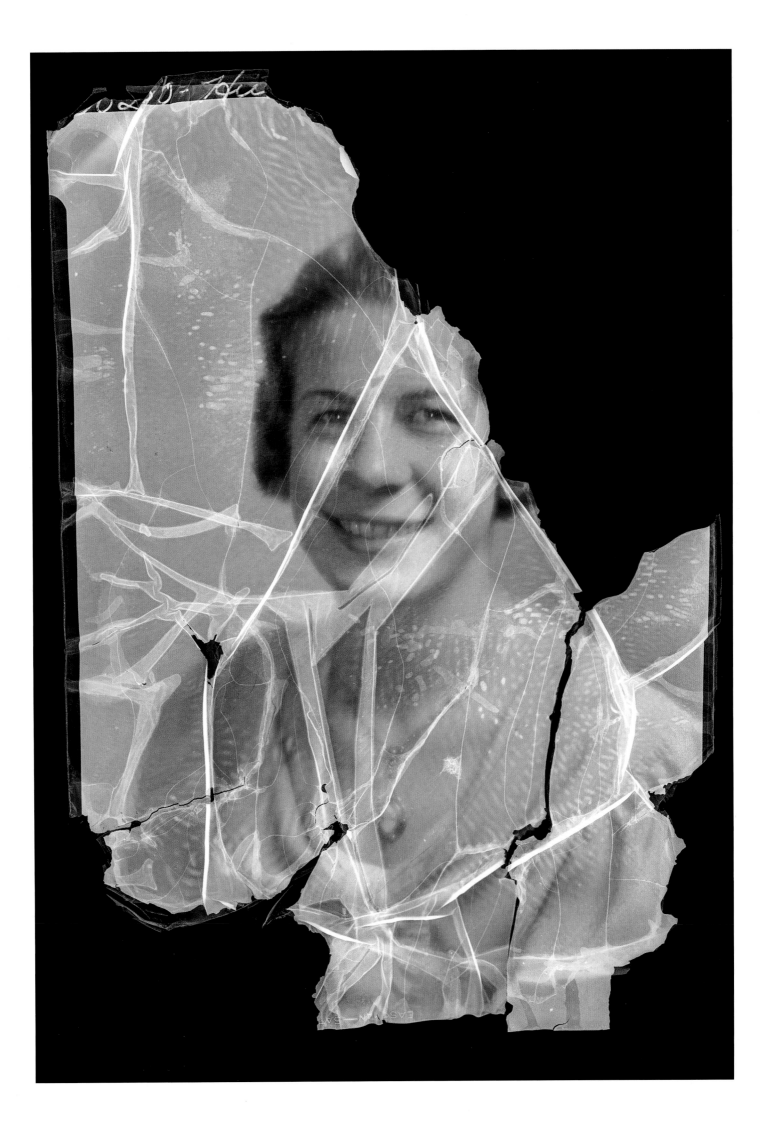

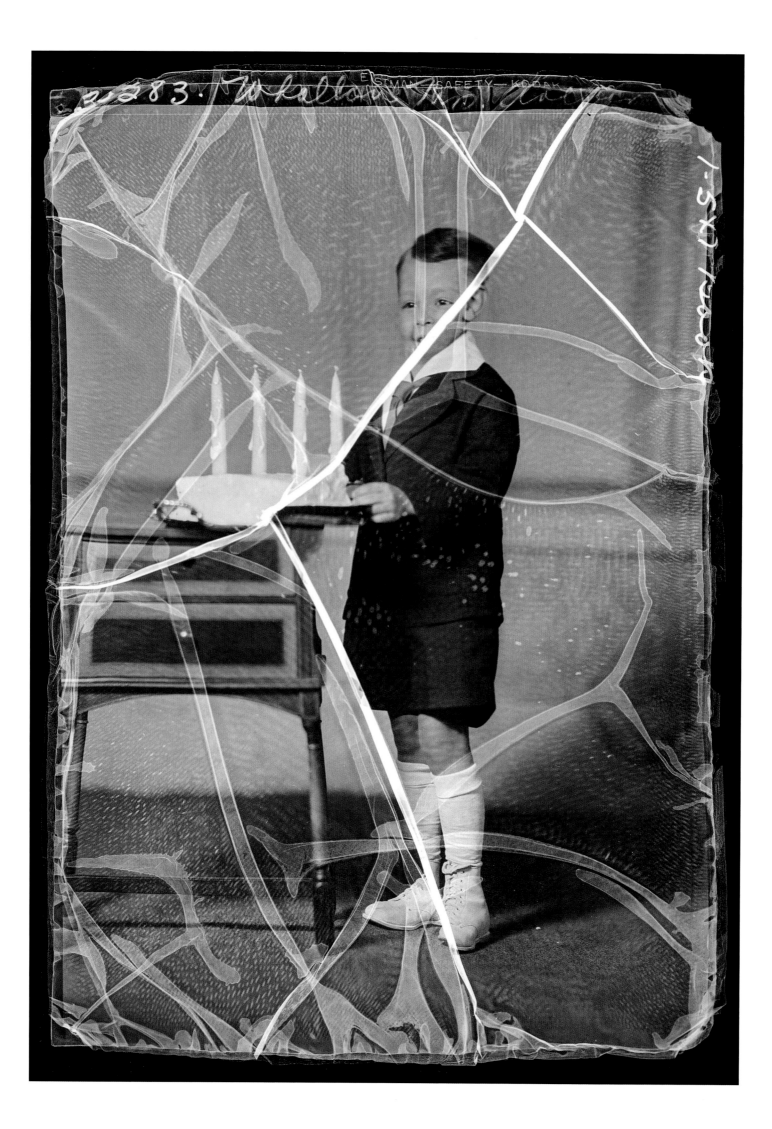

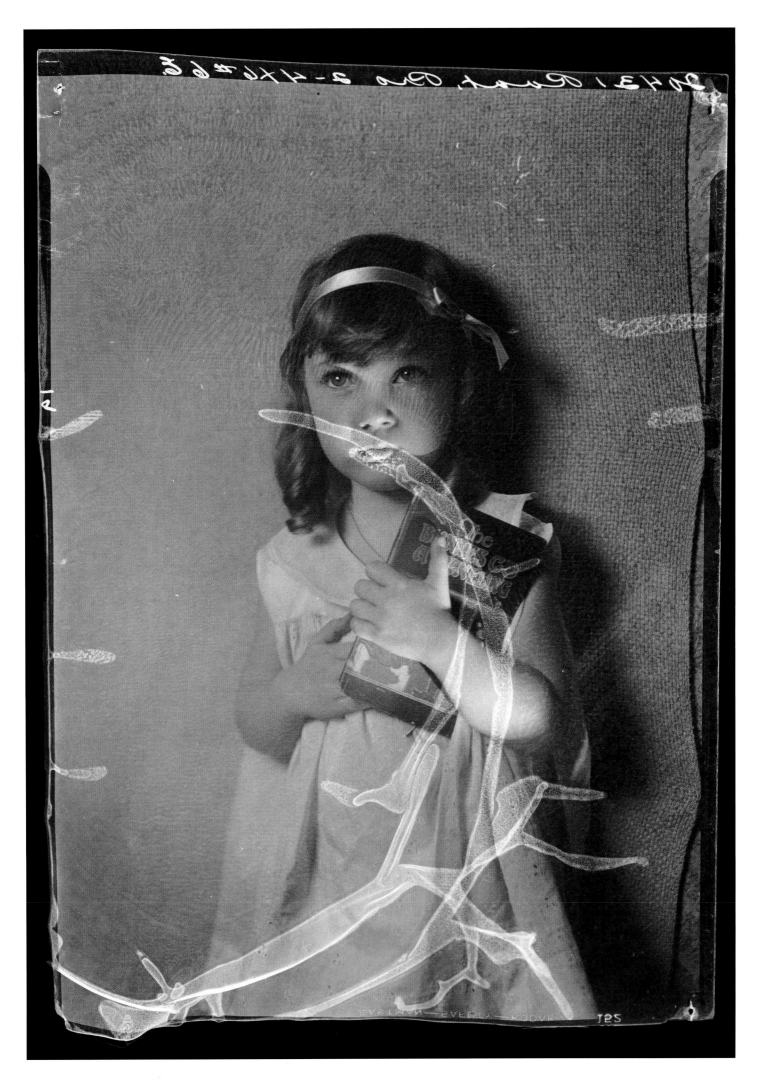

Scrapbooks tell the story of a family. Frequently a little boy or girl is born. Usually the besotted mother chooses to document their lives in the pages of a scrapbook. My mother Dorothy's love affair with documentation began with me, her first child. On the introductory page of her brand-new scrapbook are five 3 1/2 inch square black and white photographs. As if little Diane, she wrote, "I was three years old when we had our first California snow storm on January 12, 1949. It was cold!!" Sure enough, there I was, standing beside three snowmen in five photographs that look exactly the same. It was a beginning. In the middle of my scrapbook, Mom broke protocol with a large color cartoon she cut out of a *Life* magazine featuring a screaming bald-headed baby throwing food off the

table. Underneath, she notes, "Diane wasn't a bit like this one!!!!" A few years ago, I began to collect scrapbooks at the Rose Bowl and Long Beach swap meets. Like Mom's they were filled with cut-outs from *Life*, *McCall's* and the *Post* magazines. Some highlighted simple tales of happy homes, trips, movie stars, and even athletes. Scrapbooks are as unique as their makers, and yet no matter what the topic they contain glue and paper. Paper disintegrates easily, causing most scrapbooks to crumble if touched. Often, glue damages or discolors pages. They pose one of the biggest conservation challenges for libraries, archives, and museums. I think of all those hopeful mothers' stories. Who knew scrapbooks would be destined to a crumbling world of disintegration?

Babies

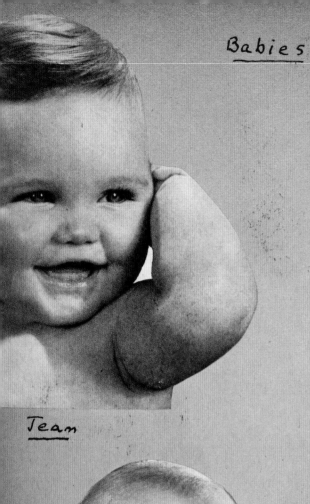

Jean

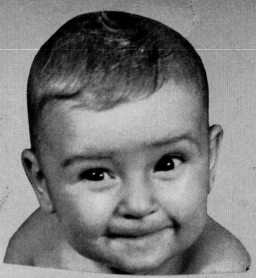

Charles

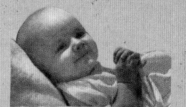

Amna.

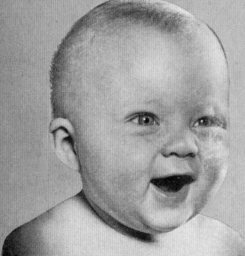

Michael

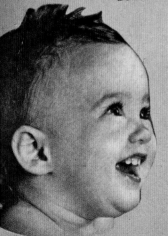

Gloria

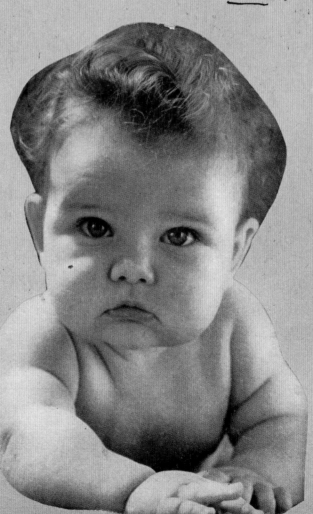

Jenny

Hi, Lucy,
I'm Bobby

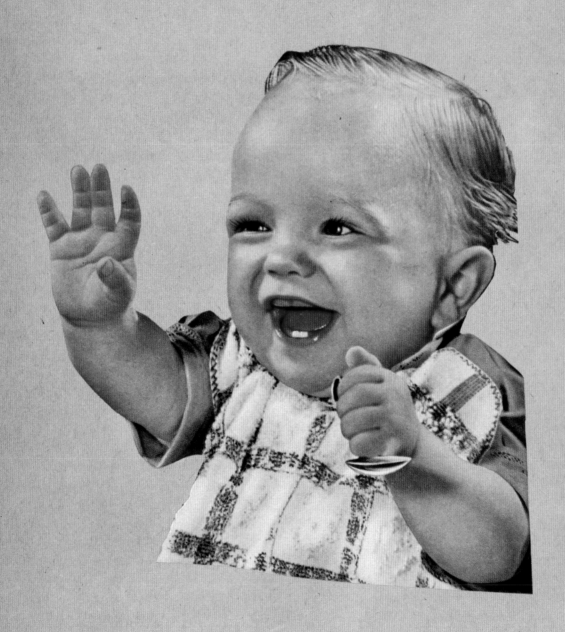

Puberty

The girl passing into womanhood changes physically + psychically. The general carriage of the body is more womanly + dignified. The voice changes becoming lower and more melodious, in brunettes the tendency is toward a contralto, in blonds toward a soprano range. Transformation begans around the age of 10. The girl feels that a great change is taking place in her being + the pride of womanhood + of of anticipated wife and motherhood swell in her.

Puberty

Transformation starts around the age of 14 years. The mind undergoes alteration in it's three parts the will, the intellect, the emotions. The voice changes becoming fuller & lower in scale. He grows from childhood into manhood.

Here are a few DON'TS

Don't Be late for meals.

Don't let Hair get in the Wash Bowl.

Don't Nag!

Don't burn the toast!

Don't leave a ring in the Bath tub —

Don't Boss ~~

PLEASE DO NOT DISTURB

SHOWERS ON THE SOUTH EAST

PORTION OF 69TH & OGLESBY

NEAR 8 PM 1/28/35

RAIN SHOWERS FAIR VERY DRY

FORECASTERS

And So — They Were

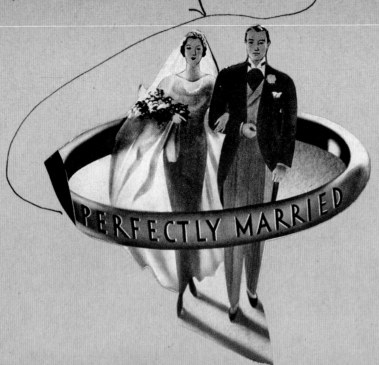

PERFECTLY MARRIED

"Her headaches and tired feeling *disappeared*—"

No more Short-hand—

No more Keys—

From Now on She will live a Life ot Ease—

THEM DAYS IS GONE FOREVER!

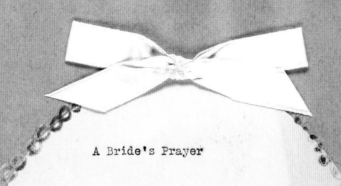

A Bride's Prayer

Oh Father, my heart is so filled with happiness that I am almost afraid. This is my wedding day – and I pray Thee that the wonderful joy of this morning may never grow dim with years of regret of the step that I am about to take. Father, may its memories become more sweet and tender with each passing anniversary. Thou hast sent me one that seems worthy of my deepest regard. Grant me the power to keep him always loving and true as now. May I prove a helpmate, a sweetheart, a friend, a steadfast guiding star among all the temptations that beset the impulsive heart of man. Give me the skill to make home the best loved place of all. Help me to make the lights shine farther than any glow that would dim its radiance. Let me, I pray Thee, meet the cares and misunderstandings of my new life bravely. Be with me as I start on my new mission of womanhood and stay my path from failure all the way. Walk Thou with us even to the end of the journey.

O Father, bless our wedding day, hallow my marriage night, sanctify my motherhood if Thou seest fit to grant me that privilege.

And when all my youthful charms have faded, and all the great cares and lessons of life have left their touches, let physical fascinations give way to the charm of companionship, and so may we walk hand in hand down the highway to the valley of Final Shadow which we will then be able to lighten with the sunshine of good and happy lives.

O Father, this is my prayer.

Amen.

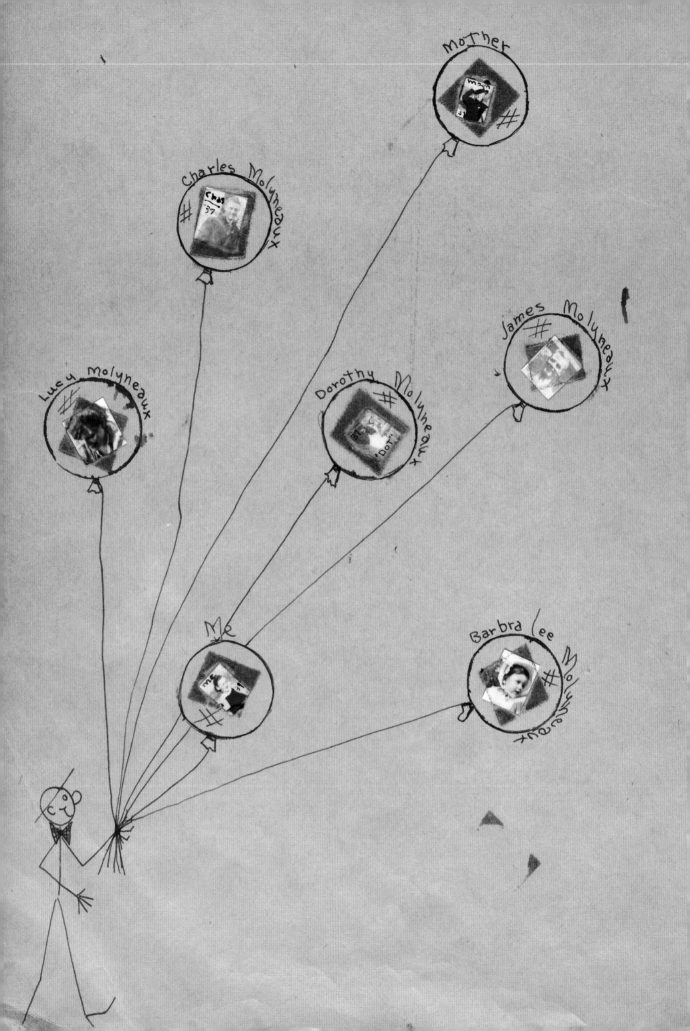

have a picture of Inez
that is going with me
as far and long as I go
also a bigger memory
picture of the same girl
is and will be with
me always.

just lonesome
for you

one thing I do know ya.
sure do make a heap of
happiness where ever you
are – Sweetest girl in the
world. Love you

I am Yours

na. I do

You do not have to
dress in Silk & Satin
to out class those by any
other girls

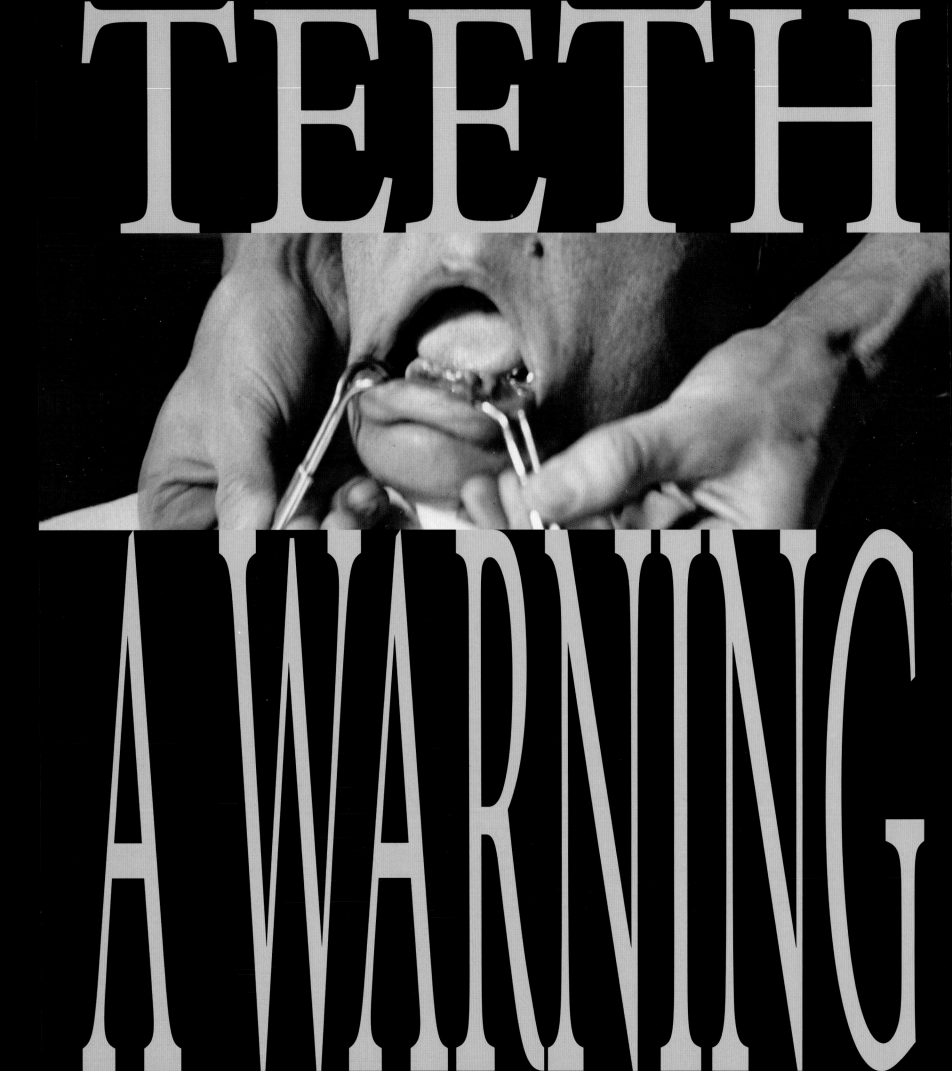

have bad teeth, and I've taken bad care of my bad teeth. Many have been removed. Several months ago my temporary bottom left molar fell out. My dentist, Dr. James Robbins, was very good at gluing it back in. Recently, he sat me down, looked me in the eye, and informed me my hard, bony, enamel-coated teeth are in dire straits. I need to have the roots pulled out in two of my upper molars on the right side. As he put it "There's not enough tooth to stay secure." It's always been a rocky road with regards to my teeth. Several years ago, while strolling with my sister Dorrie at the Rose Bowl swap meet, I came across a large book titled *Clinical Diagnosis of Diseases of the Mouth* written by Louis V. Hayes in 1935. Inside its 461 pages are 322 glossy black-and-white photographs featuring rotten teeth, swollen gums, and an ever-expanding variety of ancillary diseases. A few examples of the chapter headings read, "Cysts of the Jaws," "Correlation of Lesions of the Face," "Tongue Lesions," and don't forget "Lesions of the Gums." Dr. Hayes's choice of imagery is a daunting reminder to take care of your teeth. One photographic illustraton displays a carcinoma of the jaw with radium needles in place. Several chapters later, illustraton number eighty-five flaunts an infected tongue dangling on the outside of a man's lower lip. Apparently, his wandering rash hadn't cleared up. A middle-aged woman who had a history of seeking help from dentists was informed she not only had mucous patches, but she also was diagnosed with cancer. Look, life can be a grim, irrational, humiliating experience. As for teeth … teeth can become an island of pain floating on the gums of indifference. Some people toss off responsibility for the care of their teeth. One friend thought he was funny when he said, "Look, Diane … If you stood into the wind and grinned real wide you could get your teeth sandblasted whiter than white for free." An actor I worked with expressed a desire to grind his teeth into stubs before he reached his declining years so he could subsist on Jell-O, frozen yogurt, and ice cream. Before *Reds* began shooting, Warren Beatty suggested I get rid of my two gold teeth and purchase porcelain jackets so I could properly play the role of Louise Bryant in his epic movie. I did. Like so many other issues with me and my teeth, they didn't last. I doubt Dr. Hayes had a best-seller with *Clinical Diagnosis of Diseases of the Mouth*. Nevertheless, his expertise on the issue of oral treatment, in conjunction with his terrifying photographs, deserves to be applauded. I still wake up in the middle of the night panicked over the pain I suffered under the drill, but even more terrifying, the all-too-real possibility of permanent dentures. In honor of Dr. Hayes, a pioneer in the field of dentistry, I am proud to present the readers with an invaluable cautionary tale, enhanced by photographs that steal the show. At the end of the book, one patient of Dr. Hayes remarked, "I never knew teeth could be so interesting." I agree.

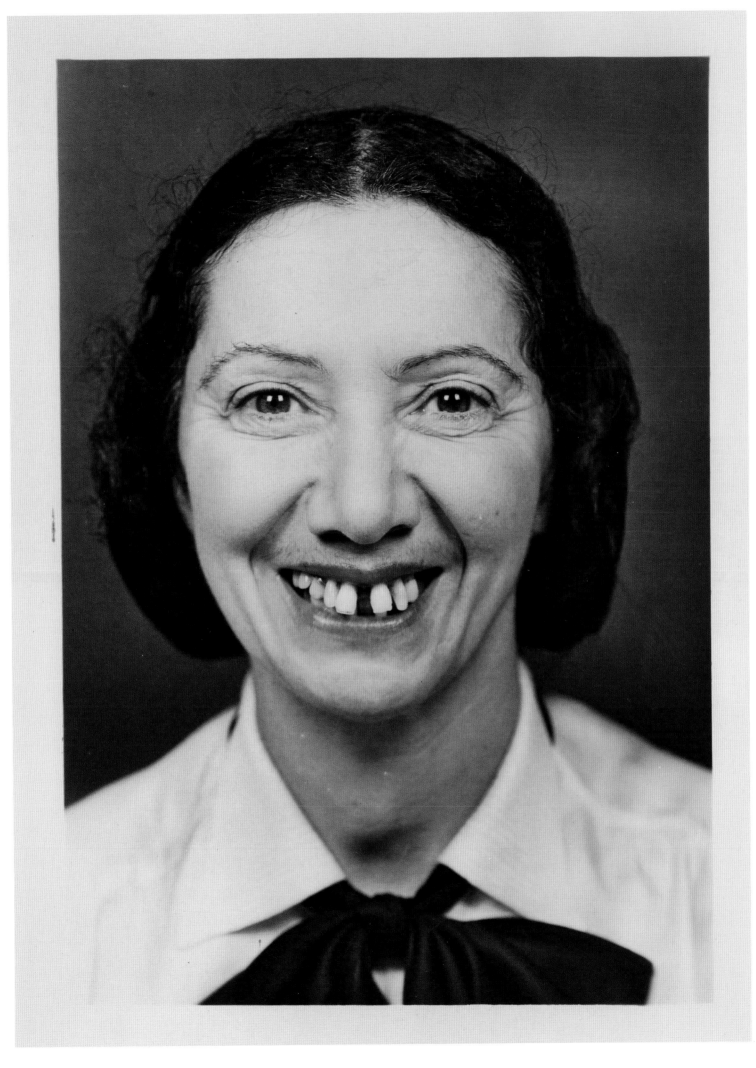

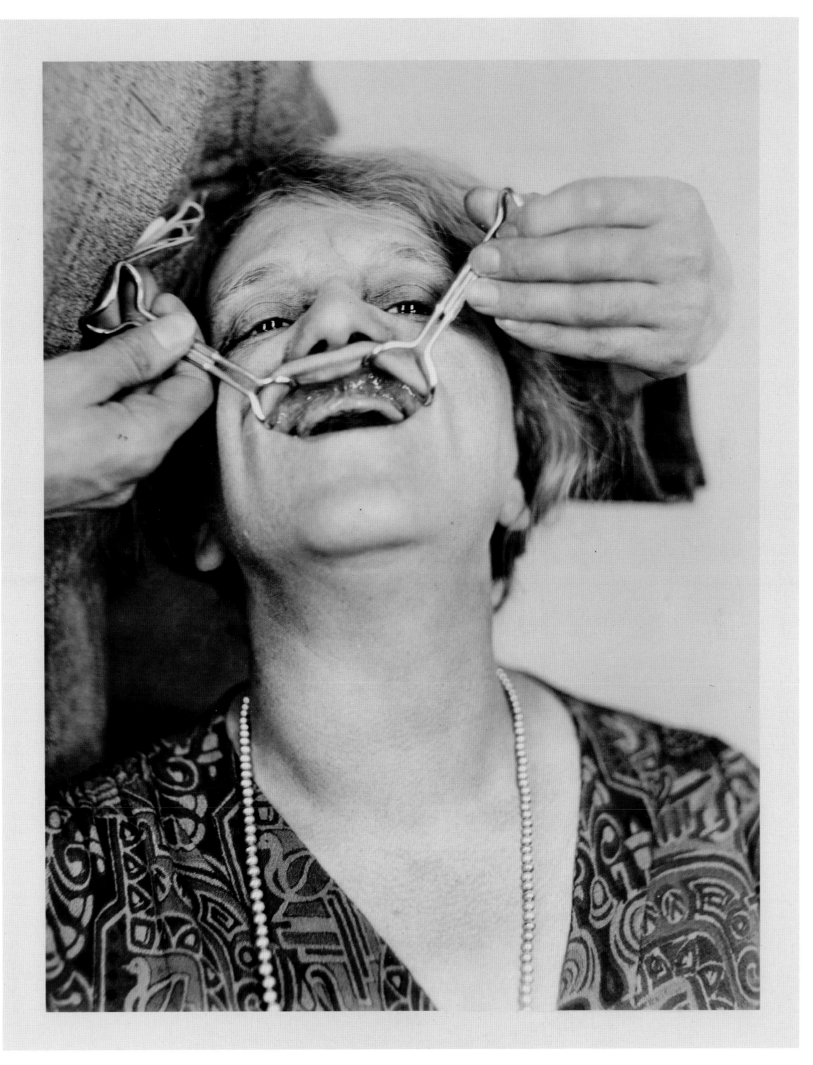

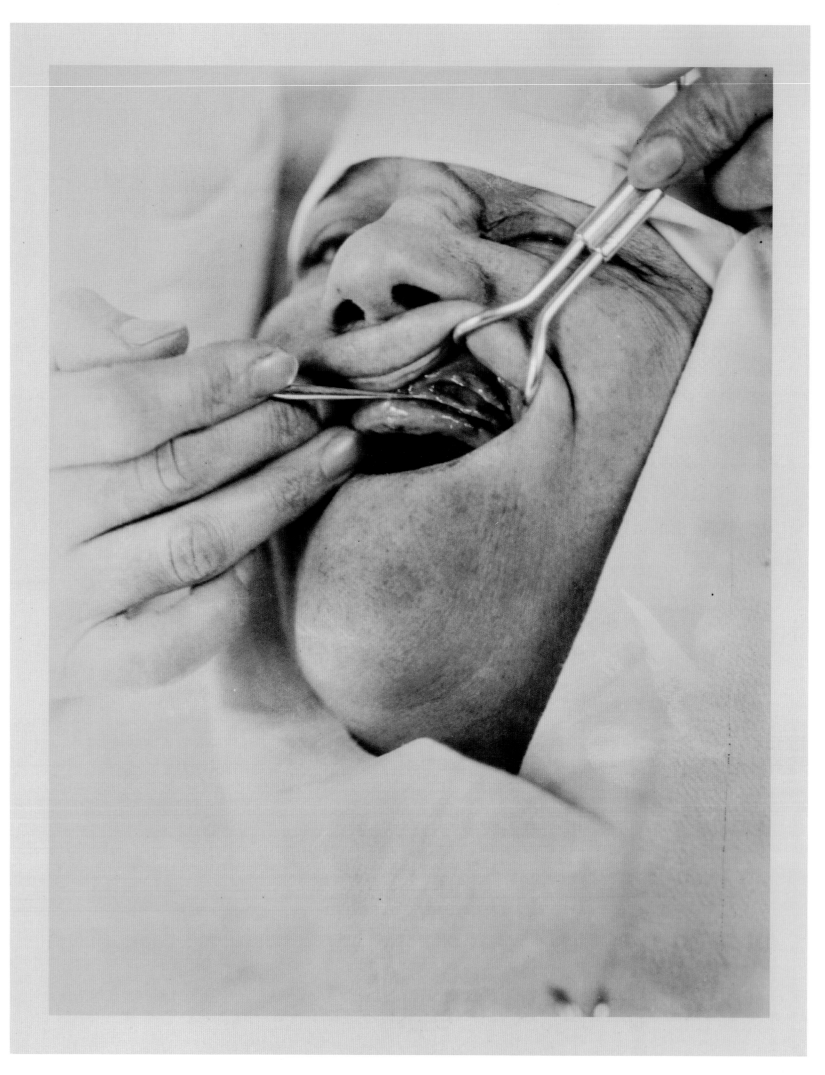

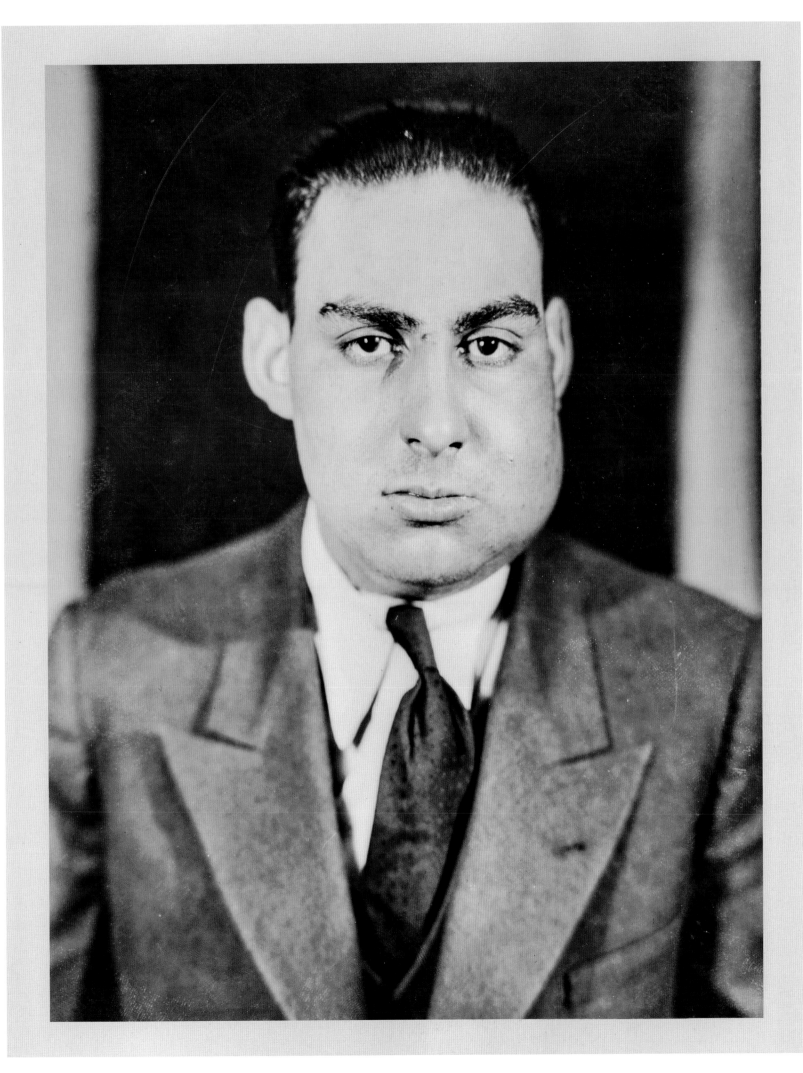

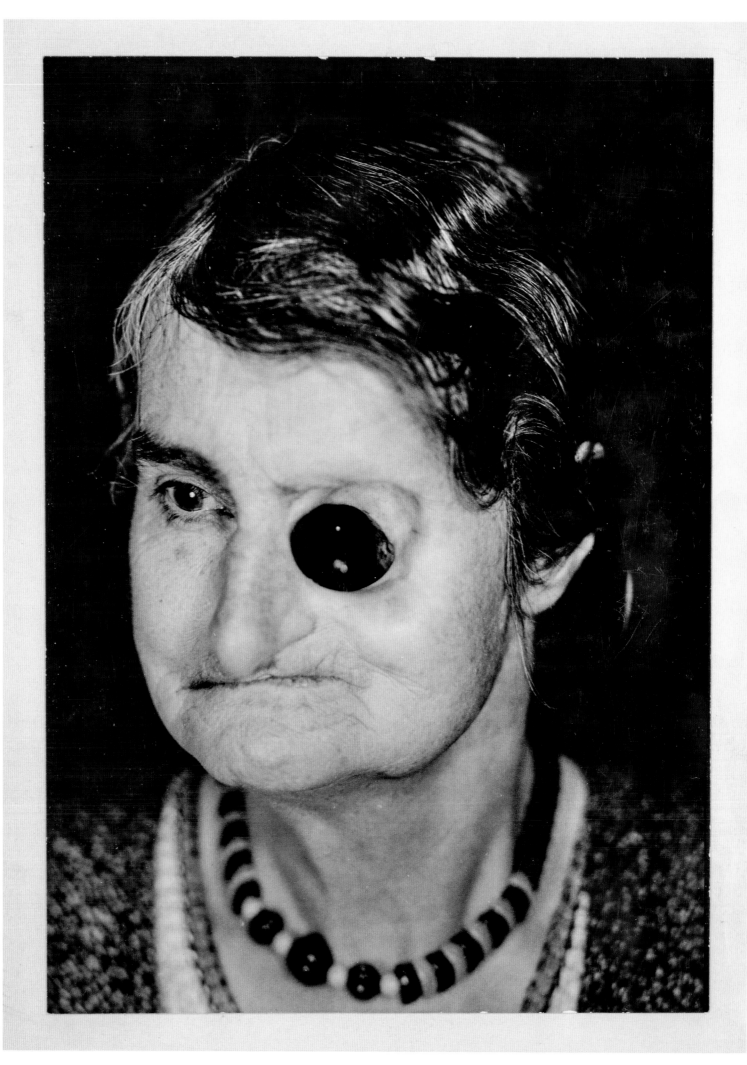

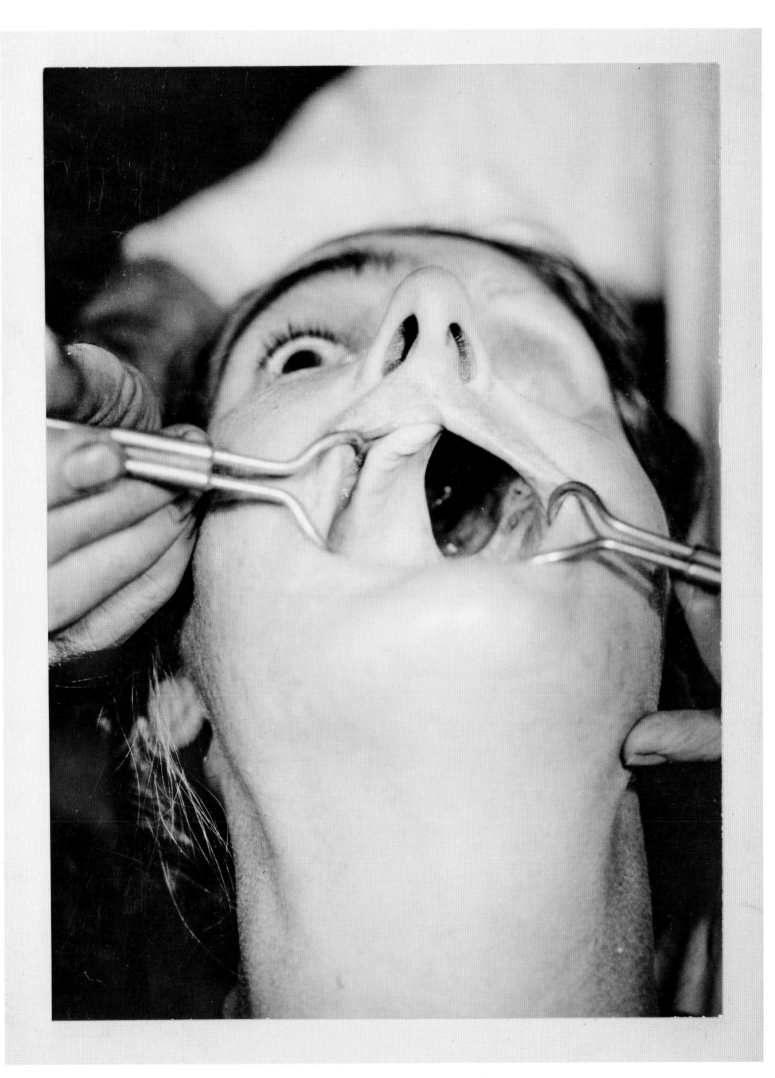

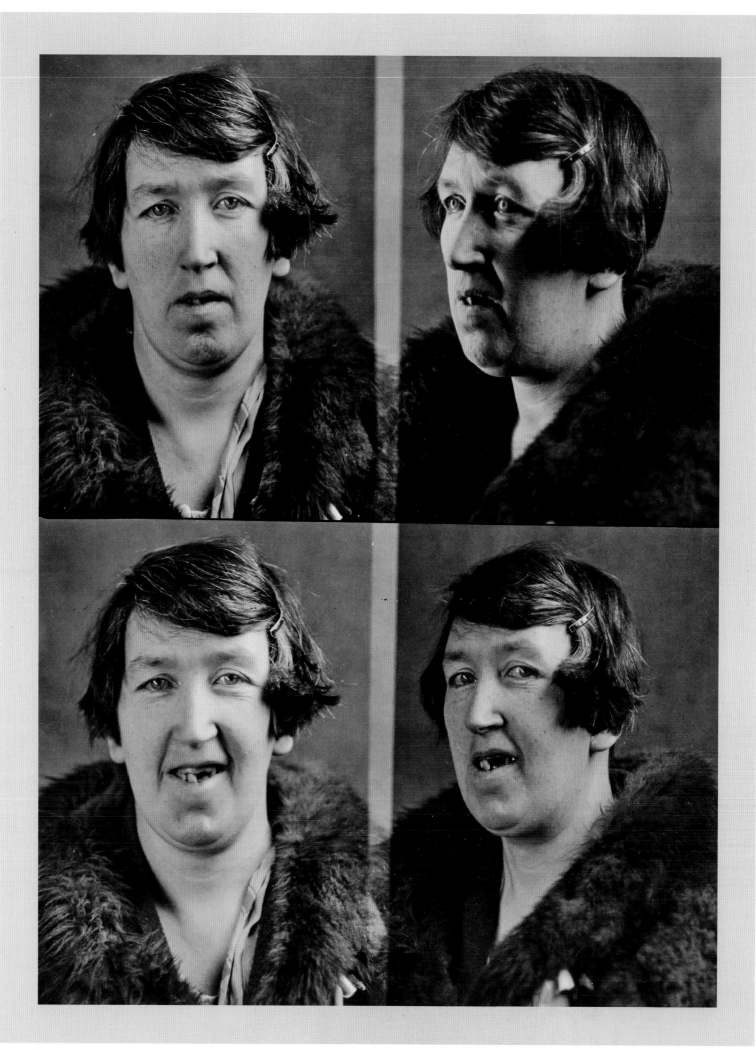

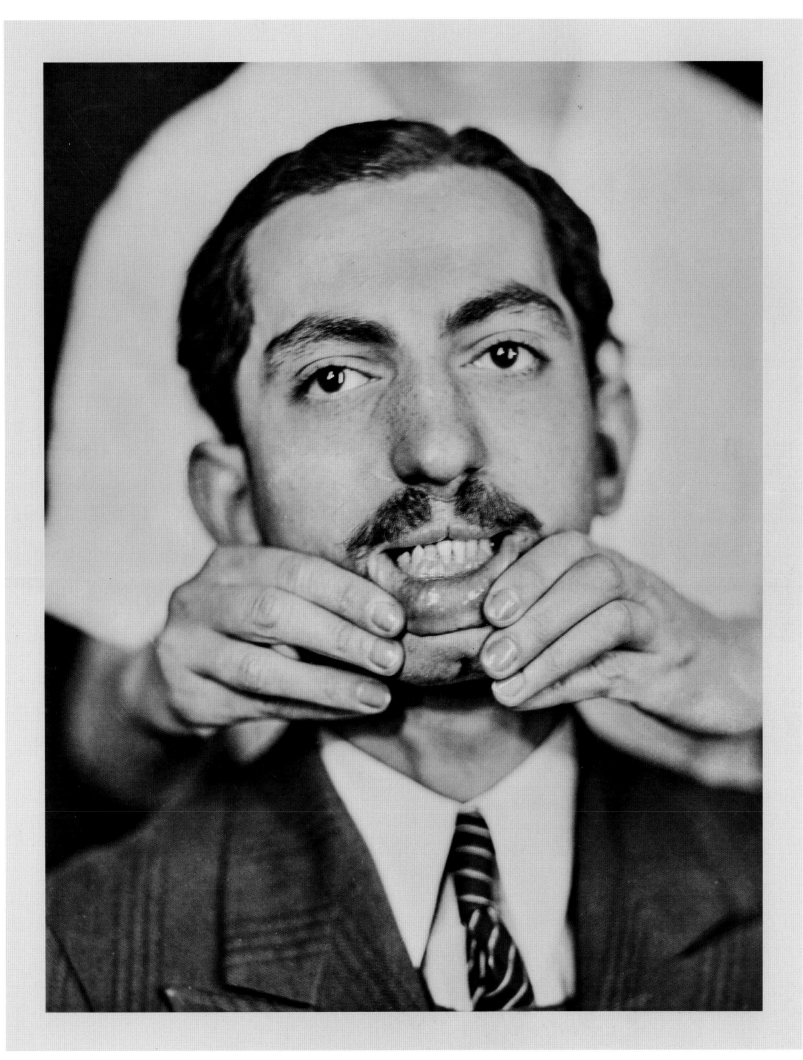

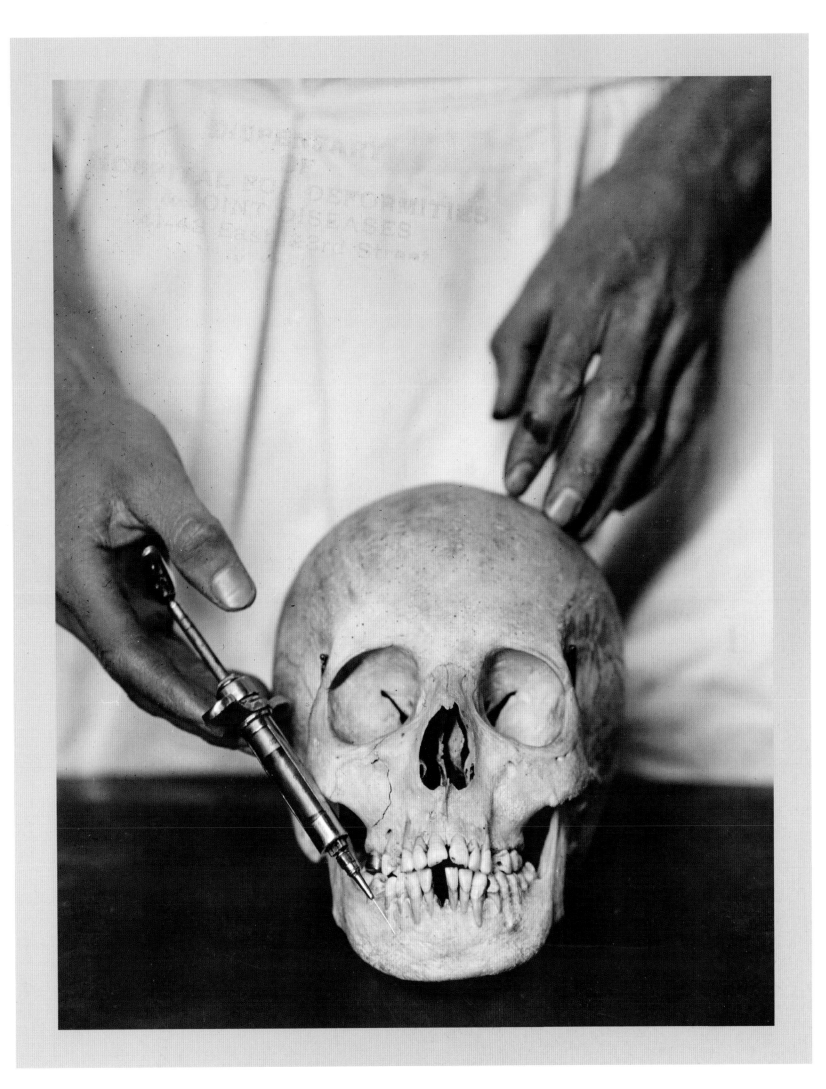

In 1980 I spent most of my time in London playing Louise Bryant opposite Warren Beatty in his movie *Reds*. I'm not sure why I began taking pictures of the pigeons in Trafalgar square. It might have been due to their constant manic swooping down on hundreds of tourists who seemed to enjoy the outrageously close proximity of our so-called feathered friends. They were astonishingly reckless, yet completely in control. I had to admire their willful plunges that occasionally landed on an arm or shoulder of some hysterical teenager or crying baby.

On my weekends off I watched crowds feed the dive-bombing birds. It was almost as if the army of winged invaders knew they were more, much more, than simply "noteworthy." I doubt you're aware of the fact that the pigeon has a noble history. It is one of the most loyal and devoted of birds. When raised with love and attention, it can be a faithful, treasured companion. It's said that Charles Darwin owned a diverse flock of adversarial pigeons. Nikola Tesla had one he adored. "I loved that pigeon as a man loves a woman and she loved me. When she was ill, I knew and understood. She came to my room and I stayed beside her for days. I nursed her back to health. That pigeon was the joy of my life. If she needed me, nothing else mattered. As long as I had her, there was a purpose in my life."

My friend Woody Allen used to call them rats with wings. Yet pigeons' homing talents helped shape history in both World Wars. One named Cher Ami completed a mission that led to the rescue of 194 stranded US Soldiers. Some pigeons have been trained to distinguish between cubist and impressionist paintings. In Project Sea Hunt, a US coast guard search and rescue program in the 1970s and '80s, pigeons were shown to be more effective than humans in spotting shipwreck victims at sea.

The pigeons of Trafalgar Square helped distract me from the challenging duties of playing Louis Bryant, an ambitious, feminist, political activist, and journalist who became known for her sympathetic coverage of Russia's political character during the First World War.

Because of my pigeon friends, not only did I print my 20-by-24 inch black and white photographs, I had the joy of appreciating their own special genius. Once you've stood in the rush of their wings … watch out, you might fall in love.

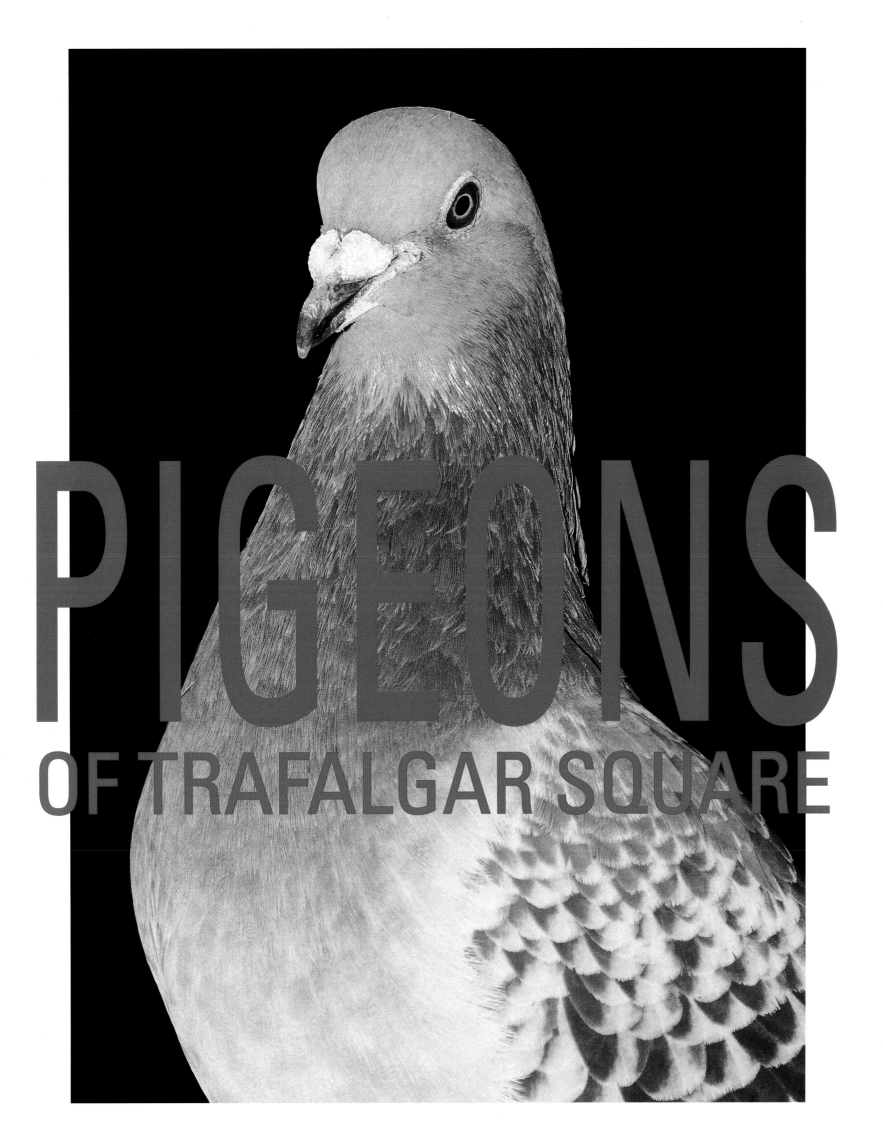

PIGEONS
OF TRAFALGAR SQUARE

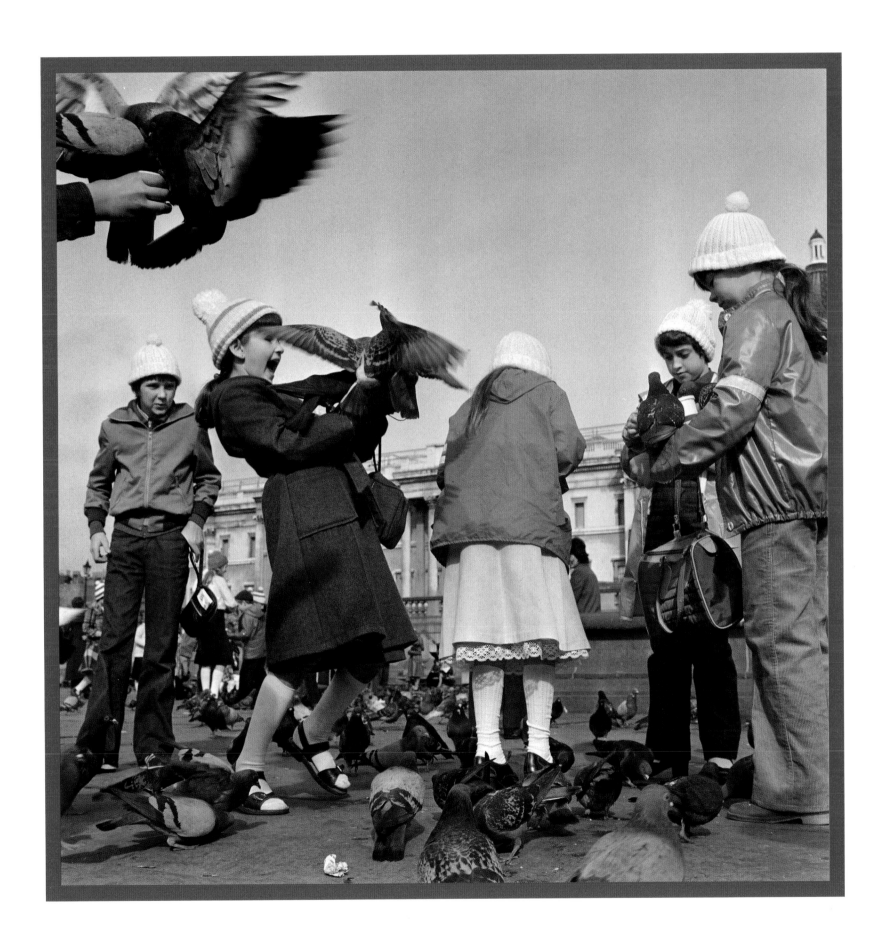

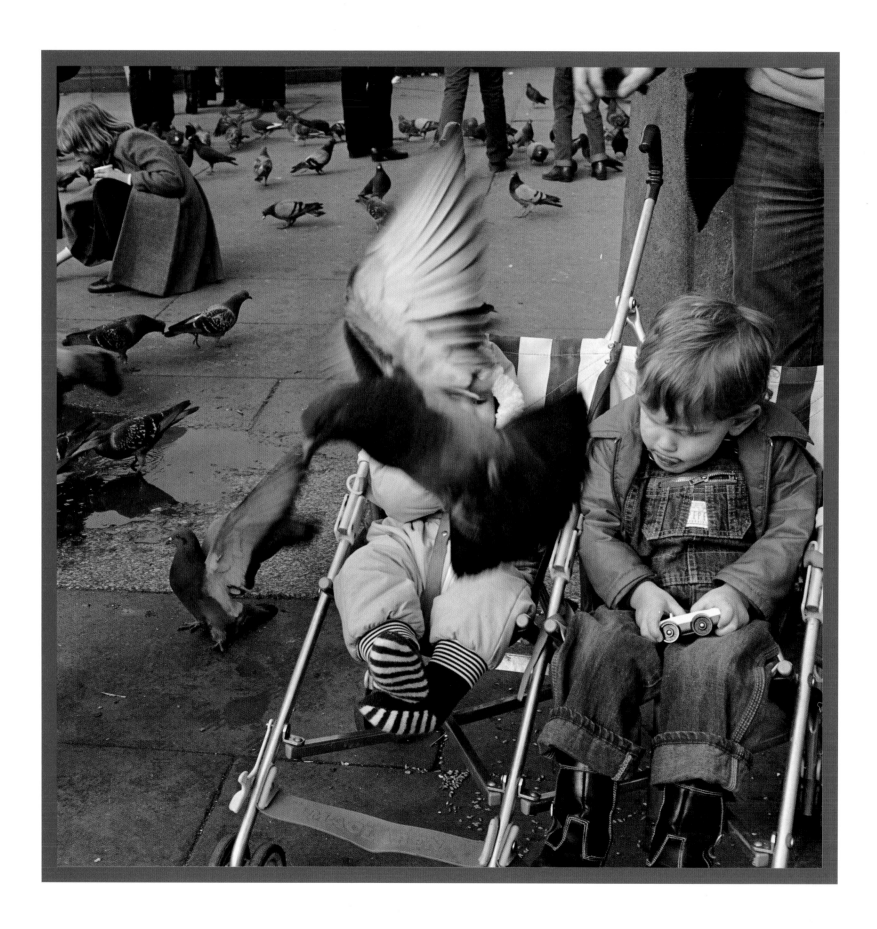

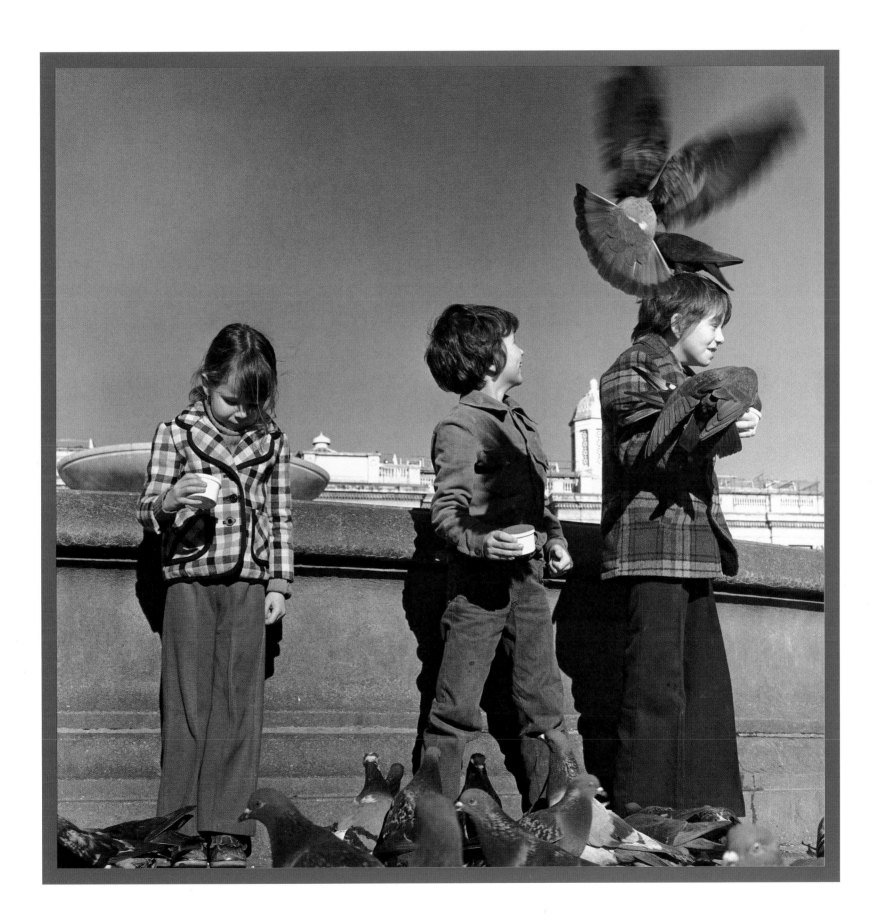

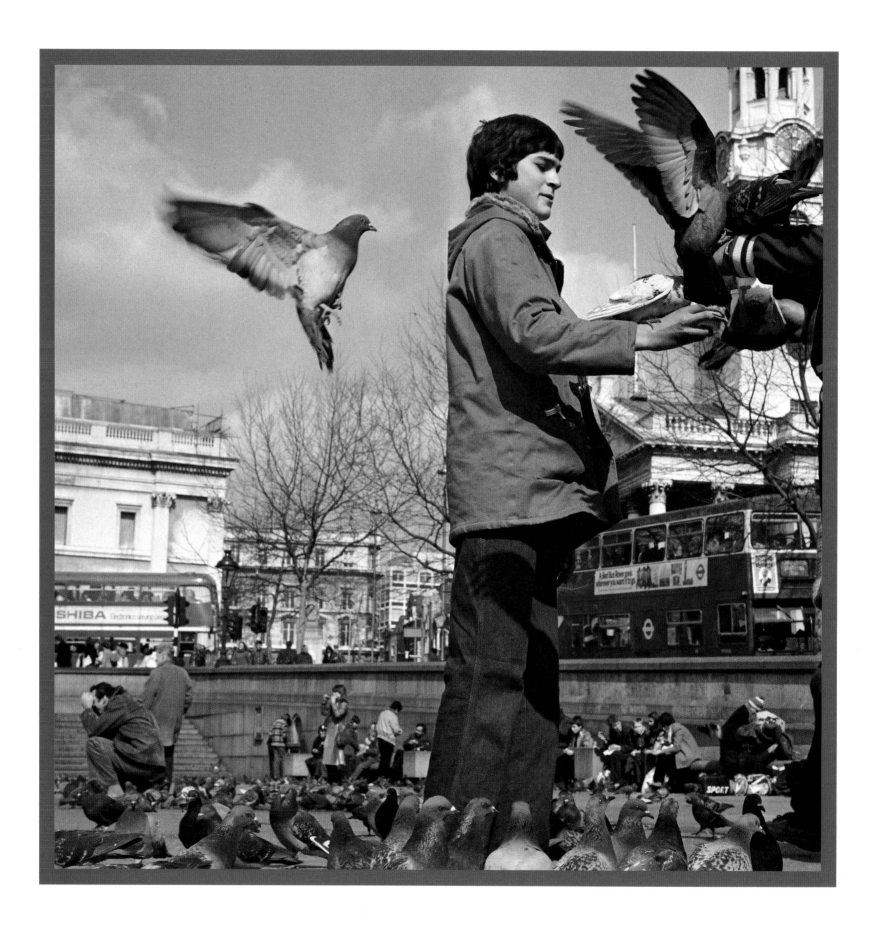

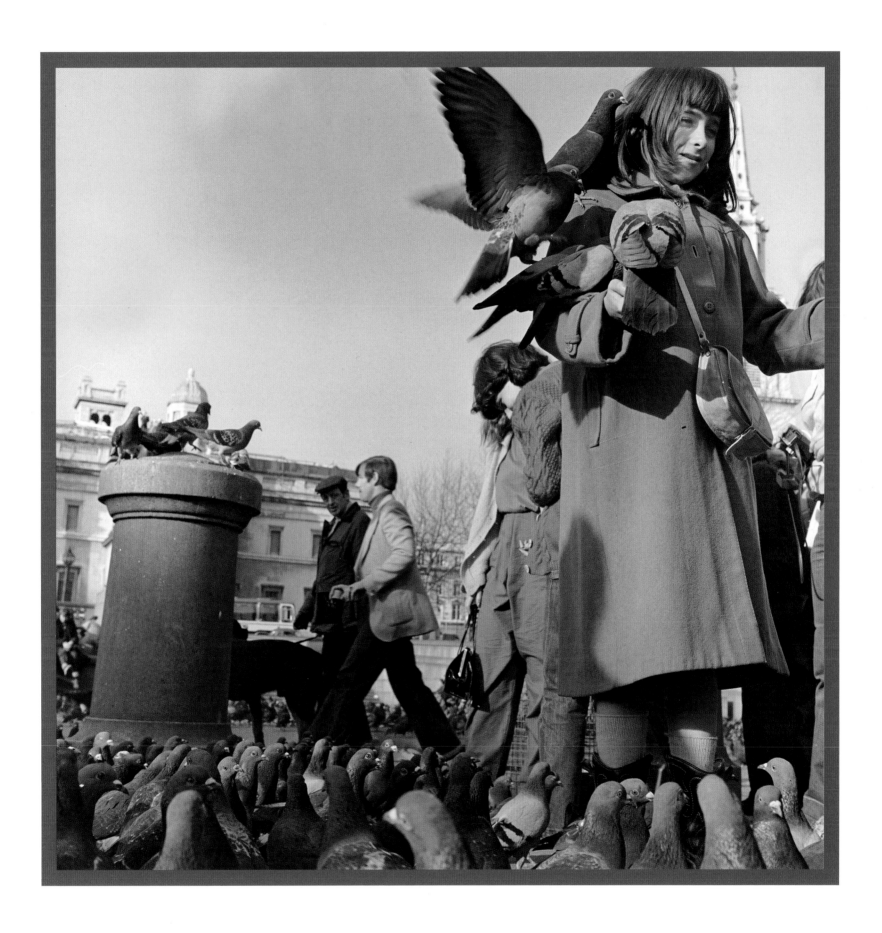

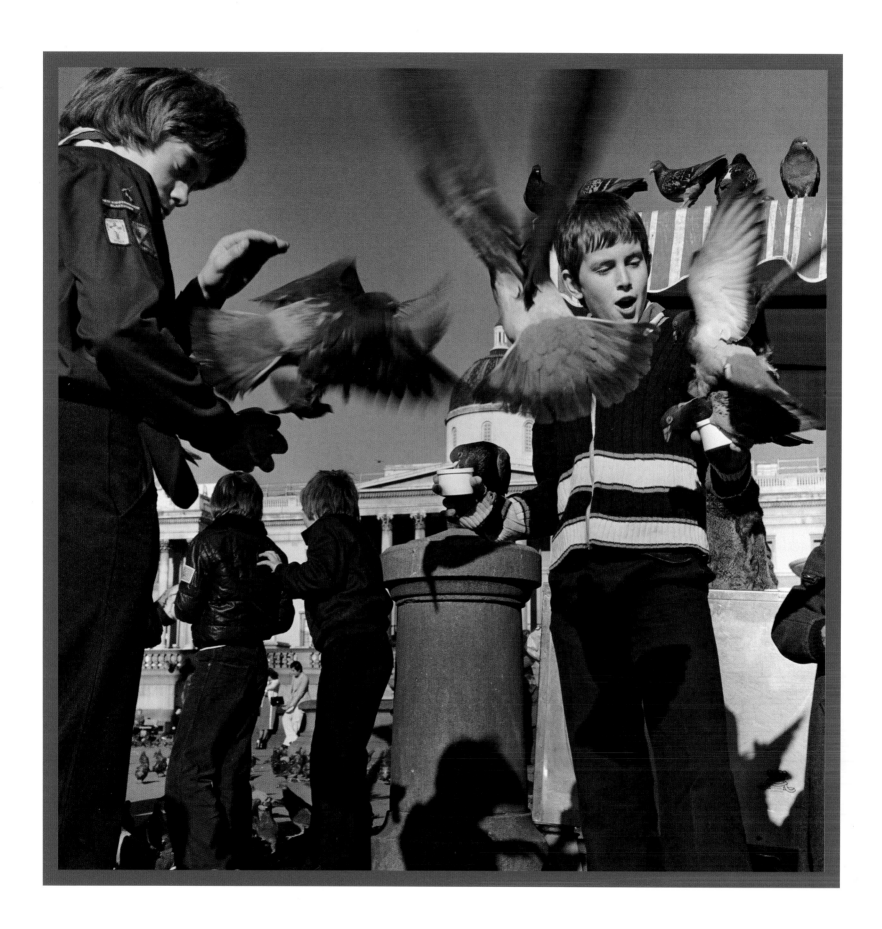

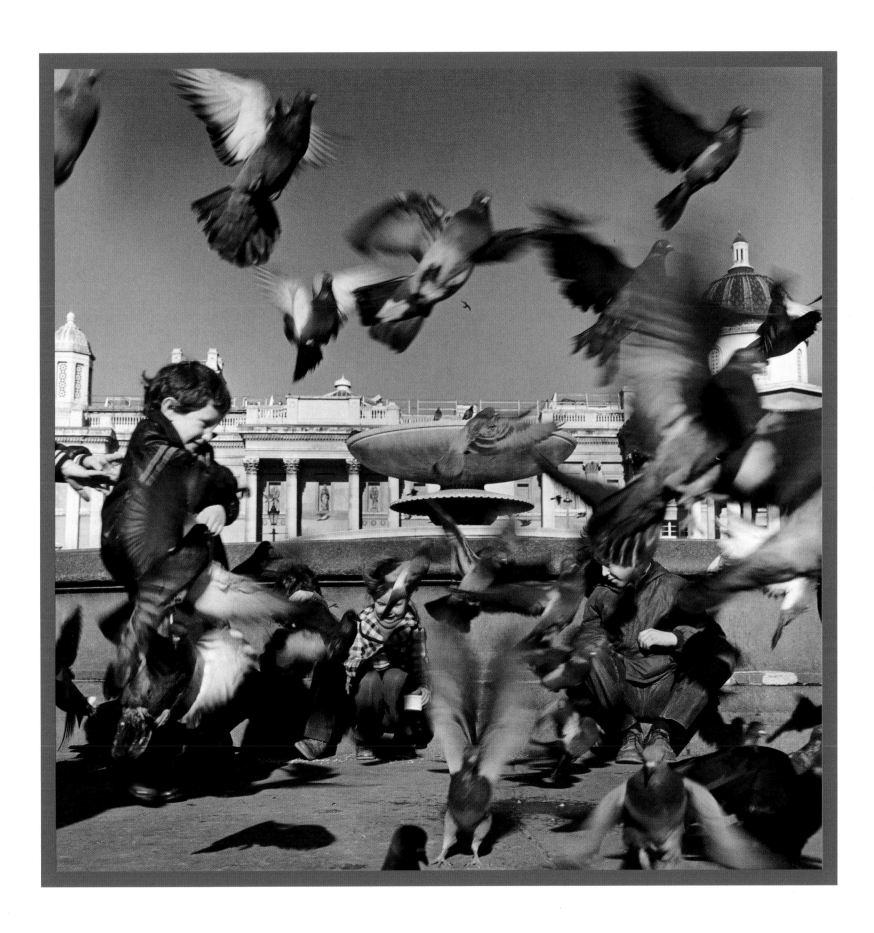

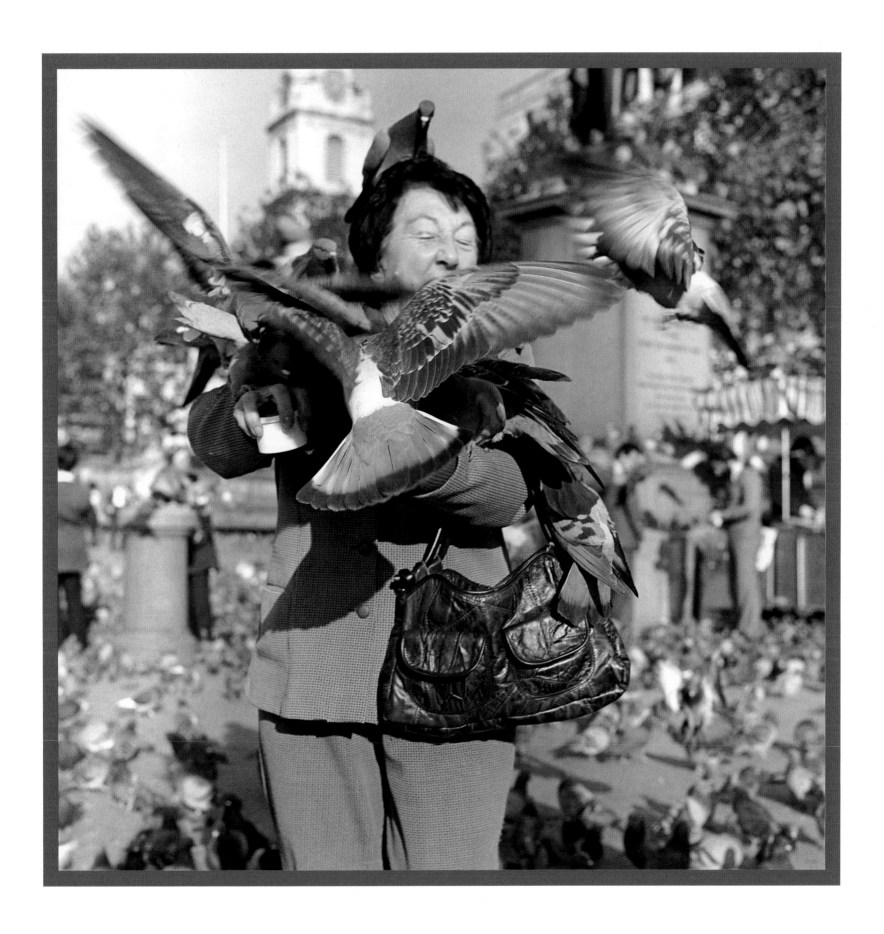

CHERISHED

TREASURES

People see hooks as objects to hold things. Not me. Signs are an unfortunate source of anger. Take my beautiful rusted example: "NO PARKING THIS SIDE." It's helped me stop screaming "Go screw yourself" every time things haven't gone my way while trying to park the car. They help me pause and rethink their meaning. For example, I remember the moment I saw a photo of a pair of endlessly long fingered gloves in a fashion magazine. After I cut it out and glued it onto a piece of paper in my three-holed black binder aptly named "Fashion," I occasionally look inside, see those crazy gloves, and marvel at the person who had the idea to make them a reality. They never fail to make me consider the structure of hands, how they spread, their function, their beauty, their touch. Inside my world, the expression of an object, even something as random as my black hat resting on a table with chains of crosses encircling its perimeters, makes me feel connected to an ever-evolving world of expression. The black silhouette of a man with a large cross sticking out of his face on a small poster is one of my favorite purchases. Why not play with a pure black cross instead of a nose? Let's say some annoying problem is on my mind as I pass by the cross-bearing gentleman. I stop and glance over the artist's unique concept. Where did he even get the idea of a large cross becoming a man's nose? It's pretty damn amazing.

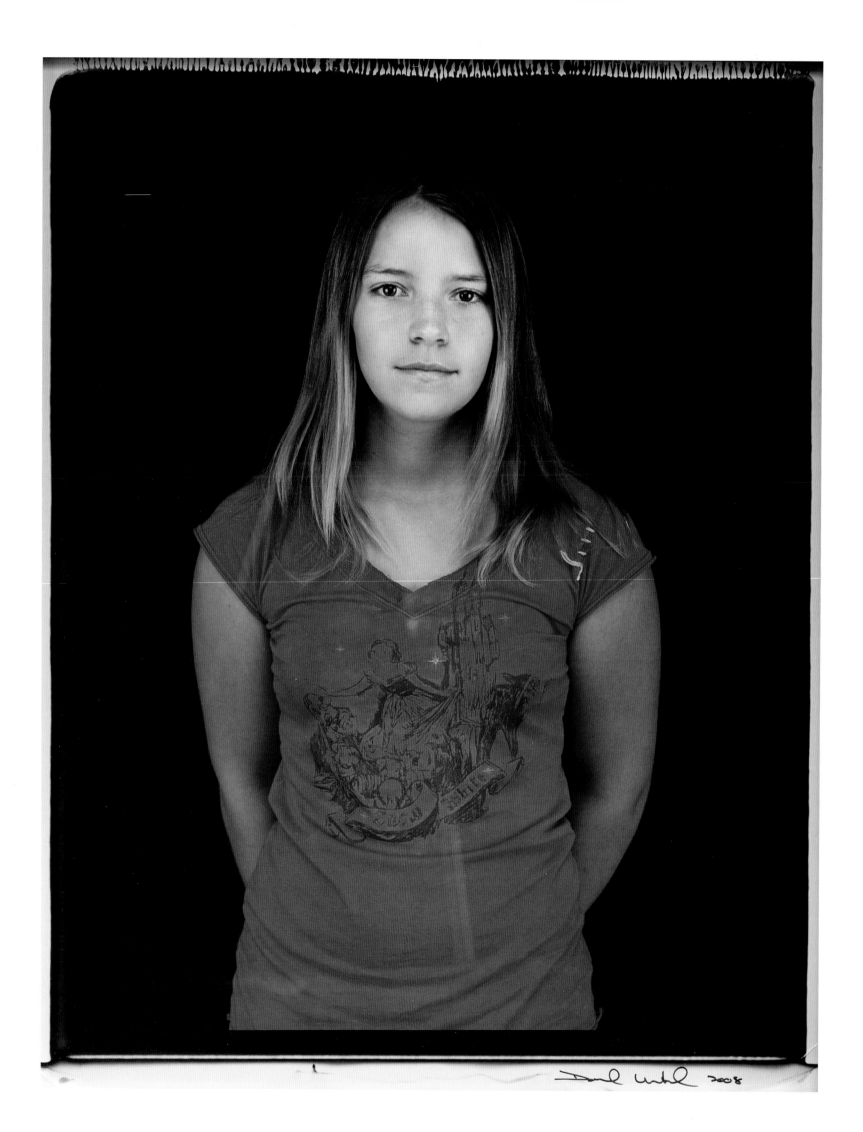

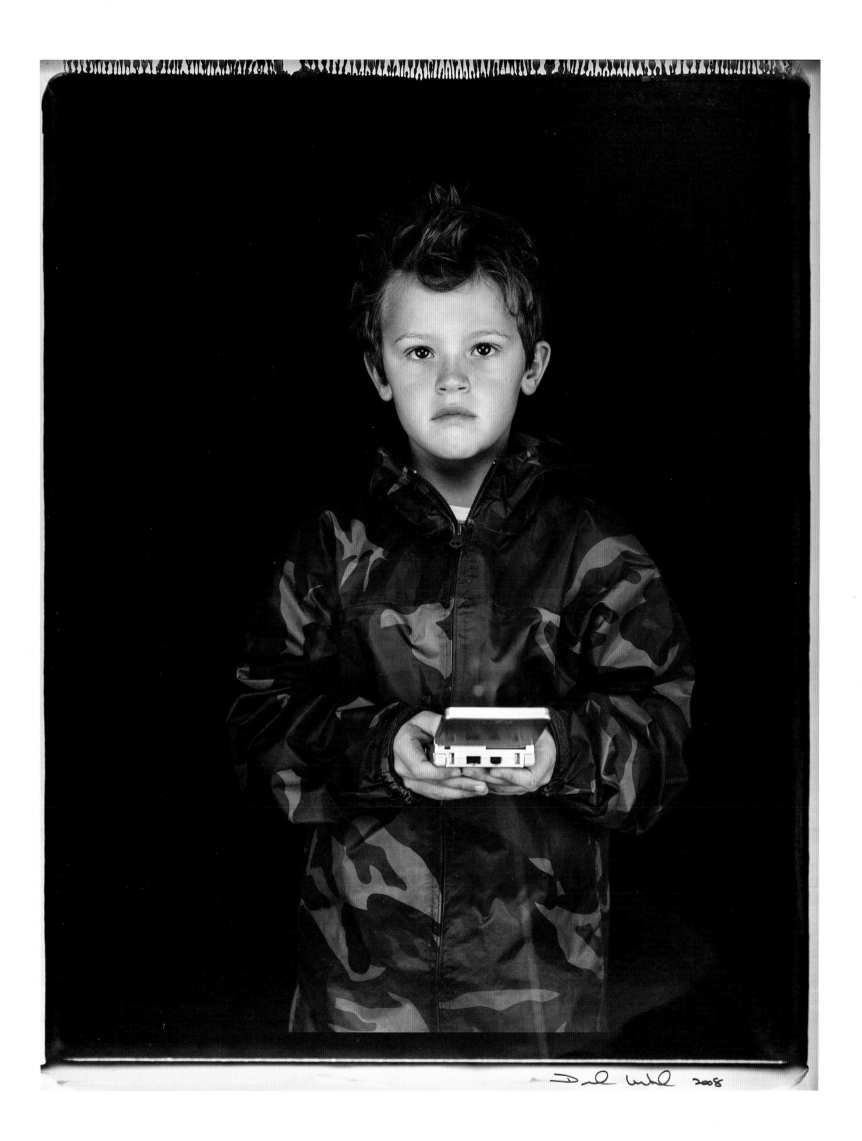

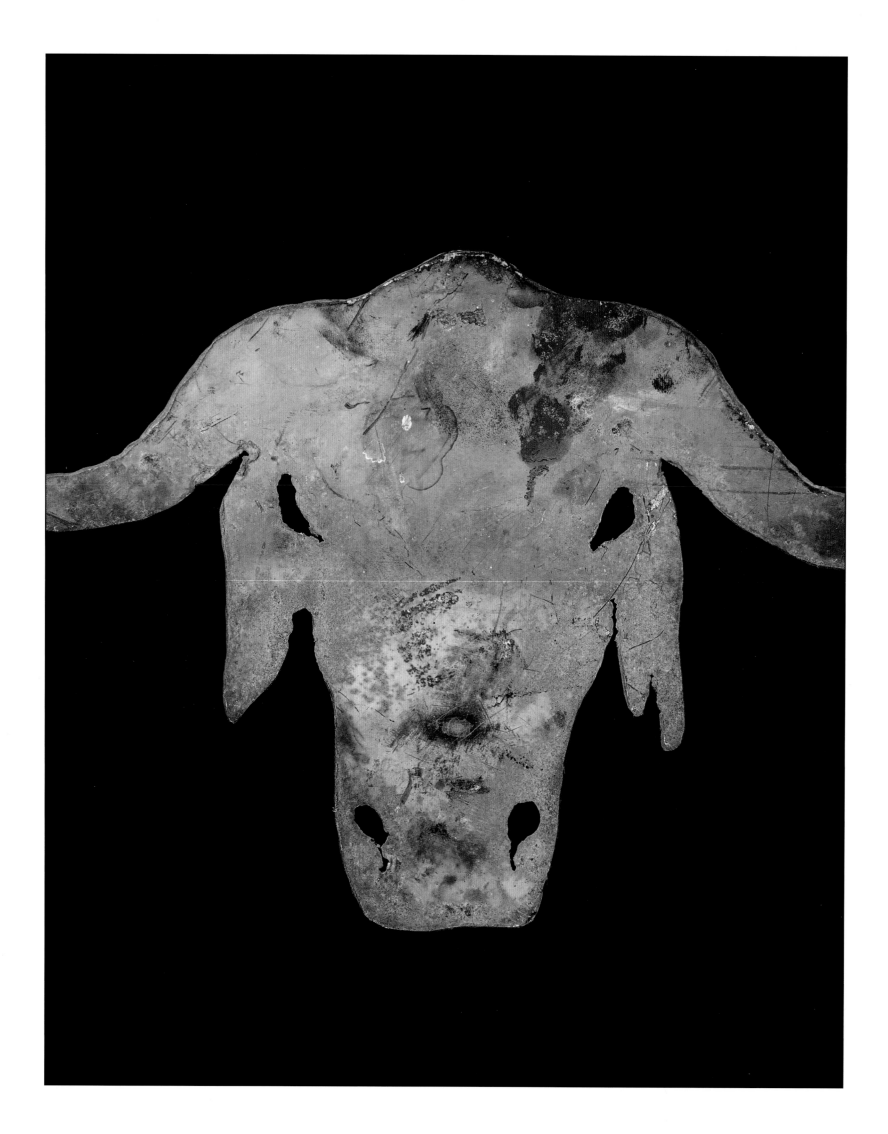

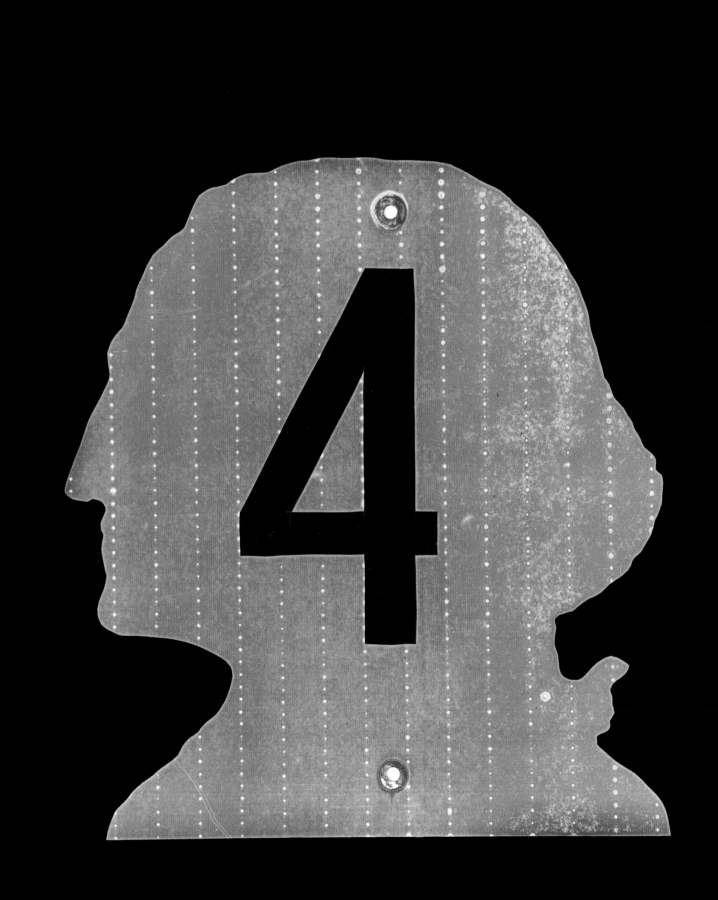

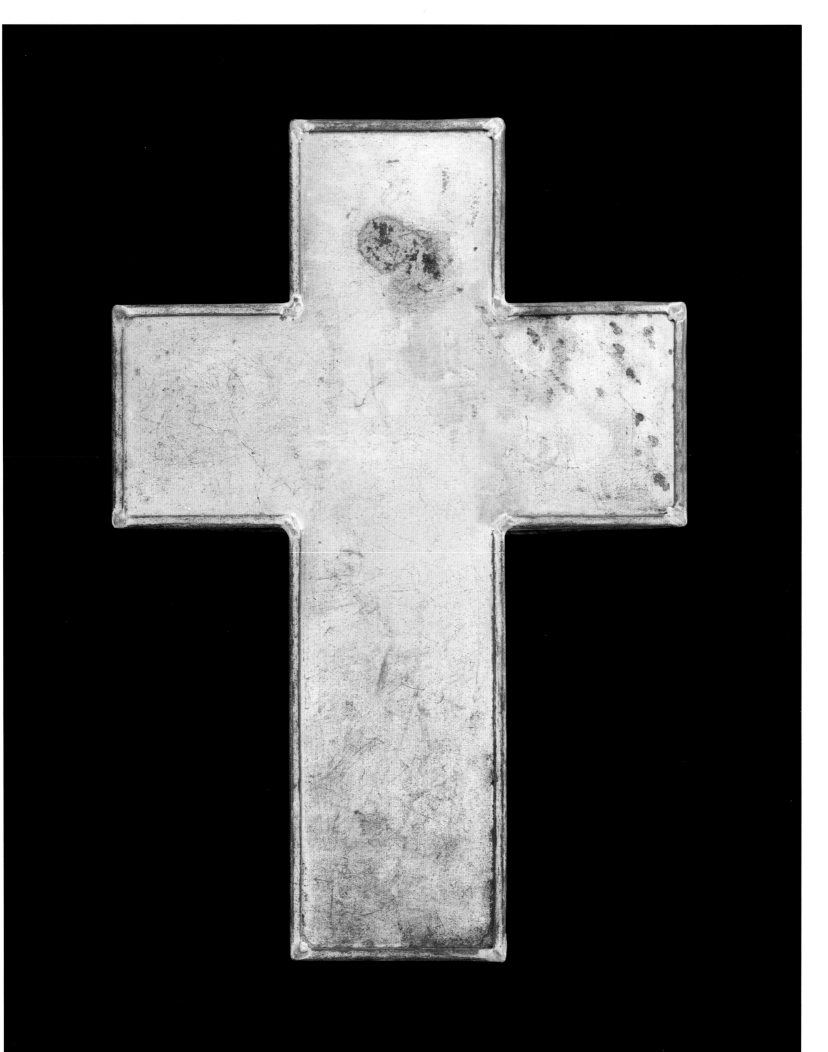

B I N G O

B (1 to 15)	I (16 to 30)	N (31 to 45)	G (46 to 60)	O (61 to 75)
2	21	32	46	66
13	30	44	58	70
5	29	FREE X FREE	48	74
6	16	33	52	68
10	26	45	53	63

61

Start with letter X in center, Free
5 NUMBERS STRAIGHT ACROSS, UP
AND DOWN, OR DIAGONALLY, WINS
12 DIFFERENT WAYS TO WIN ON EVERY CARD

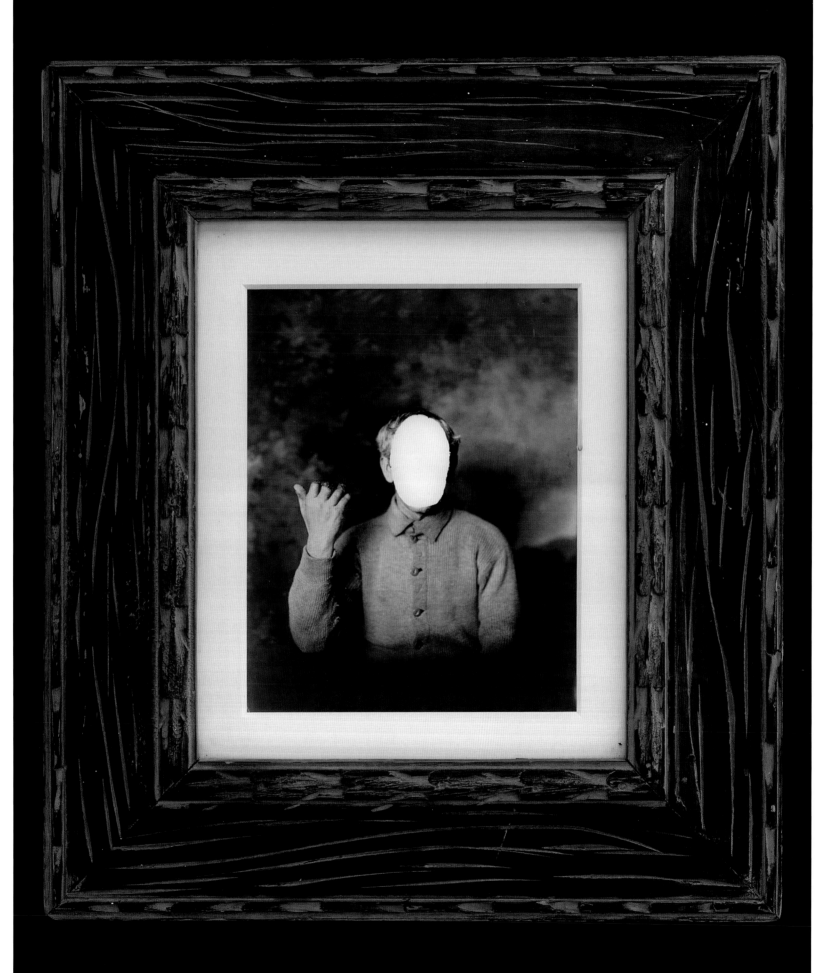

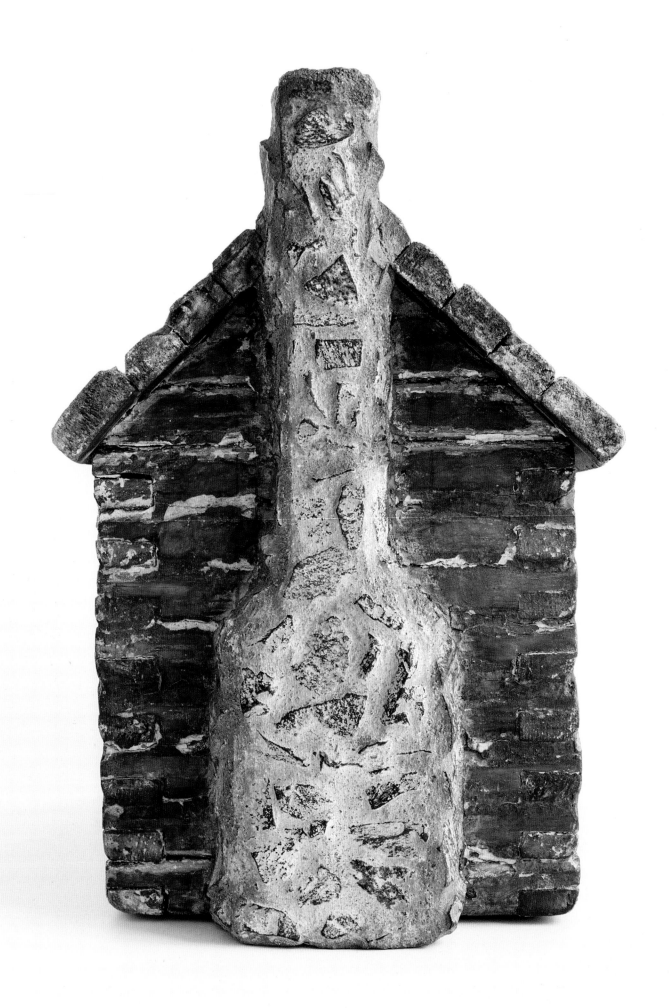

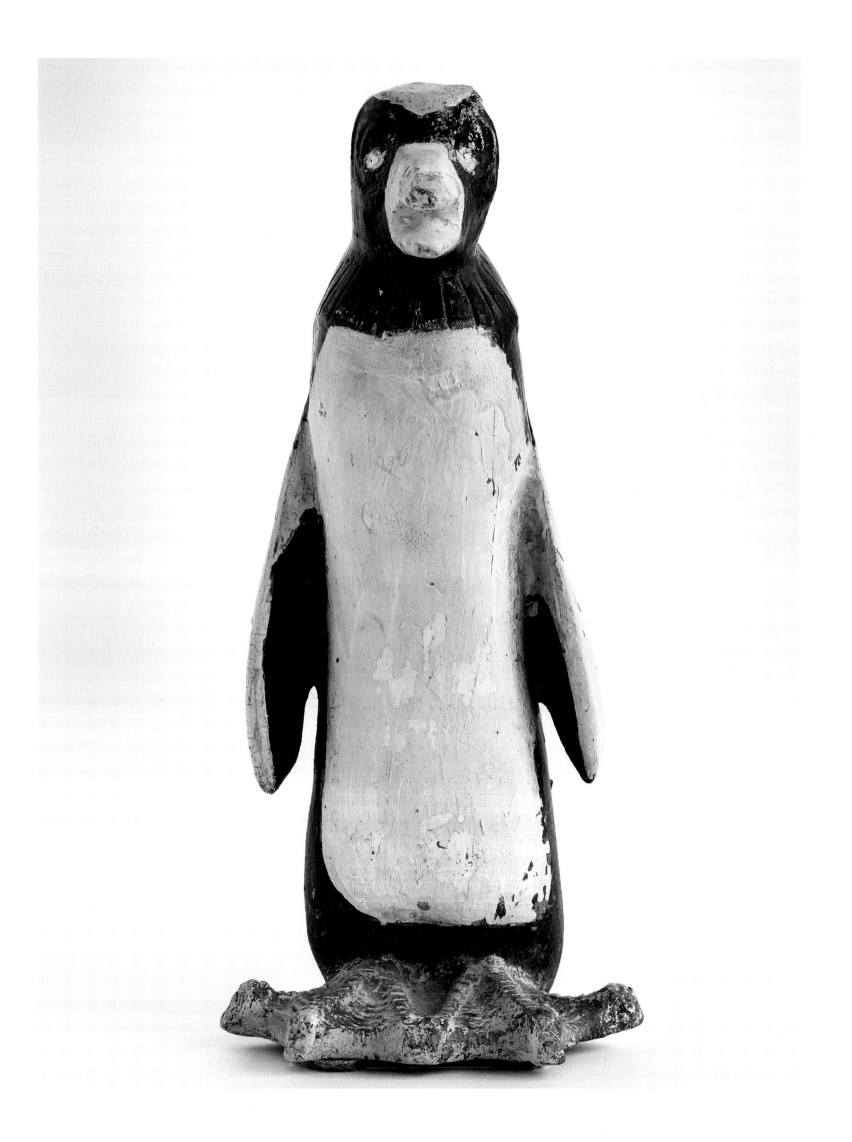

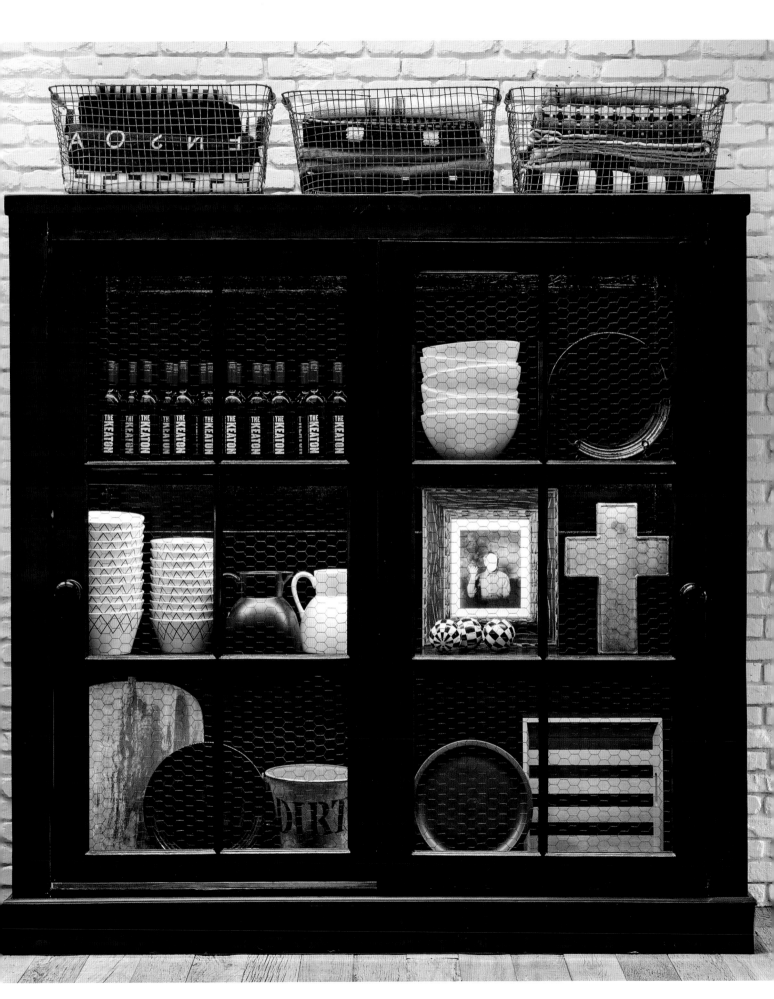

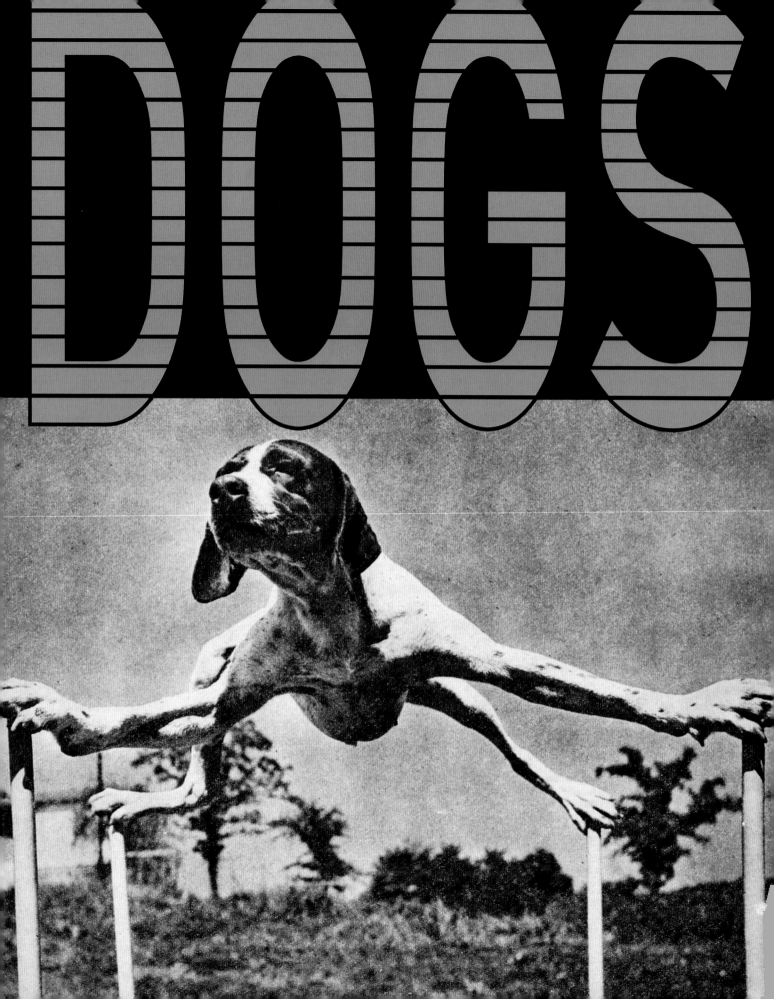

I vaguely remember our first dog, Donnho. He must been four or five years old when he showed up at home in Highland Park. I was not taken with him or dogs in general. At age fifty I was given a big shepard Josie. She wasn't what I'd had in mind either. The day she took a ch the mailman's leg was not a pleasant experience. Josie had no truck . She did not take to my suitors, and they … they did not take to he be said Josie singlehandedly saved me from the rigors of married

In 2005 I brought home a golden retriever pup for my da ter Dexter's birthday. With time Dex became busy with newfound commitment to girlfriends, boyfriends, and swim team. Duke, my son, couldn't have cared less ab Emmie, except when she peed in his bedroom. And sc tle choice but to attack my closet, eat my shoes, steal food from the kitc ertop, and bark for attention. I considered her a special mistake. I be her for her morning walk, and surprisingly, within a year, I fell in l

This year I received a four-legged gift named Reggie. W little heart I have left is engrossed with a kind of lo never imagined. Without Reggie my life would be a ba desert. I know that sounds extreme, but I don't really c I kiss her face and don't think of my former complex is relating to the expression of affection with people. I

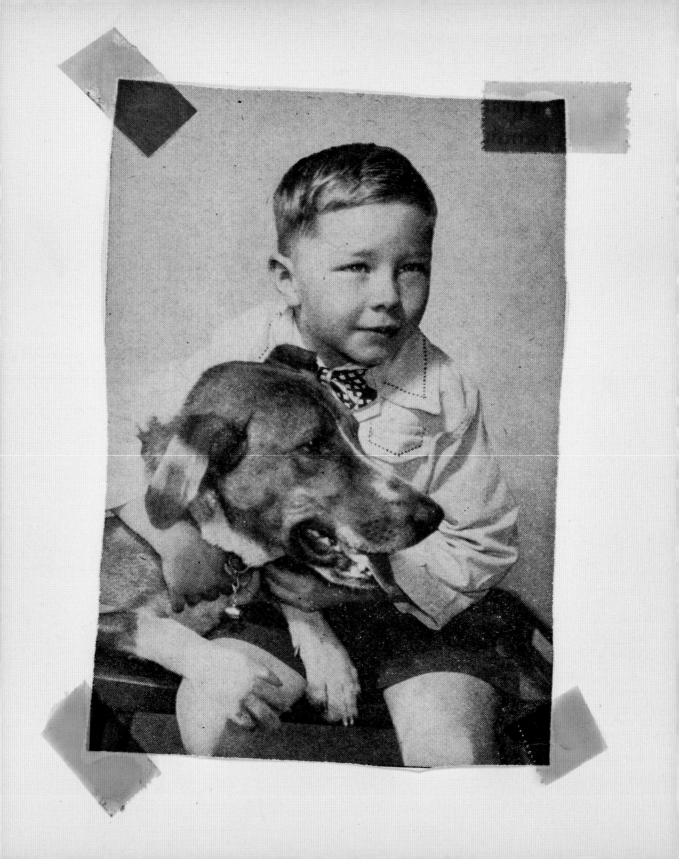

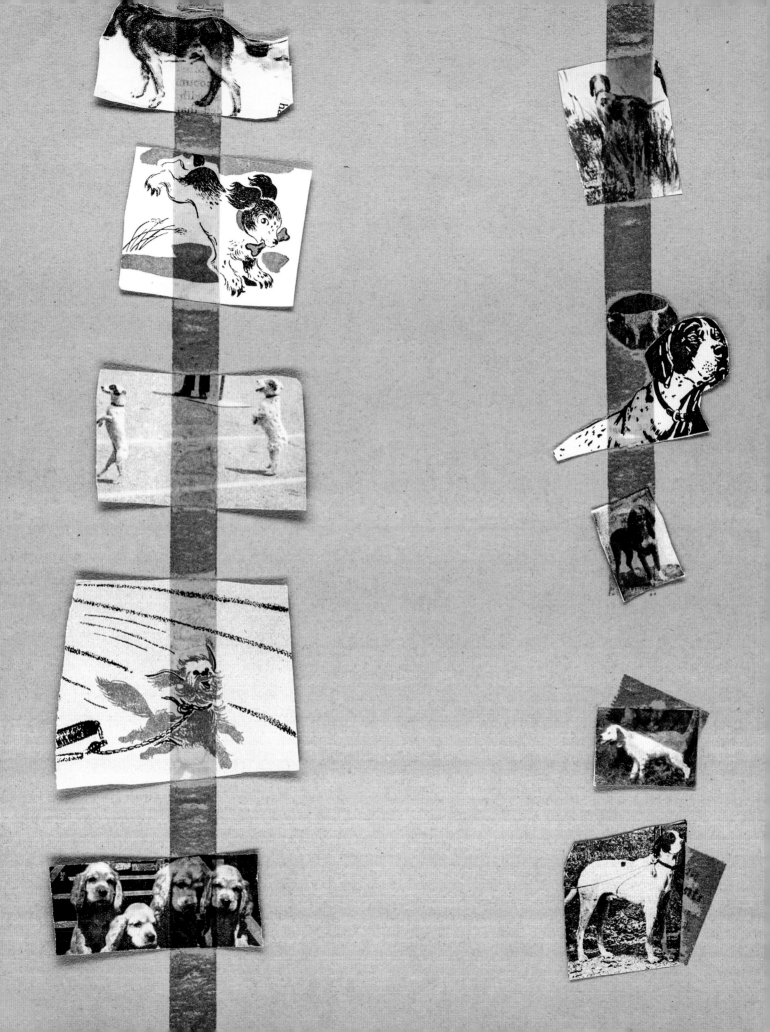

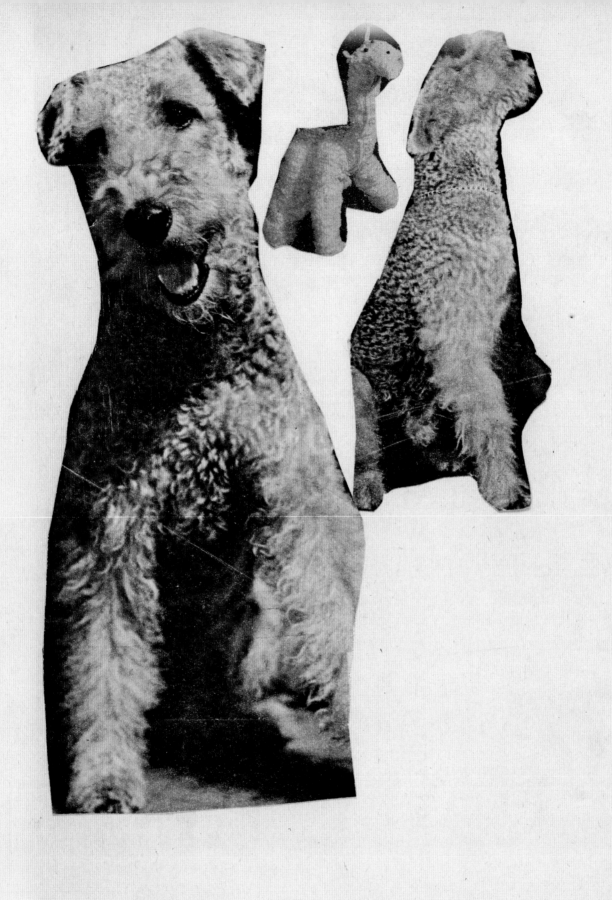

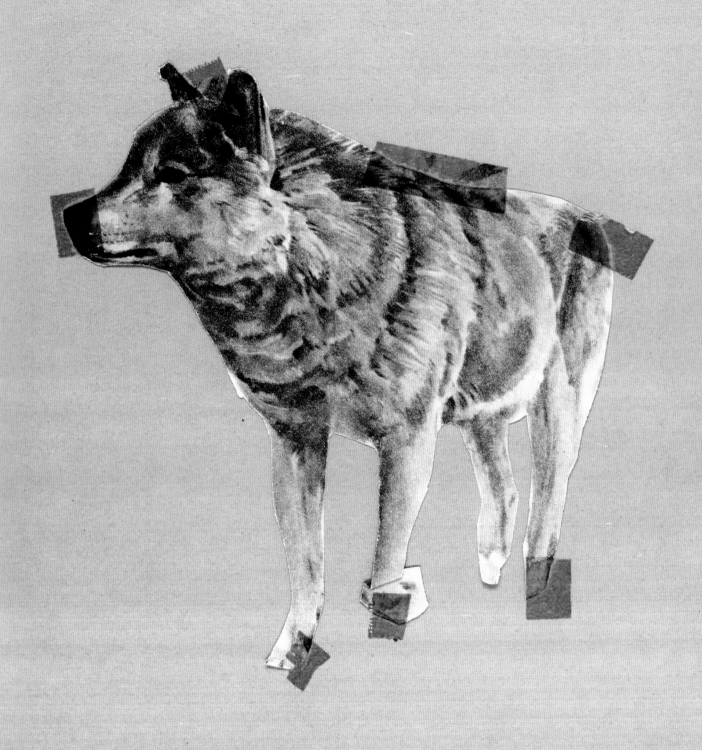

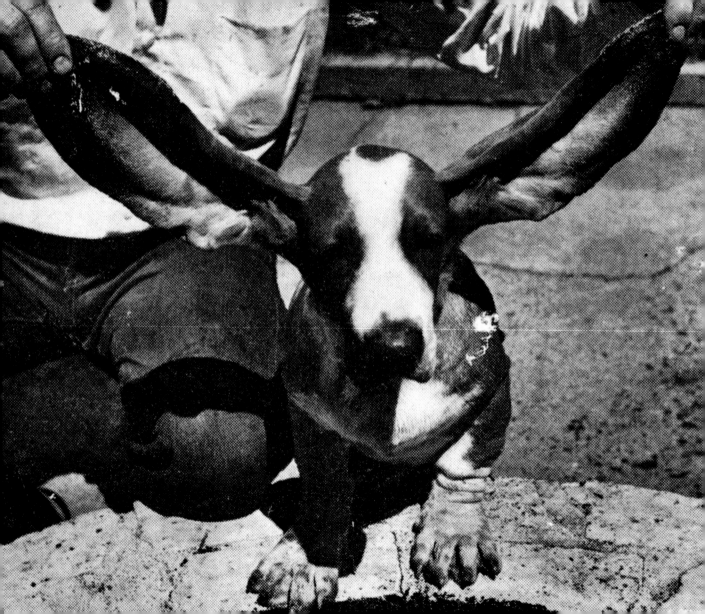

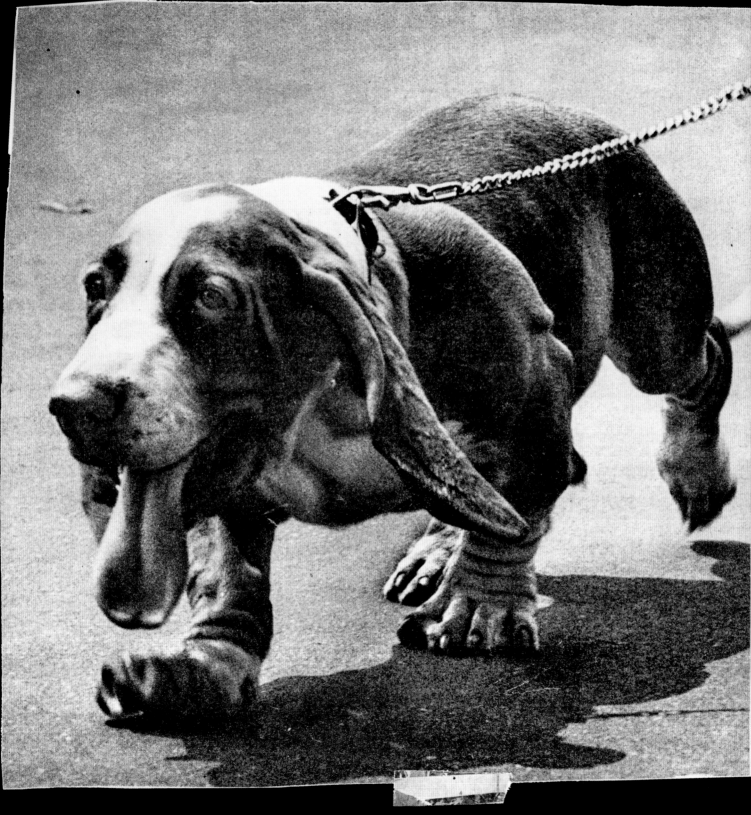

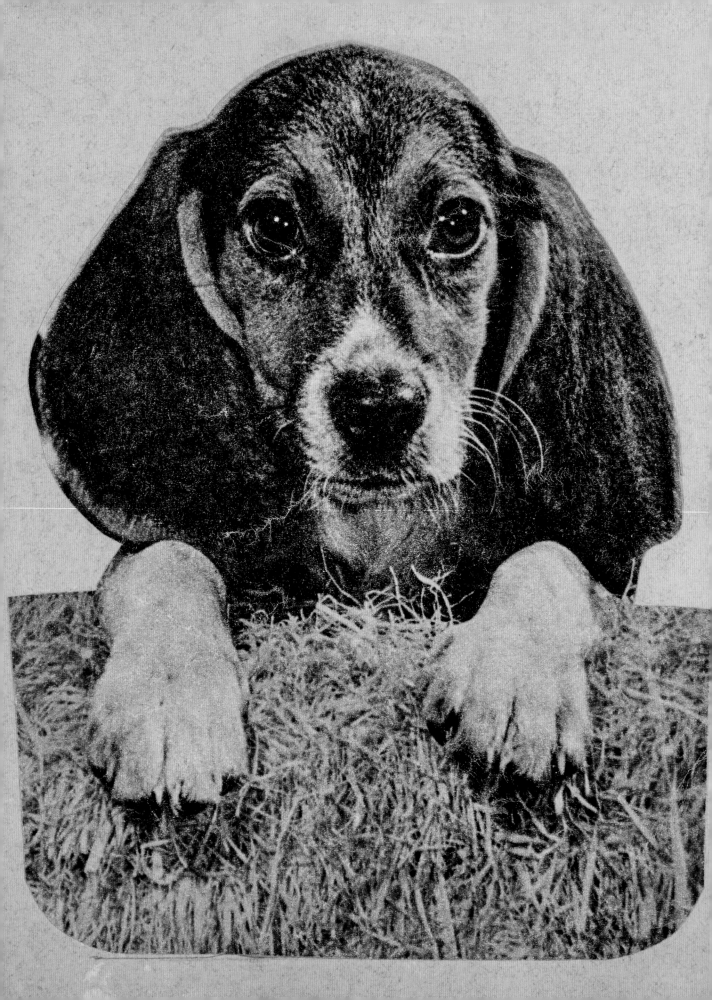

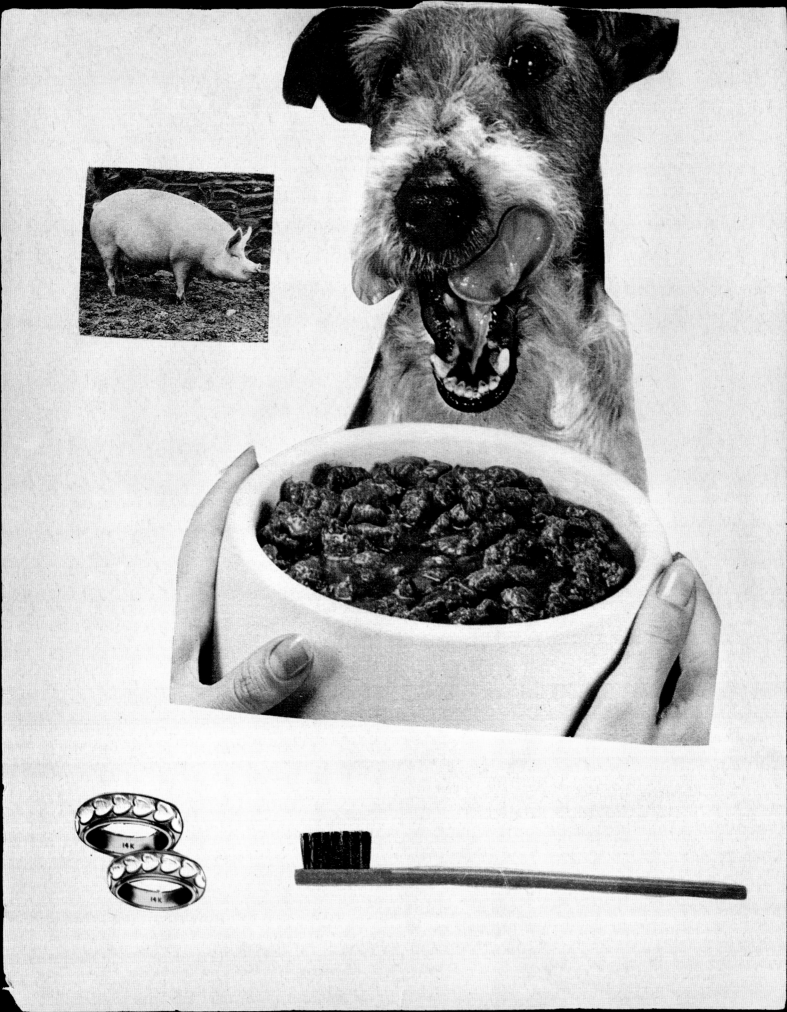

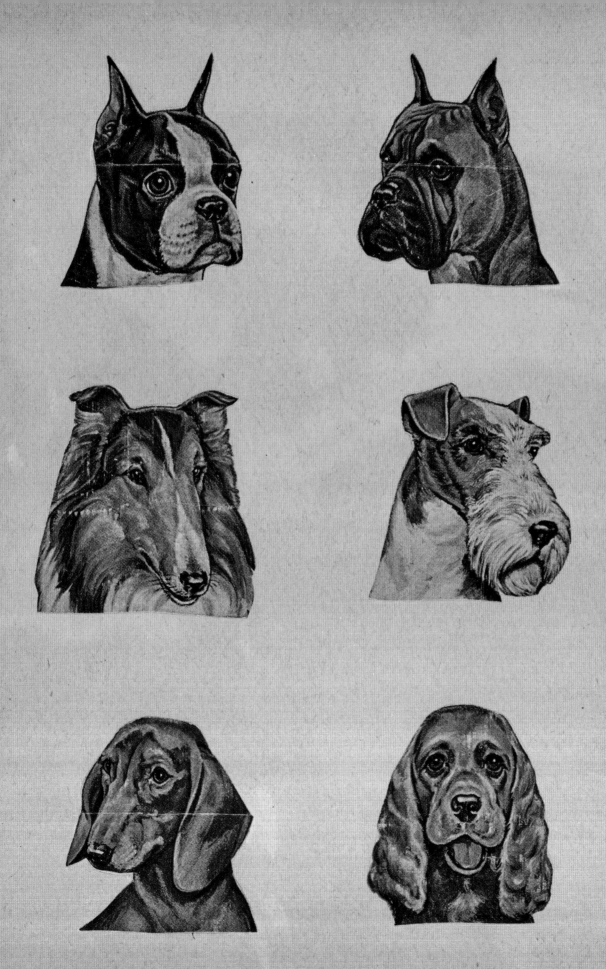

THE OSTENTA

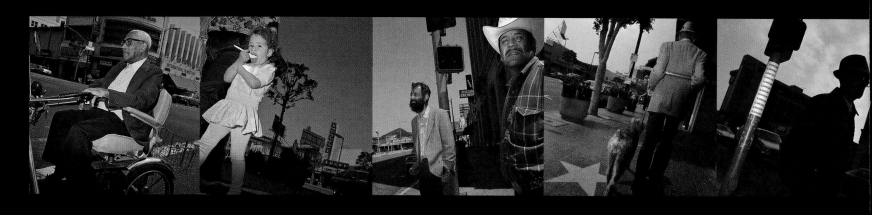

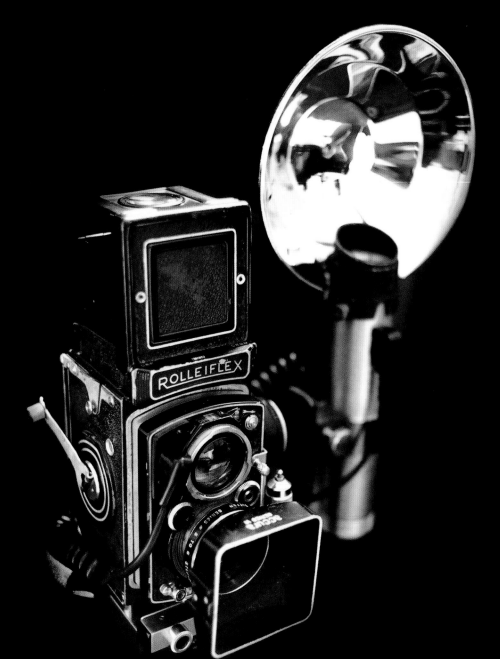

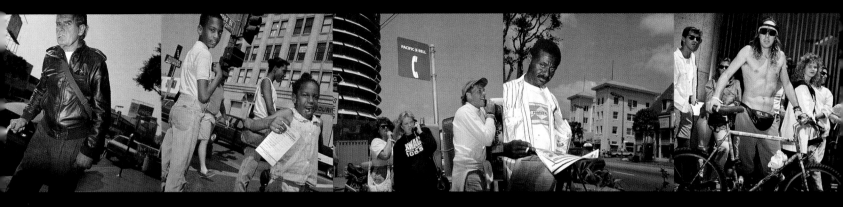

Some forty years ago I began taking my Rolleiflex camera with its ostentatious flash attachment to cruise up and down Hollywood Boulevard in search of capturing photographs that defined a certain kind of life on the street. Like all tourists, I stepped on the stars of Lucille Ball, Marlon Brando, Jack Benny, and even Ingrid Berman on Hollywood Boulevard's Walk of Fame. Instead of choosing to capture fabulous movie stars stepping out of Grauman's Chinese Theater I was in search of the so called "toss aways" drifting up and down Hollywood Boulevard I thought of them much in the same manner I think of myself ... just one more lost soul searching for some kind of redemption. I remember taking shots of a particularly dapper older gentleman who spotted my flash, ran after me and threw a bag of french fries at my head. Months later I photographed a woman begging for money in front of the Scientology building. She too chased me down, screaming obscenities. I persisted. My photograph of the young man with an open wound oozing blood out of the corners of his mouth as he slept against a wall next to Musso and Frank's made me wonder what brought him to such a nightmare reality. In spite of having the good luck of experiencing the rarified side of the Hollywood dream come true, I reminded myself that success comes to the few and far between. The connection I felt for the people I photographed rather than the gifted people I've worked with came from Phil Ochs, who sang it best. "There but for fortune, may go you or go I — you and I." Along with the drifters parading on the Boulevard thousands of ordinary people also come to explore the dream world of Hollywood Boulevard After driving out of their way to buy tickets to Grauman's Chinese Theater, tourists wanted their pictures taken with the likes of Donald Duck, The Simpsons, and Woody Woodpecker. They couldn't wait to watch box office hits like *Home Alone* while I hit the street taking black and white photographs. Over time I became attached to a few regulars like eighty-year-old Grace Johanneson a lovely street greeter, and the grossly overweight man who preferred to walk with sweaters strewn on top of his head. The handsome elderly man who never failed to wear a suit and tie screamed out obscenities the day I shot him off guard. The gypsy woman dressed in several long skirts with masses of jewels glued onto her only outfit passed me by without so much as a glance. I took her picture. She didn't seem to care. I never failed to be touched by the masses of middle-class families in pursuit of a transforming theatrical experience. It reminded me of being a sixteen-year-old wannabe singer when Mom and Dad drove our whole family to see the *My Fair Lady* premiere at the Egyptian Theater on Hollywood Boulevard. Now it stands in disrepair, permanently closed Little did I realize that years later I would hit the boulevard of broken dreams to photograph the so-called nut cases street livers, drug addicts, and the ordinary visitors, like my family who came to Hollywood Boulevard in hopes of finding dreams come true; dreams that don't disappear in the pursuit of the impossible. I know, I'm still one of them

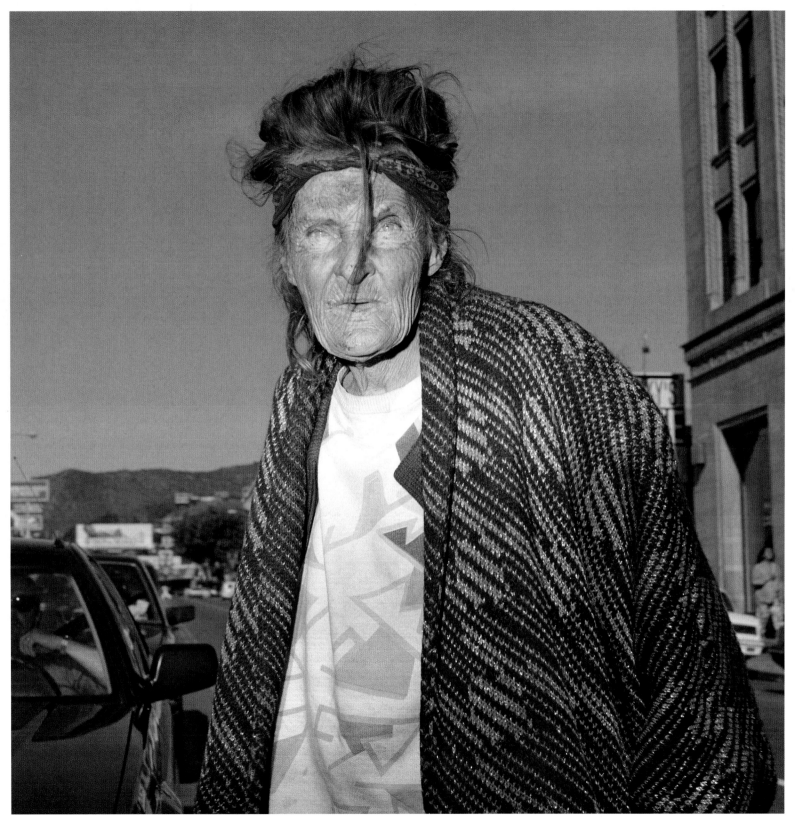

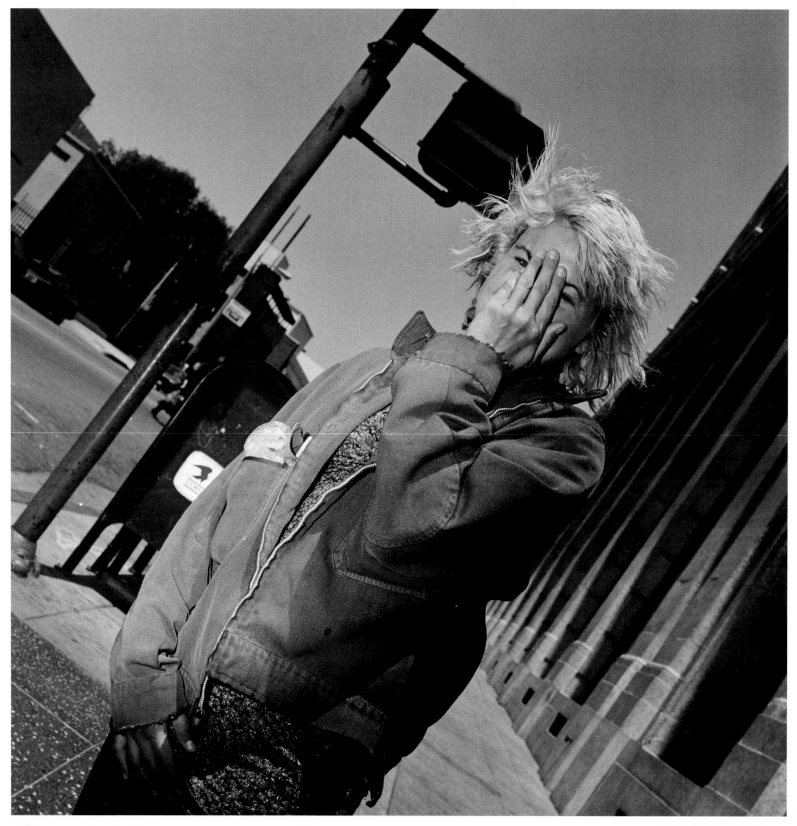

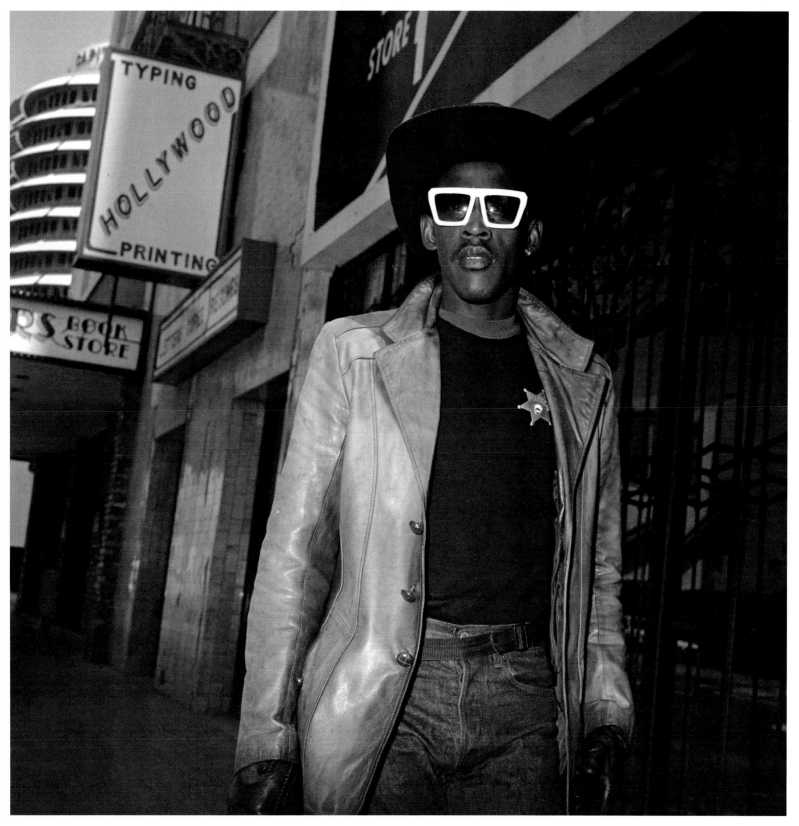

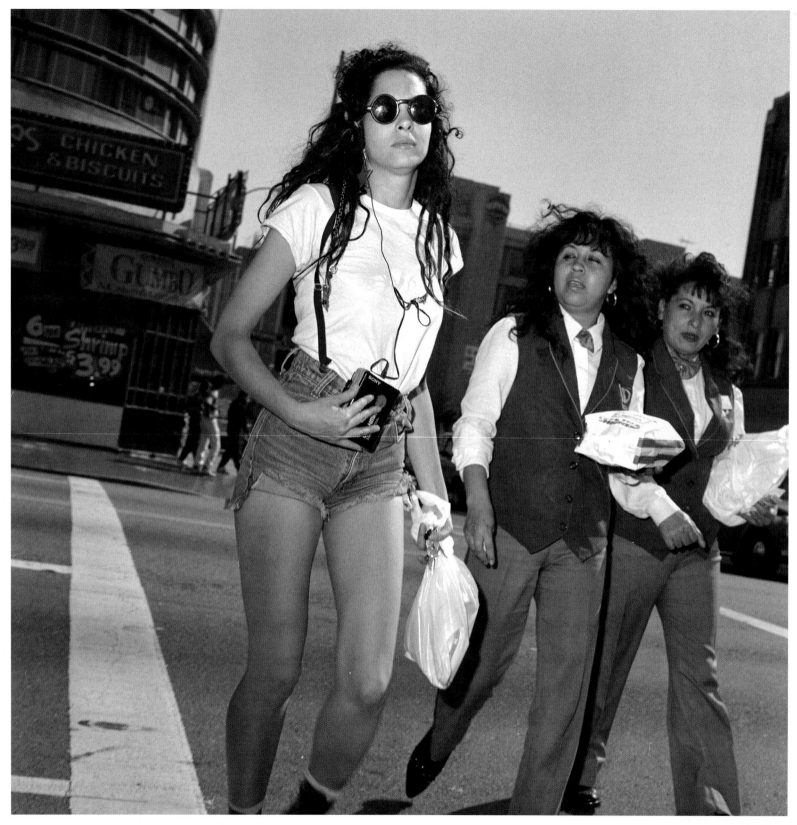

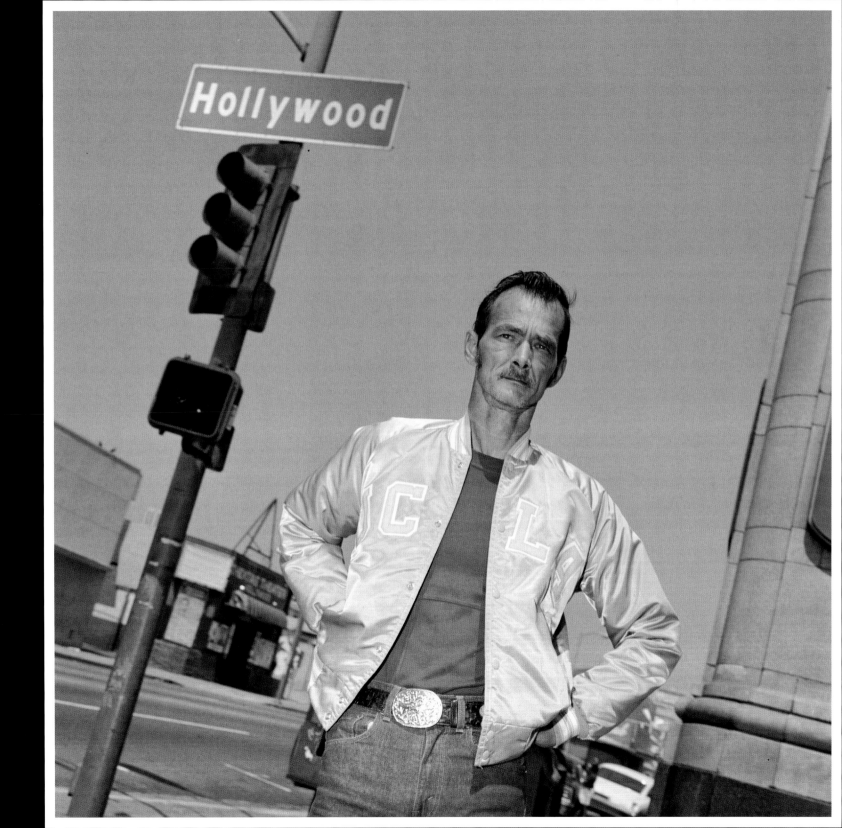

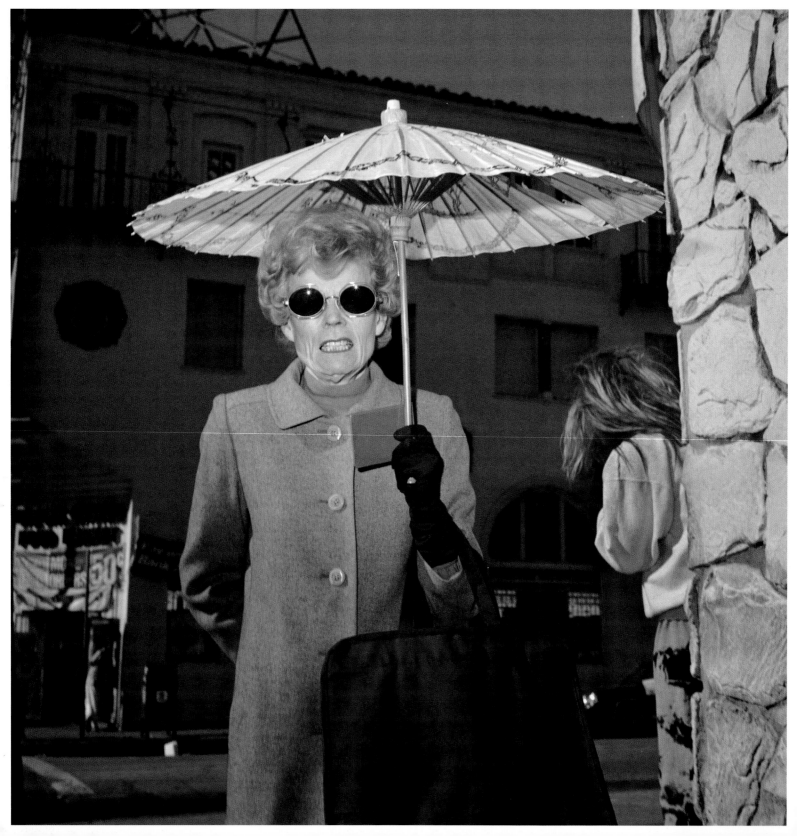

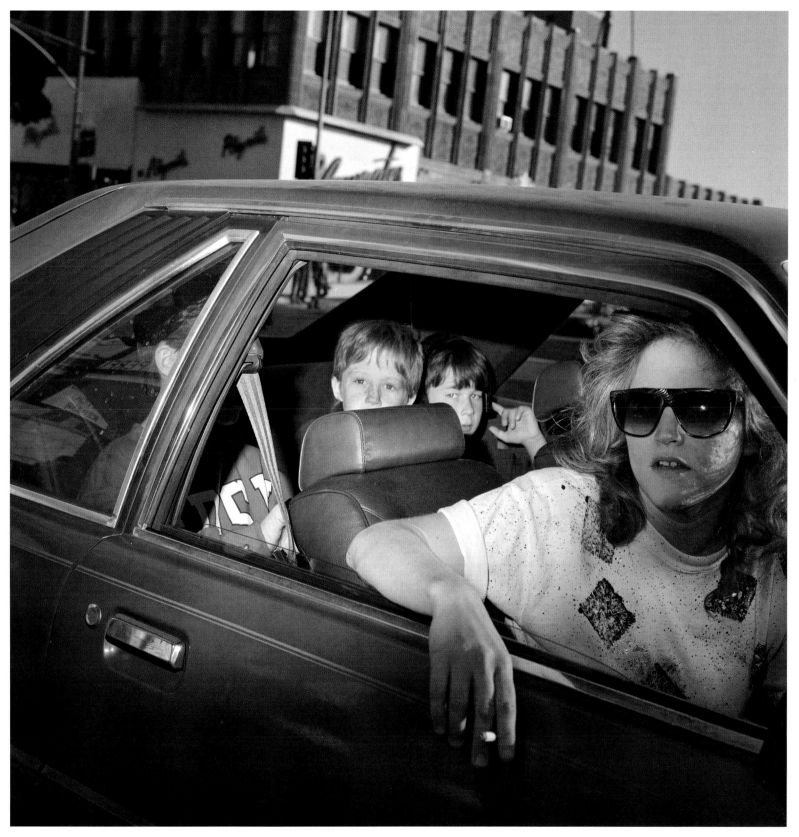

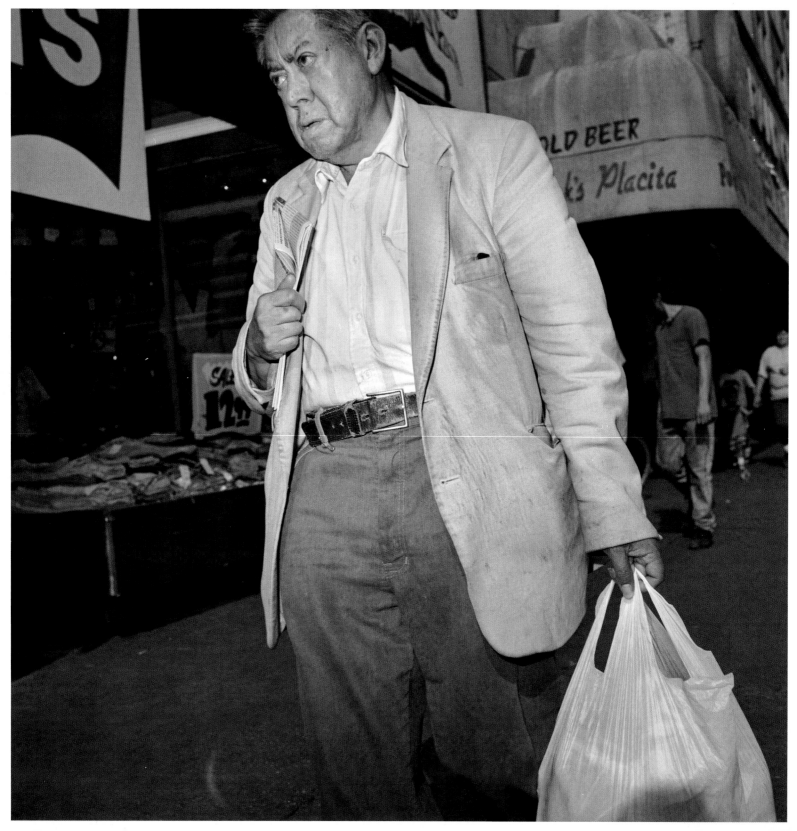

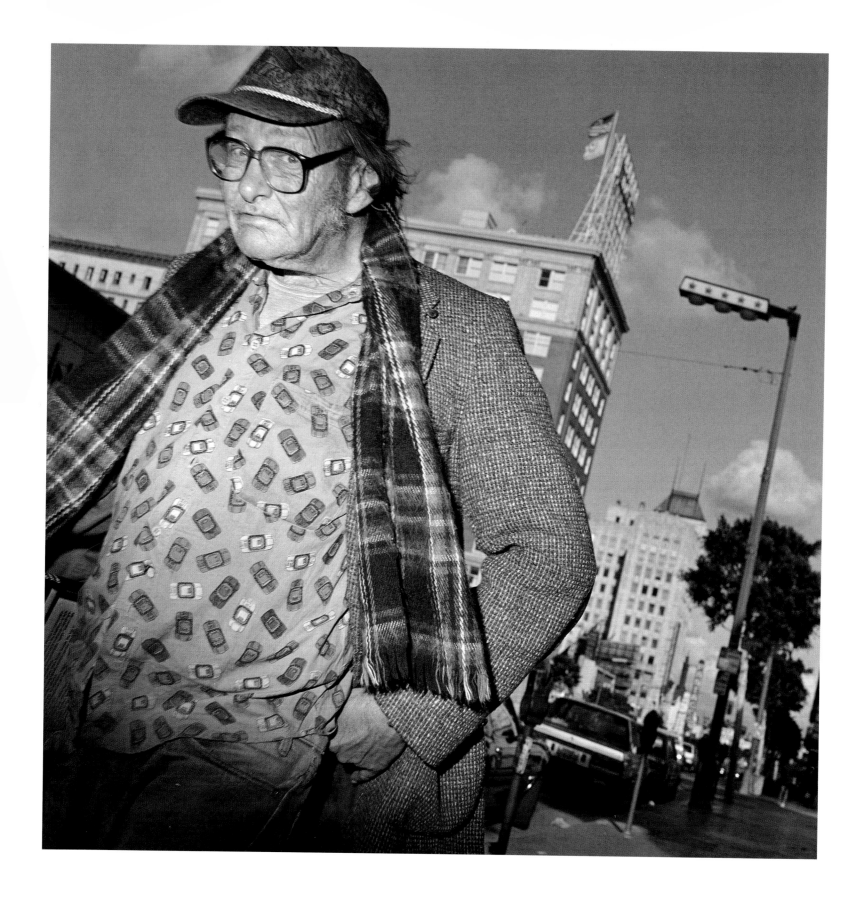

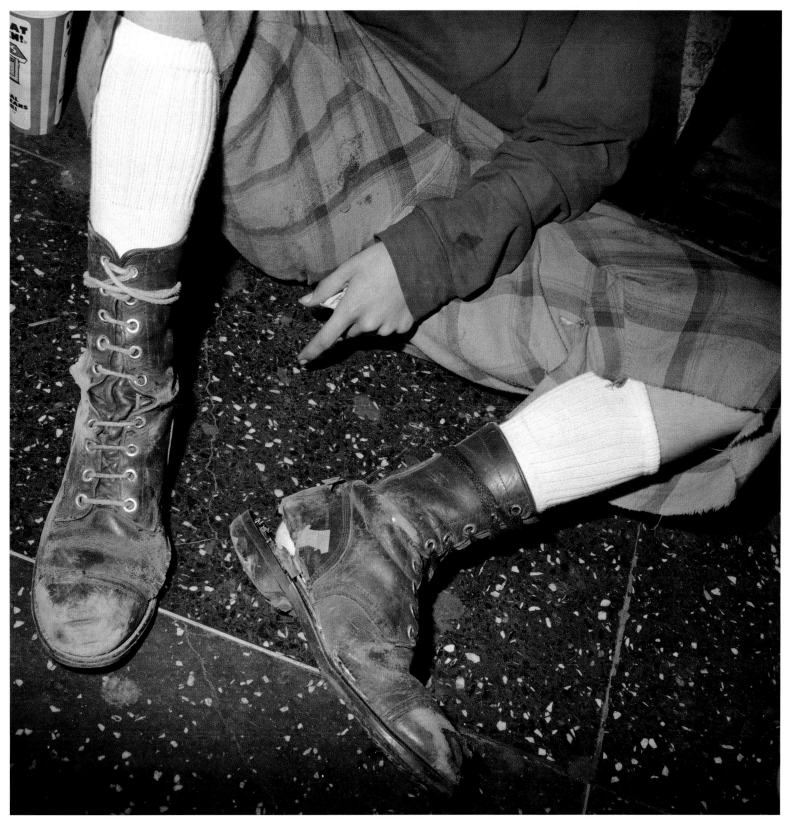

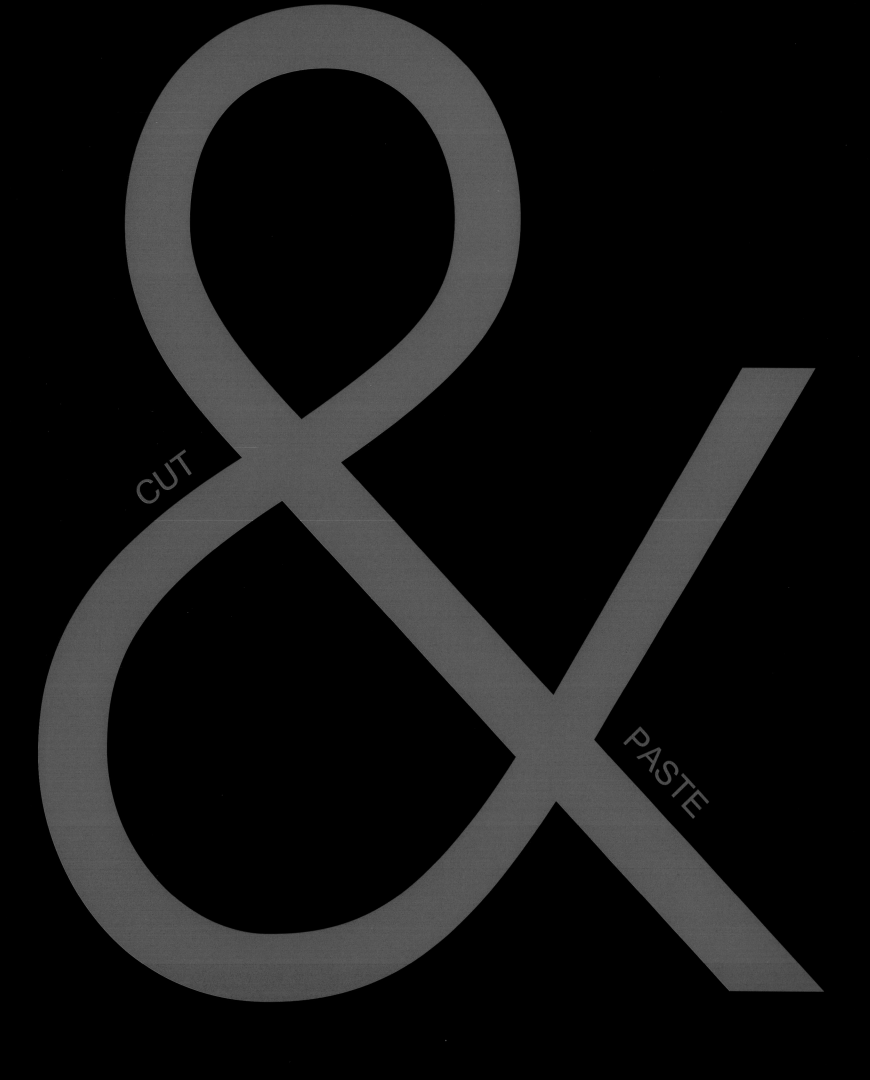

Housewives from the '50s frequently cut up *Life* magazine's pages to paste in their family scrapbooks. My mother Dorothy followed suit. In her footsteps my brother Randy and I grabbed our children's safety scissors and cut out our own choices. Images inside magazines told us stories of people who appeared to have dreamlike, adventurous lives. The pictures we cut out were not saved, but the memory, and Mom's family scrapbooks documented every aspect of our family. In the '60s she took it upon herself to drive all four of us kids across the country, where we went to the 1964 New York World's Fair, and even more amazingly, The Museum of Modern Art. Inside we saw a Joseph Cornell exhibition featuring his collages. One, titled *Allergory of Innocence*, was cut and pasted on printed paper in a wood frame with colored glass. That exhibition was the beginning of what would become Randy's lifelong dedication to cutting and pasting. My collages took shape much later. At first they were tight little concepts focusing on feminine issues like movie stars and fashion, but also the horror of teeth, a personal nightmare that has dogged me all my life. Our love of the picture world was more appealing than the beach, TV, movies, and even our family trips in the Ford station wagon to Death Valley or Doheny Beach, where Dad pitched tents as we rolled down the sandy hills of the desert, or played in the waves. For Randy and me, *Life* magazine offered a much more engaging view of the amazing, complex world around us. You don't have to be a John Stezaker, Joseph Cornell, or Hannah Höch to enjoy cutting and pasting while playing around with the absurdity of real-life images glued into strangely unique situations. Collages are fanciful, dream-ridden escapes. My brother Randy and I picked elusion over the scrapbook story of our lives told by our inspired mother. That was Randy and that was me, but he took it further, much further.

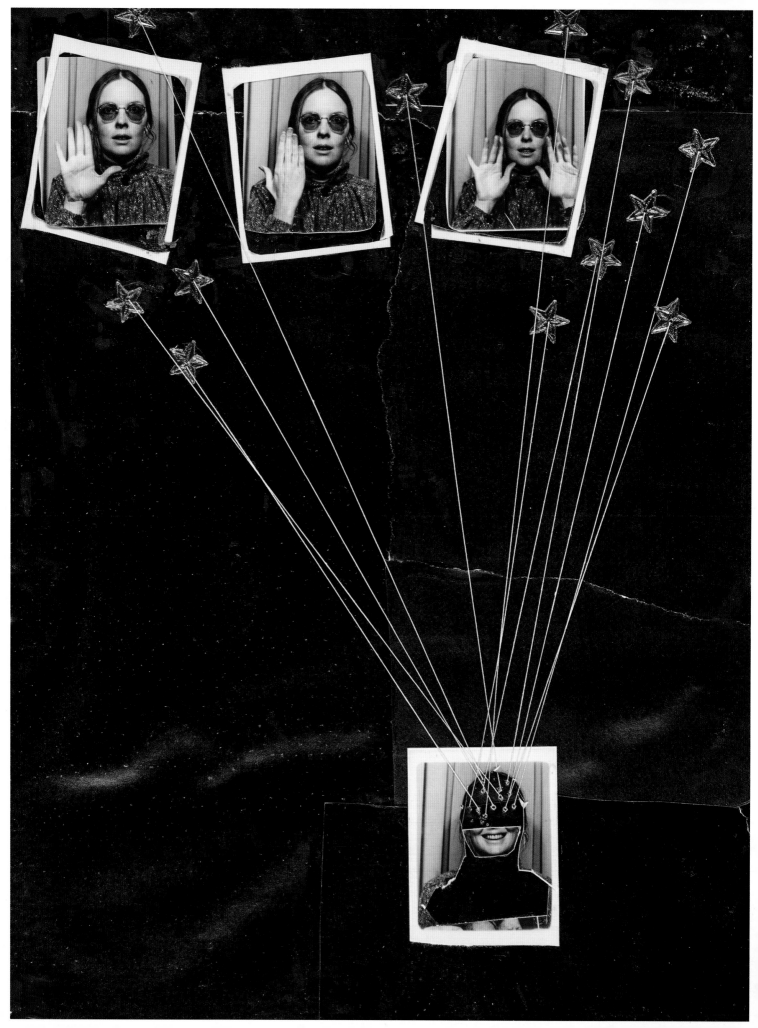

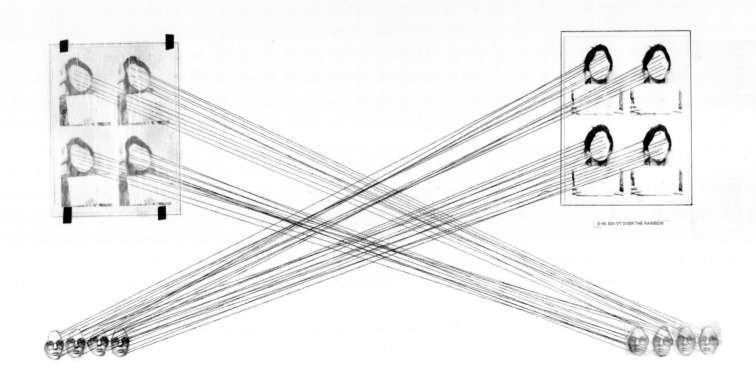

S-48. 934-VT OVER THE RAINBOW

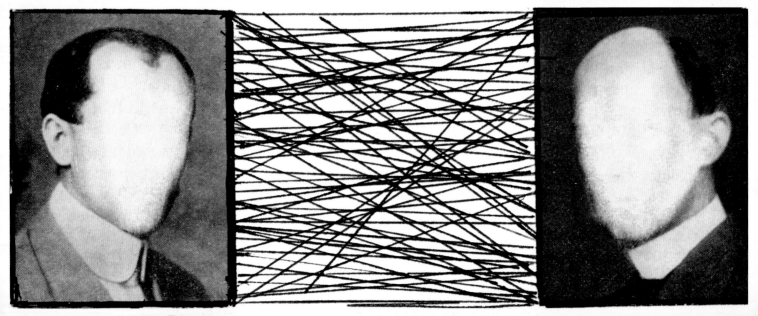

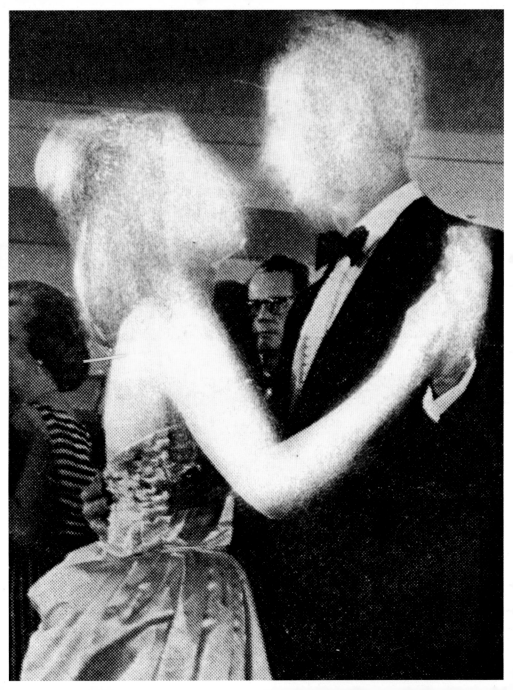

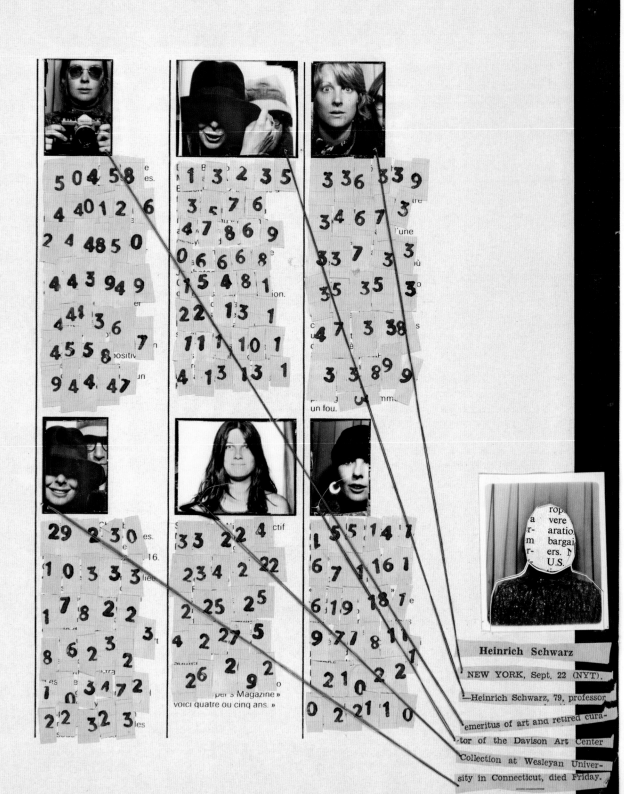

Heinrich Schwarz

NEW YORK, Sept. 22 (NYT).
—Heinrich Schwarz, 79, professor
emeritus of art and retired cura-
tor of the Davison Art Center
Collection at Wesleyan Univer-
sity in Connecticut, died Friday.

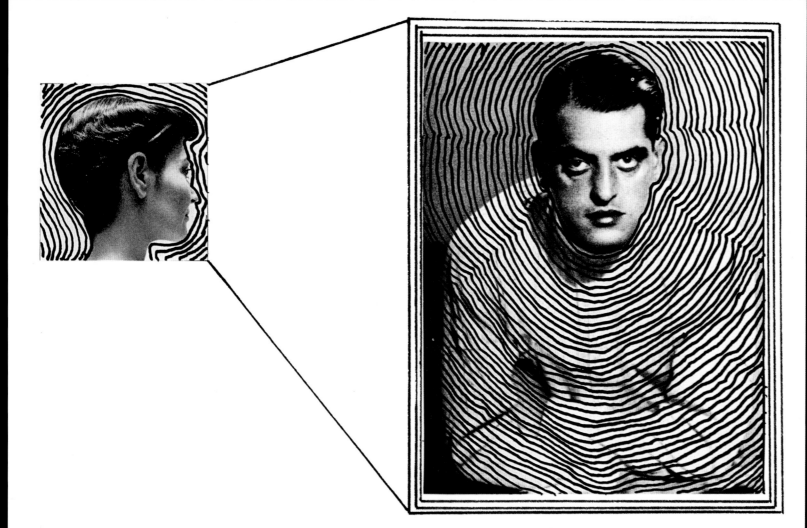

flammes

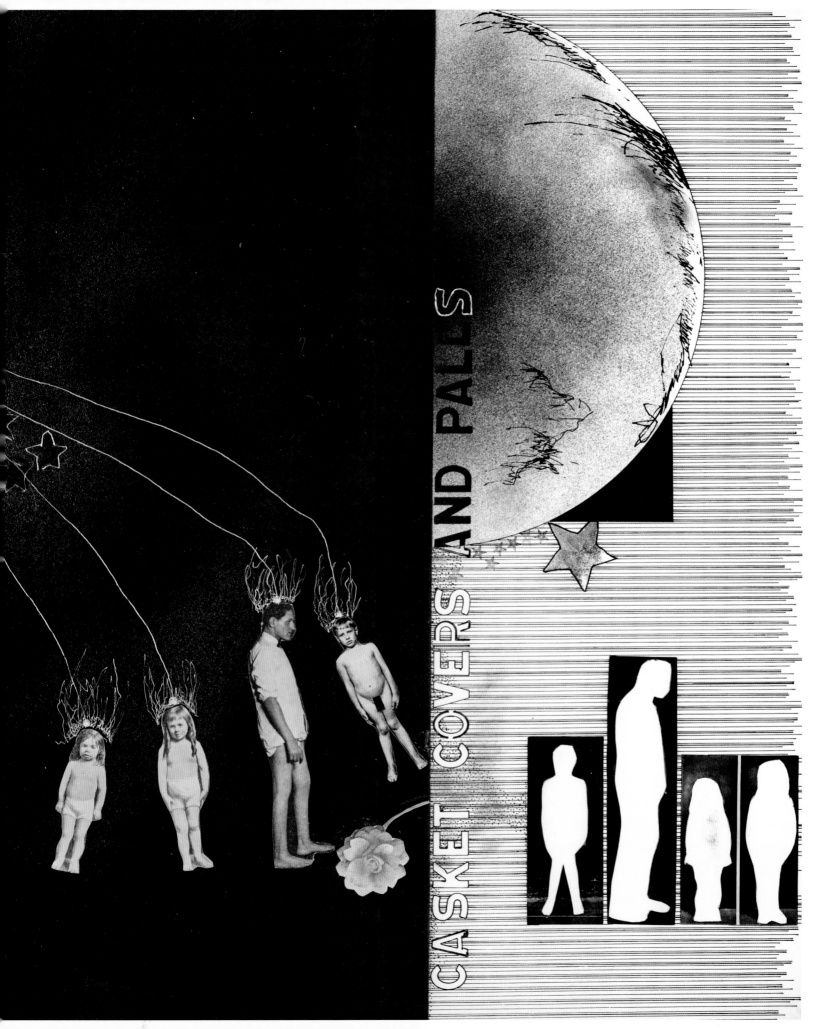

CASKET COVERS AND PALLS

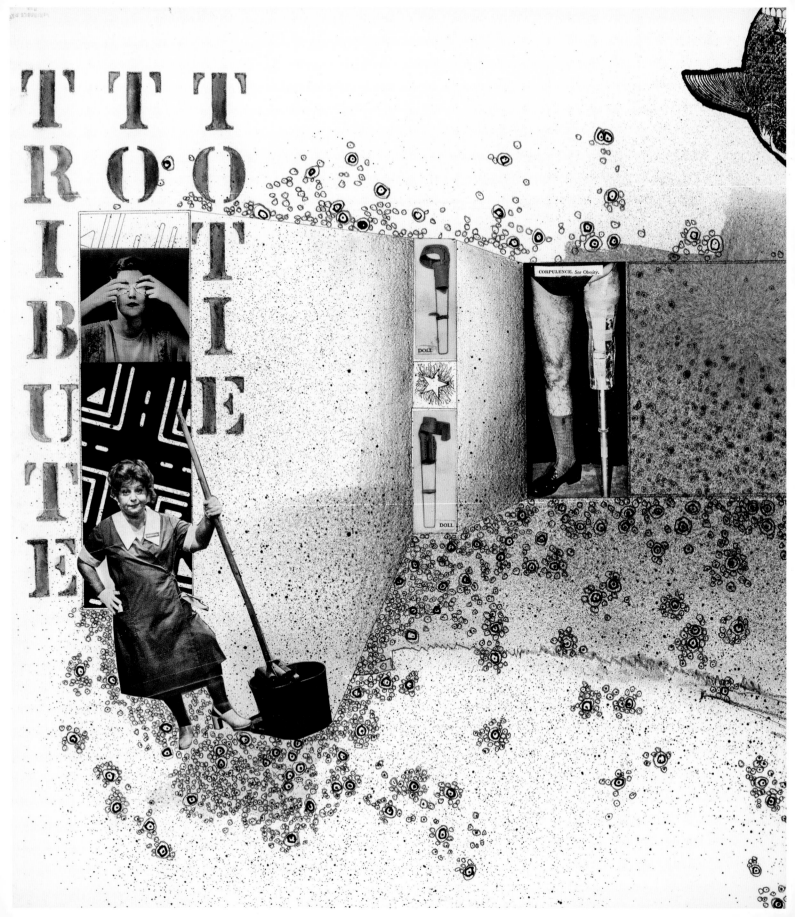

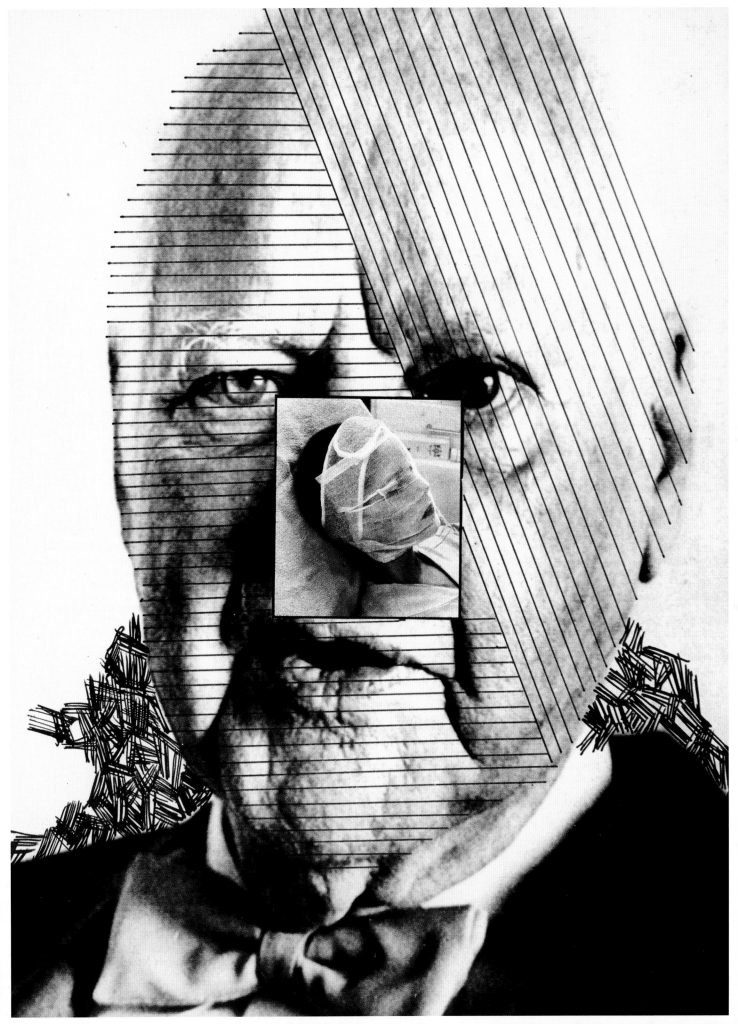

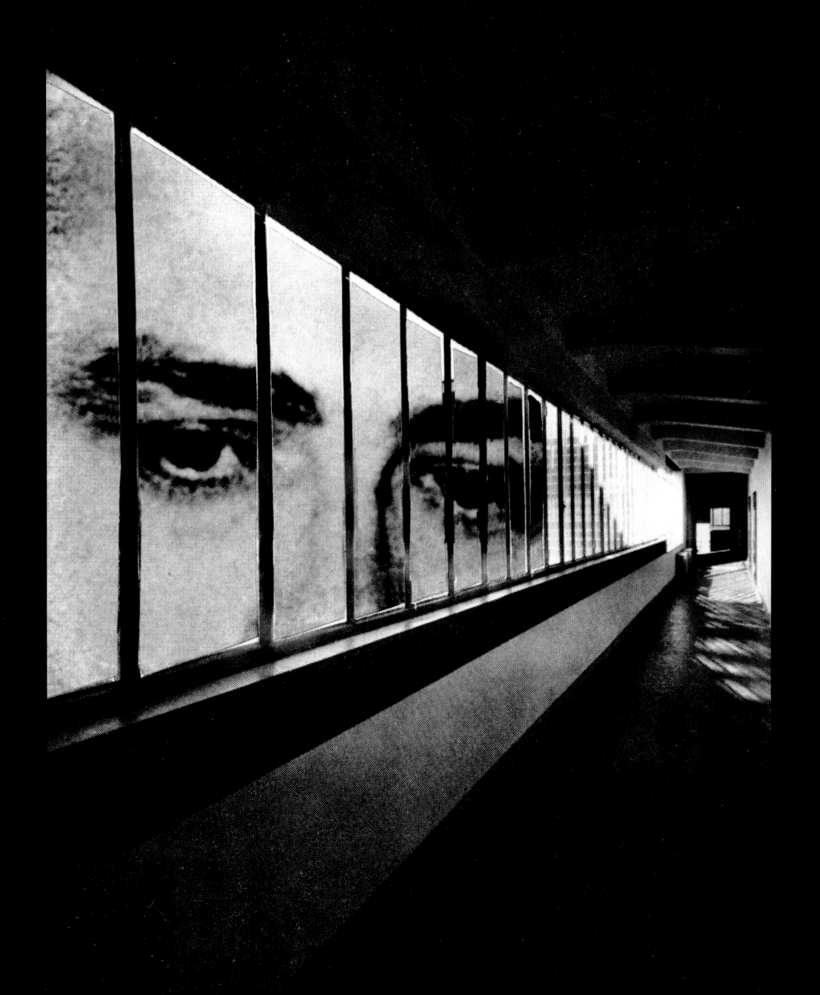

THE NEXT PE

Home was always a dream. There was the Quonset hut Mom and Dad rented when I was two. There was the two-bedroom house dad bought and drove to the vacant lot in Highland Park where we lived until I was seven. There was the ugly tract house in Garden Grove Dad leased until he secured the job of Assistant City Engineer in Santa Ana. I was nine. Our new board and batten tract house had a rock roof and a big garage. All six of us lived in that four-bedroom, two-bath home for ten years. Dad loved real estate. On Sundays he would drive me to model homes for sale. Not only was it his idea of heaven, it also became mine. Even when I was young I collected pictures of houses, mainly from Mom's magazines. I liked to make up stories, not only of the people who lived them, but the houses themselves. How did they weather storms? Were they eventually torn down like our neighbor Ike's house on Monterey Road? How many people lived in them? Were they happy? Were the rich homeowners north of 17th Street happier? A four by six inch photograph of eight people standing in their Sunday best under the porch of an impressive two-story home made me wonder who amongst them owned it. The picture of a woman with a broom in her hand after opening the only door of a random white structure with no windows made me sad. On the back of the photograph Mom found in an old scrapbook at the Goodwill, a woman wrote: "Wait till I get some plants around here. It will look better." Another photo details an unusually long, narrow building described as a Mess Hall on stilts with steps leading to the entrance. The peaked roof framing a wood-planked home with four windows on each side includes a hand written note… "Our house has a brown roof and shutters. It looks barren in the picture because you can't see all the other houses." Every single picture I've saved

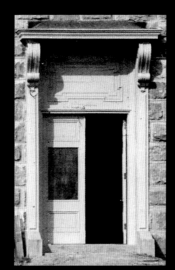

of a home, and I've saved hundreds,
ago, worn away token of the people
longings and losses. I wonder if
across old pictures of the Hall family
and sold as an adult. Photographer
lives go by so quickly. We leave
what we thought was important.
of other lives. These homes are
nature of life. We frequently move
building and the next perfect home.
on the value of being content, or

every single one has offered me a long
who lived inside. Their dreams, their
someone someday will randomly chance
homes, or the many homes I've bought
Brian Vanden Brink put it best. "Our
behind the relics of our time here, and
When I look at these buildings I think
statues, memorializing the transitory
too fast, in an effort to erect the next
These little post cards help us look back
at least satisfied with what we have."

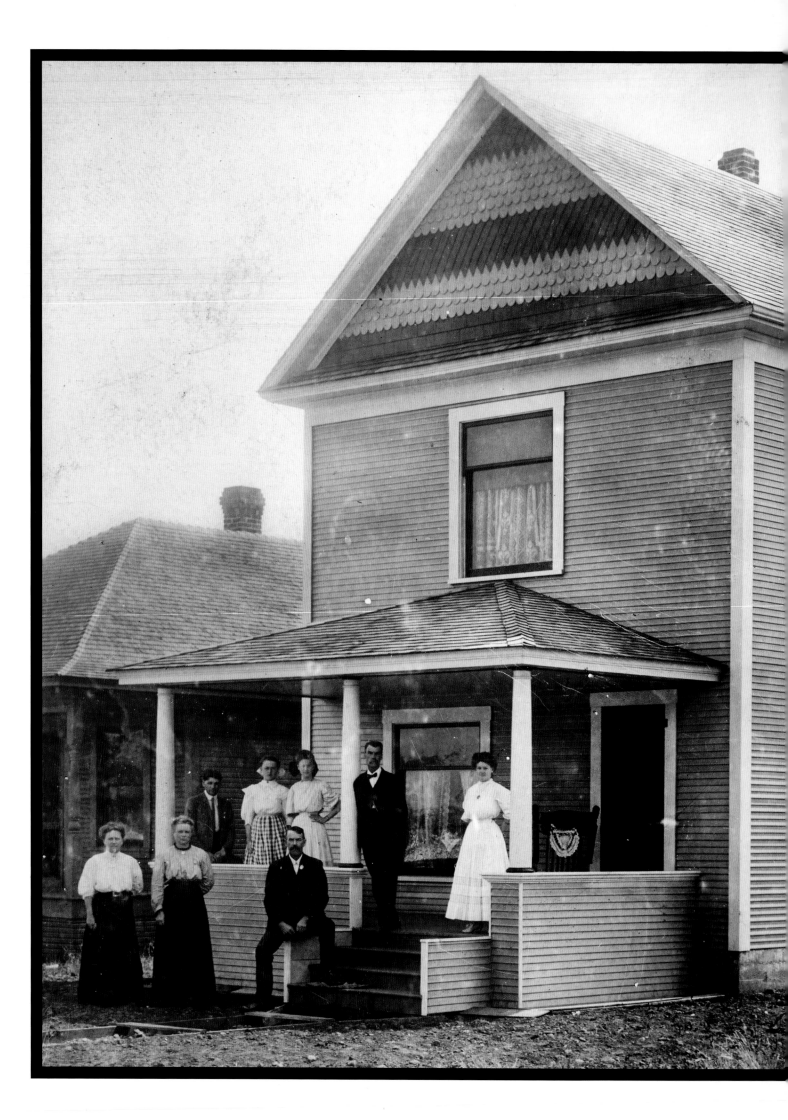

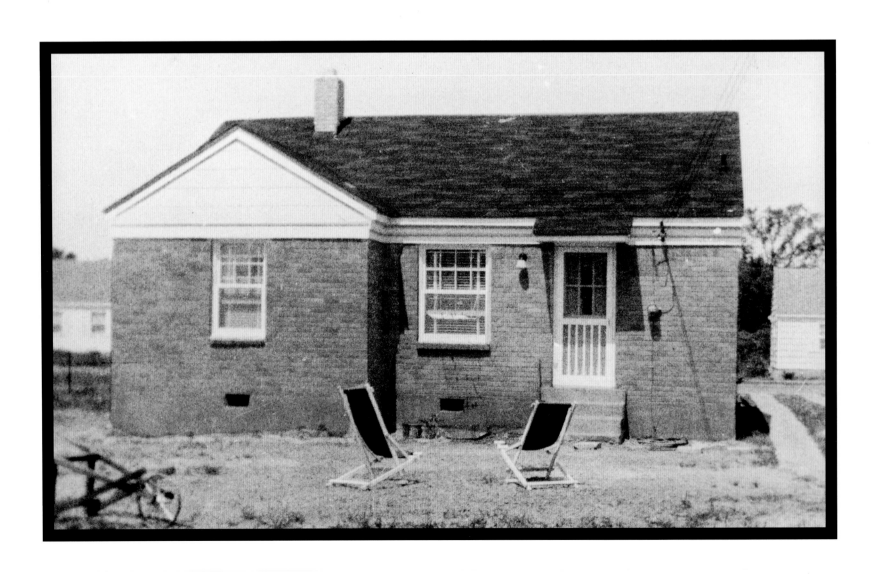

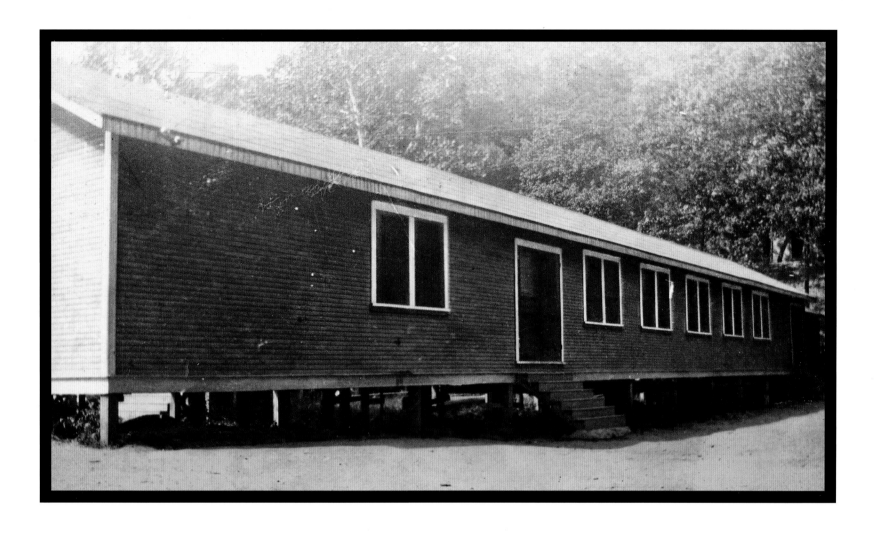

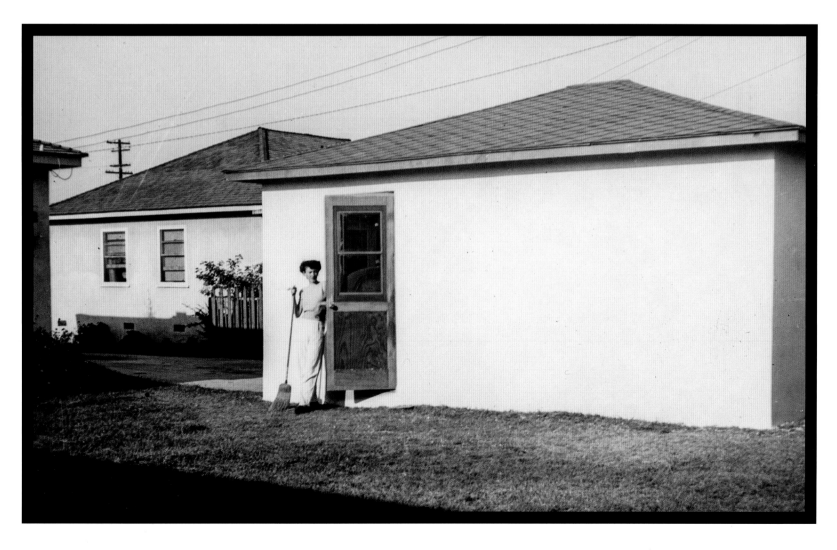

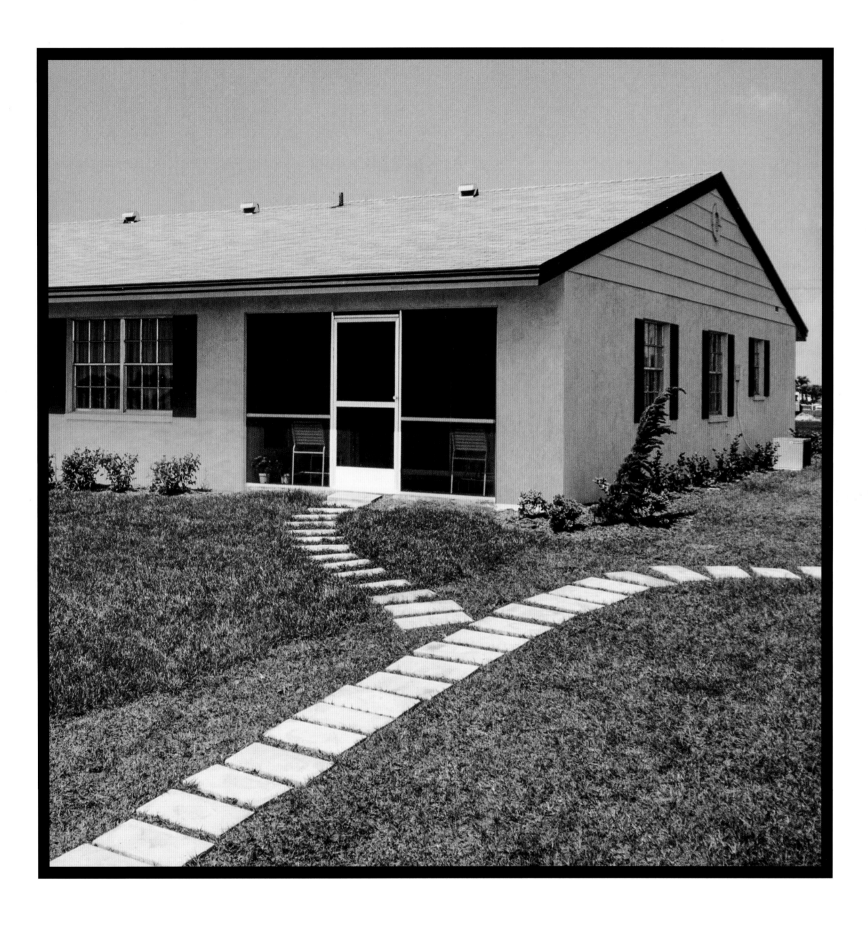

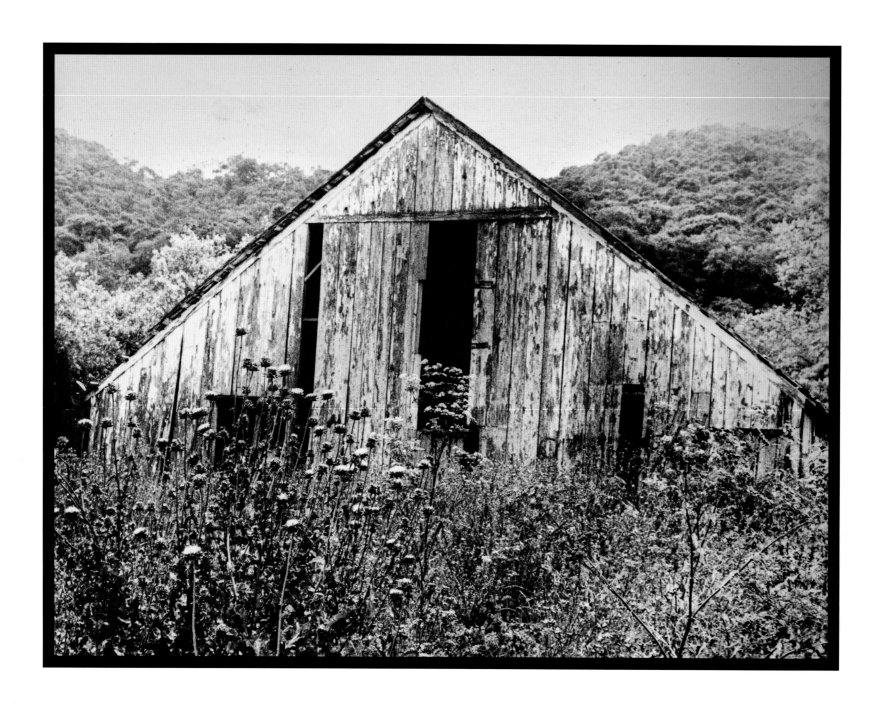

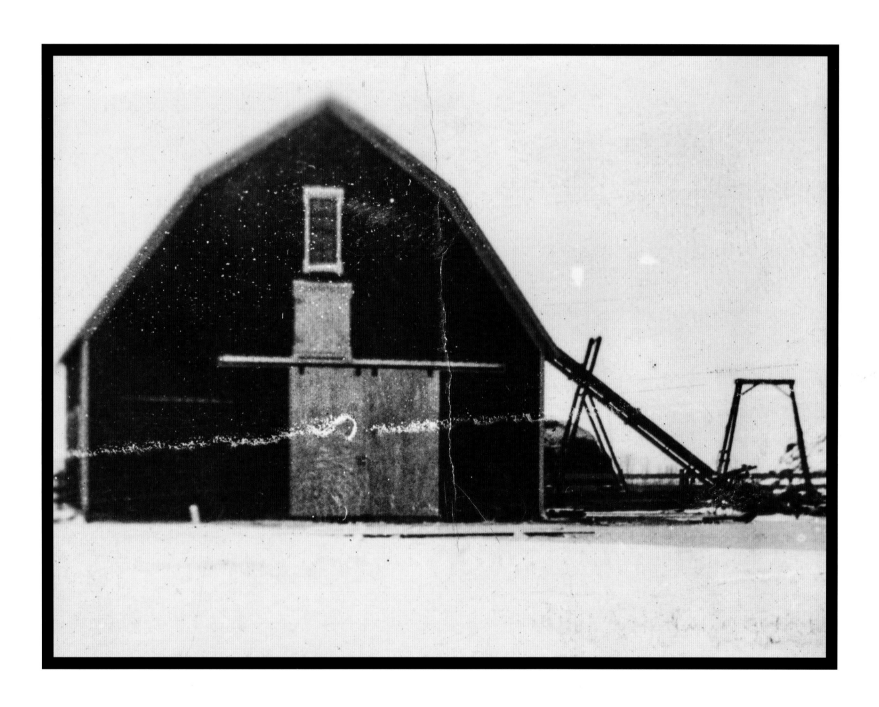

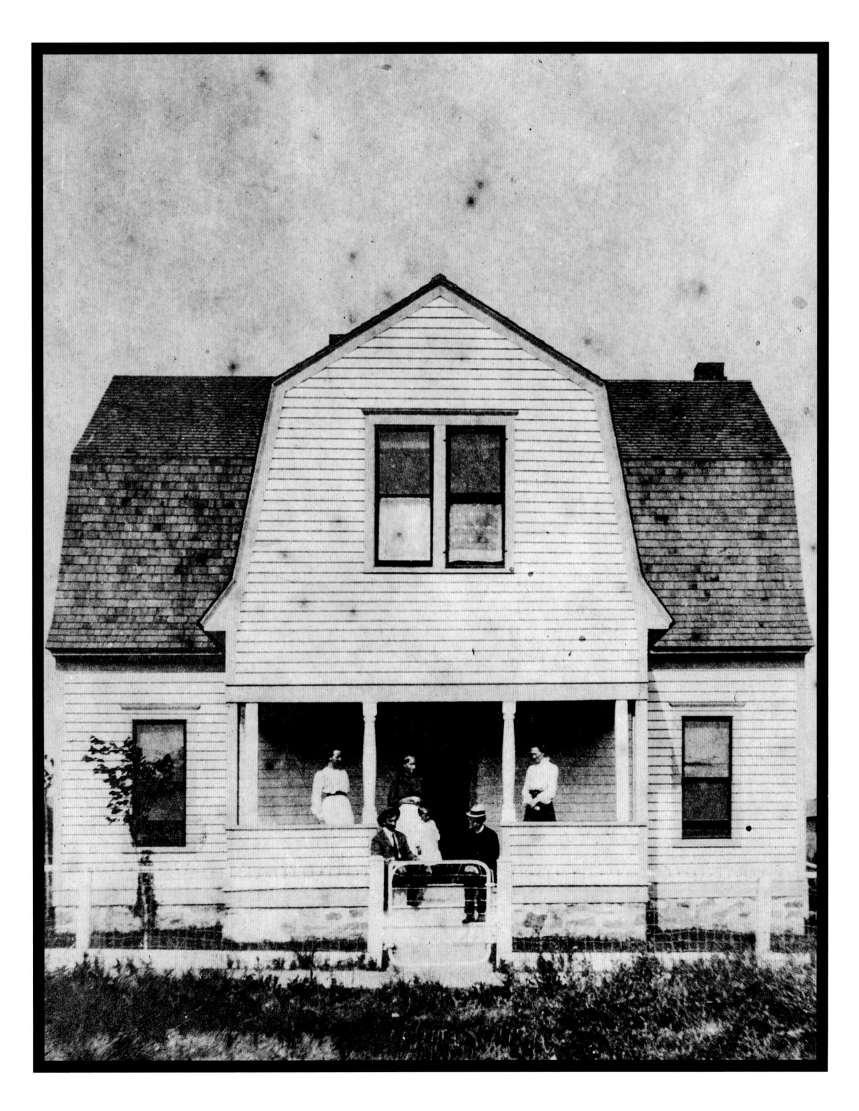

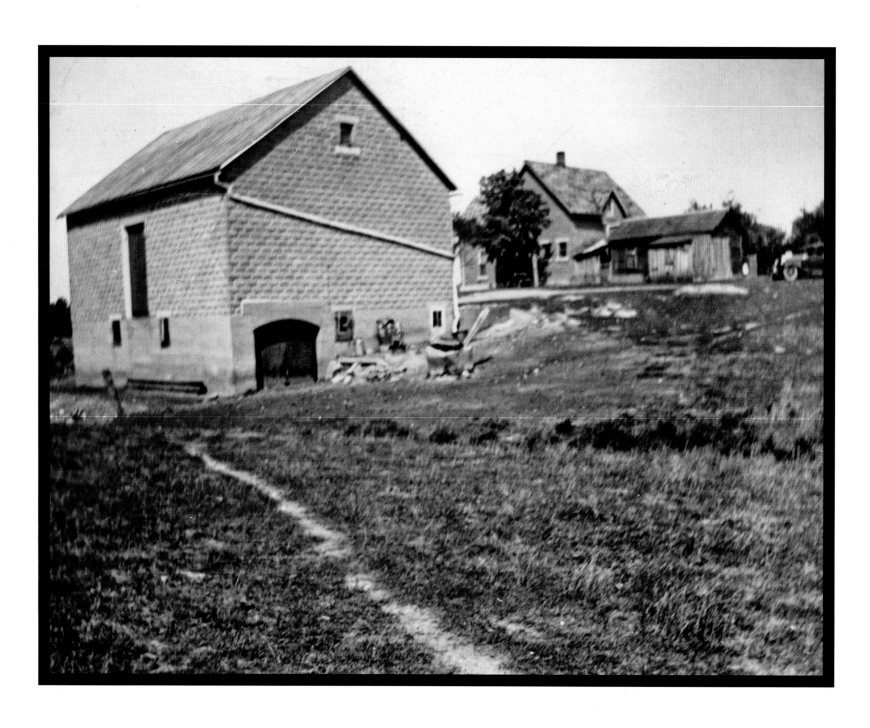

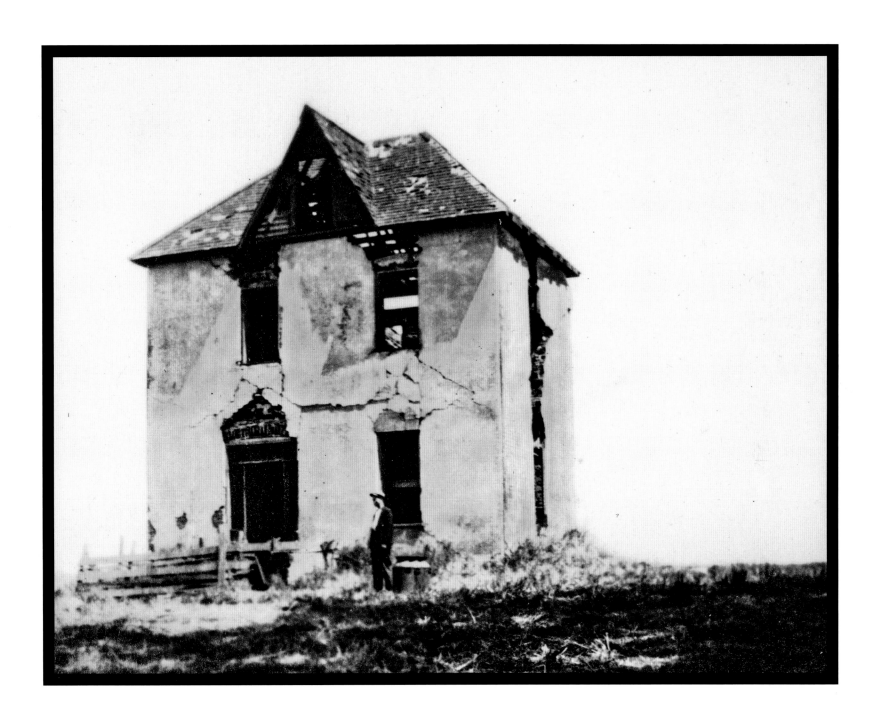

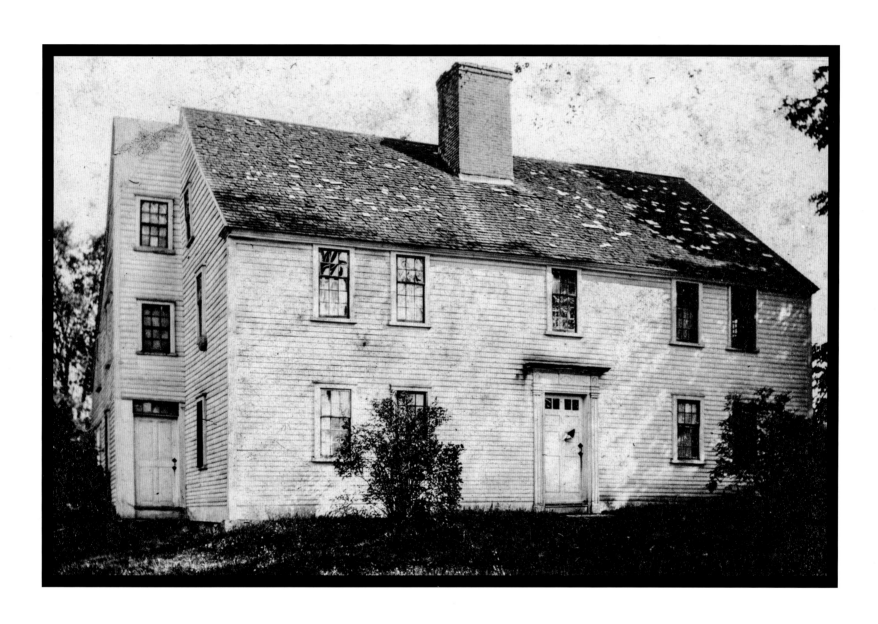

LIGHT

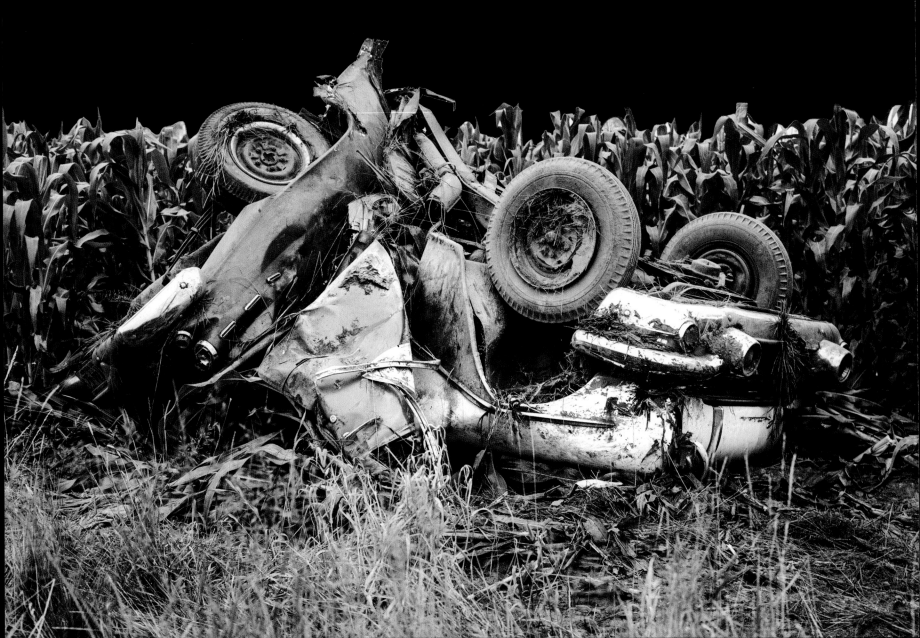

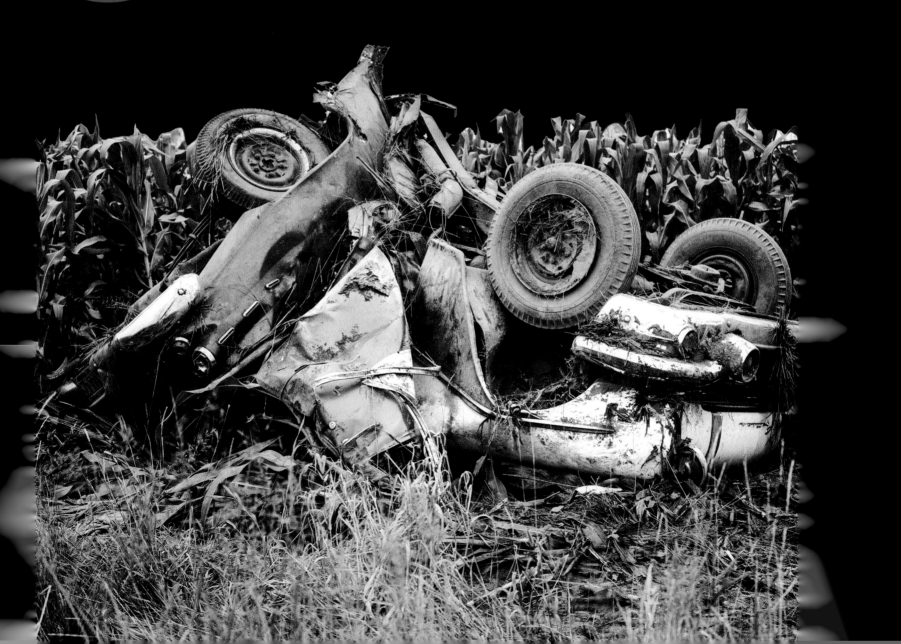

We all know cars are road vehicles with four wheels, powered by an internal combustion engine, and able to carry a small number of people. In the dead of night cars take on a more ominous role. Forty thousand people lost their lives to car crashes in 2018. Five hundred fifty-six people died from airplane accidents in 2018. I chose 2018 because my daughter Dexter had rear-end collision at night that year. Getting that call was terrifying. Night is a seduction that none of us can afford to get carried away with. For example, not that long ago, two trucks had a head-on collision at full speed and injured three people while destroying twenty cars in the process. In the *Los Angeles Times*'s local news section I read about a Mustang speeding through streets in a chase that ended in a fiery conclusion. Sometimes' our actions in a car seriously spiral out of control and we

find ourselves having injured another person. While driving a car the best course of action is not to stomp on the gas and potentially spend the rest of your life either crippled in one form or another or even taking the action of *Thelma and Louise*, who found themselves in circumstances that forced them to put the pedal to the metal and drive off a cliff. Here's a quote to remember … "By the time I stopped and looked back in my rear view mirror, the moose was getting up and then ran into the bush. Shaken but fine, we both looked at each other with a stunned expression. We both knew that moose accidents had claimed many lives throughout the years, and we knew we had been very fortunate to escape with only slight vehicle damage and no personal injury or worse. After a quick check of our vehicle, we started off again."

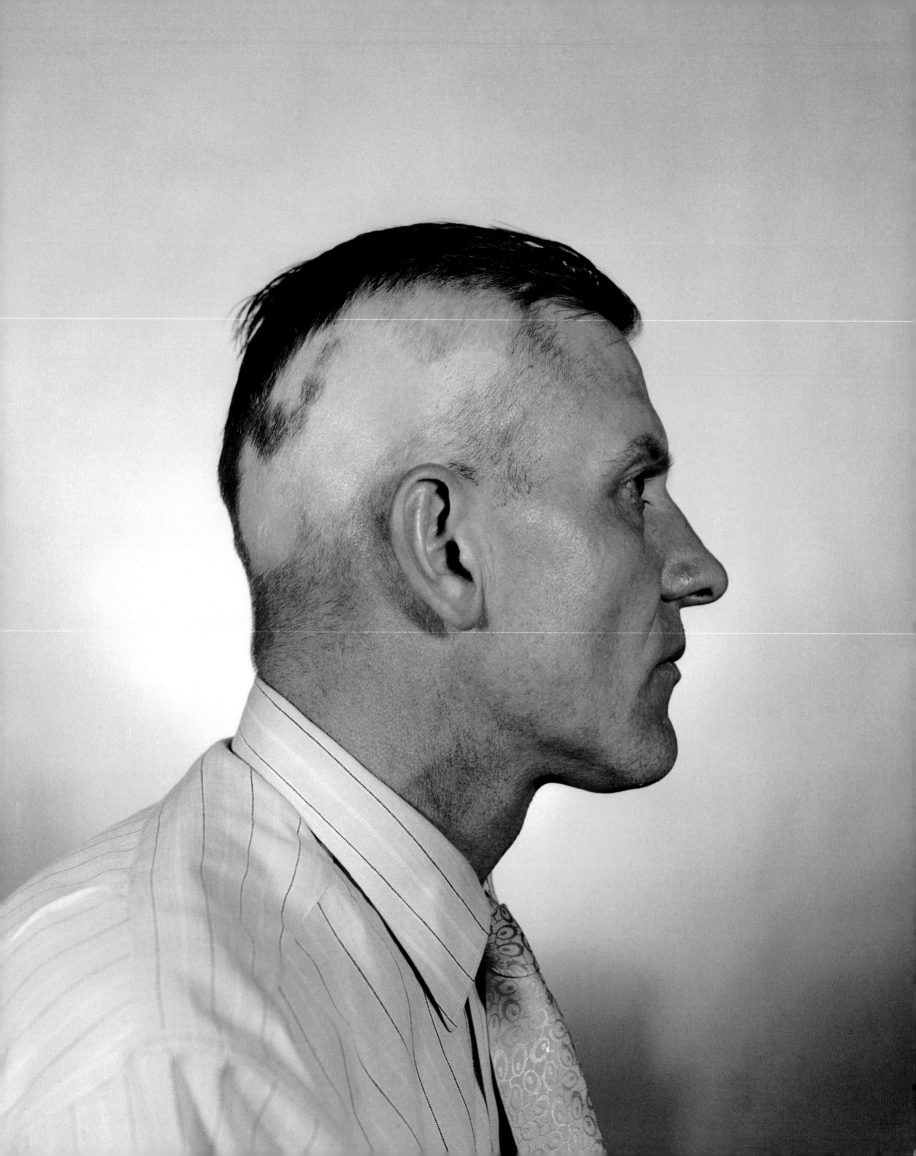

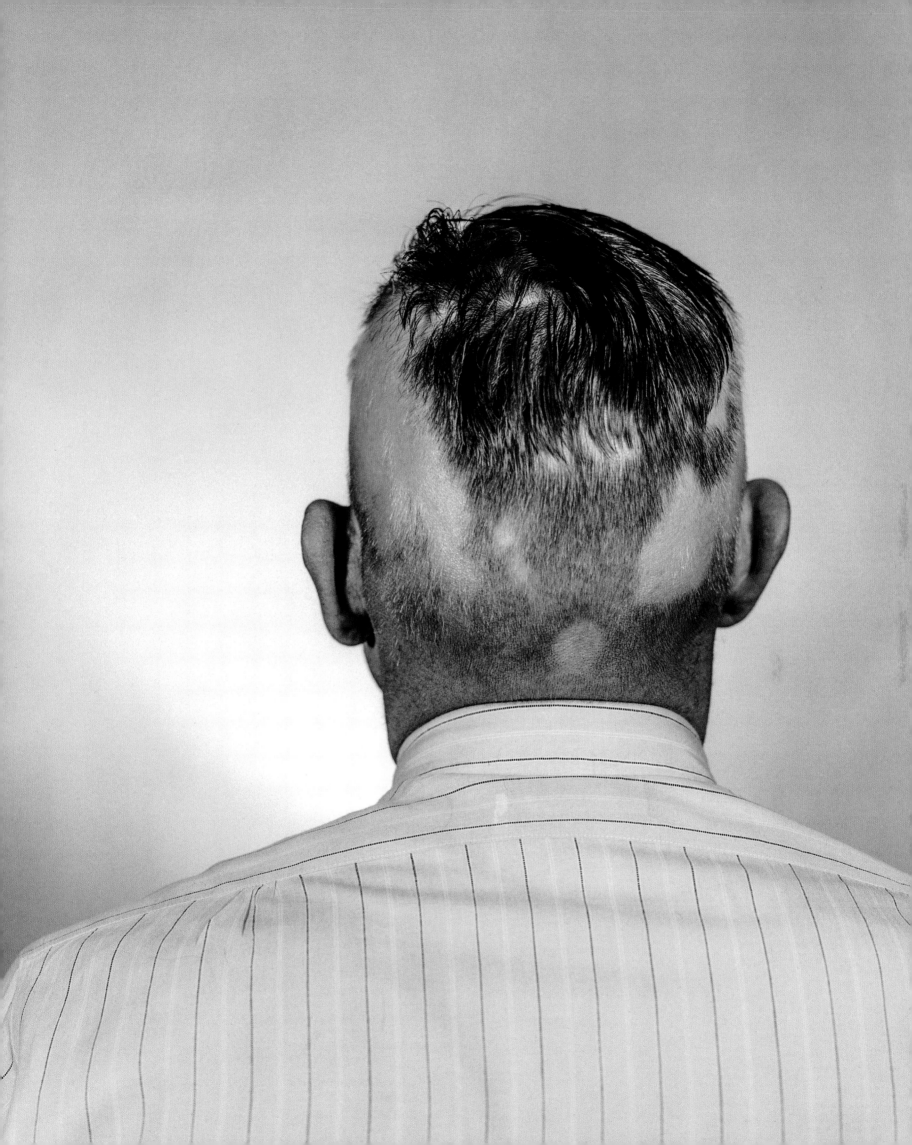

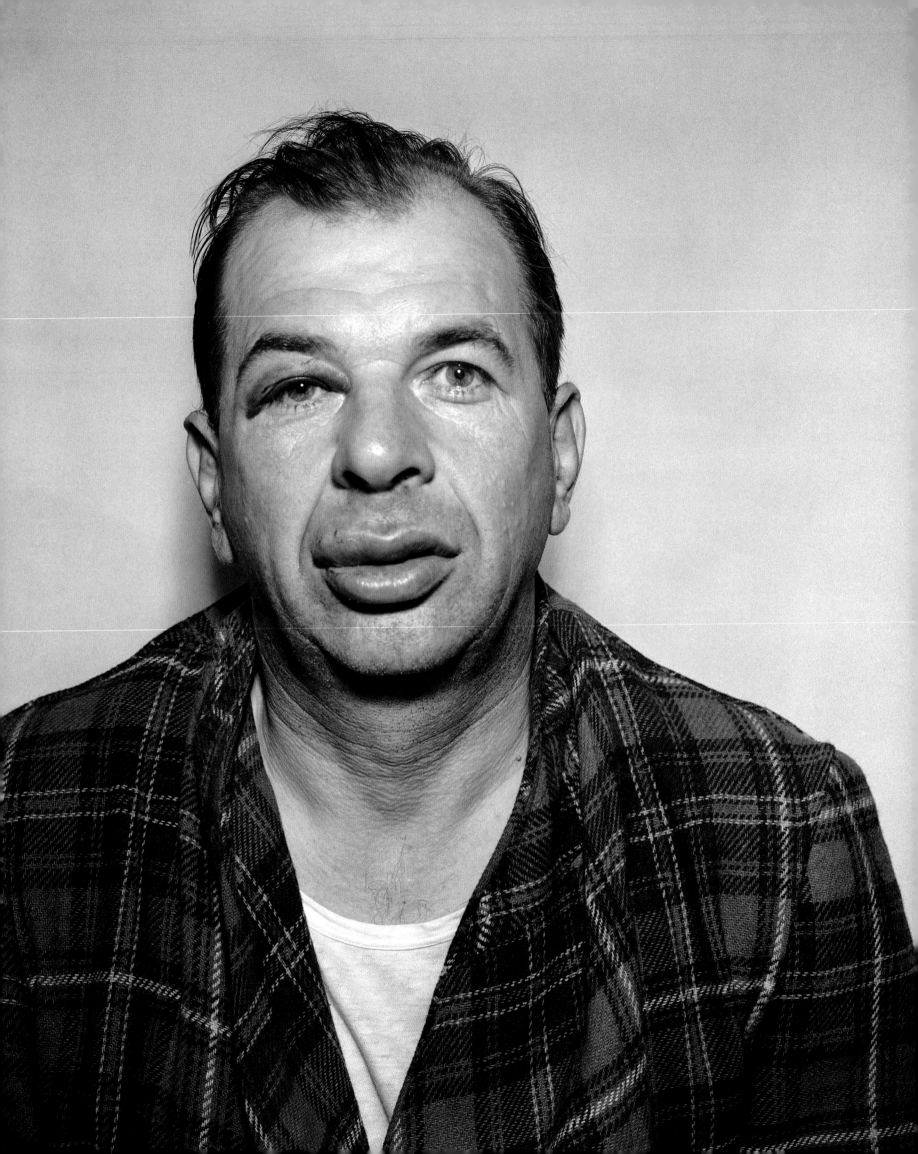

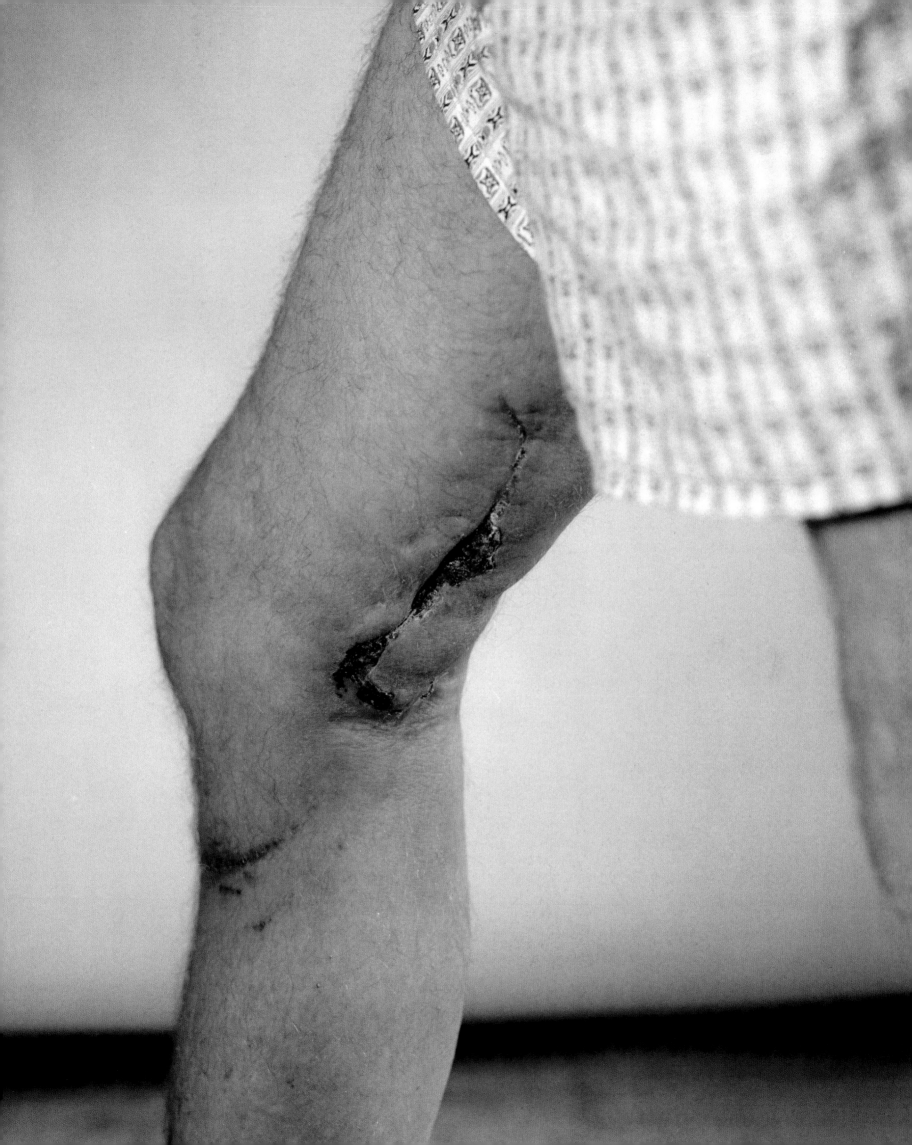

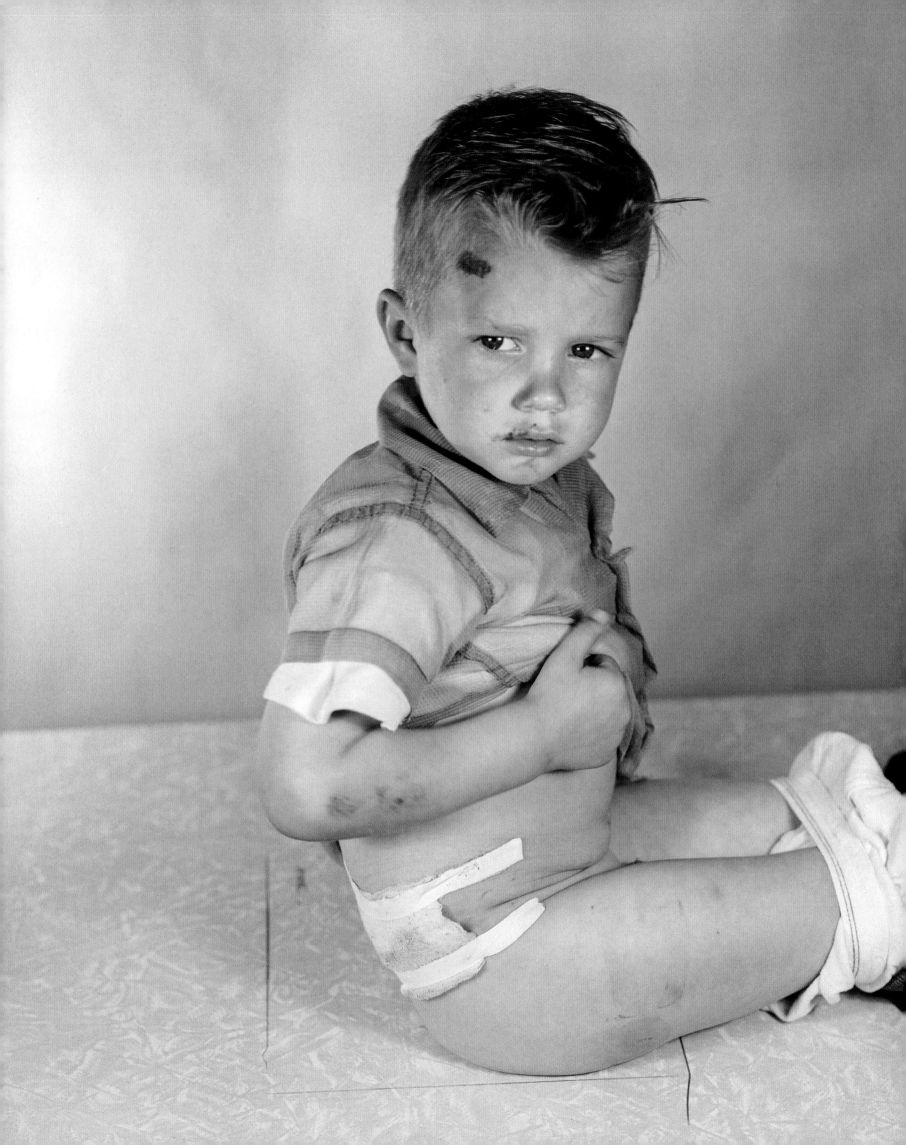

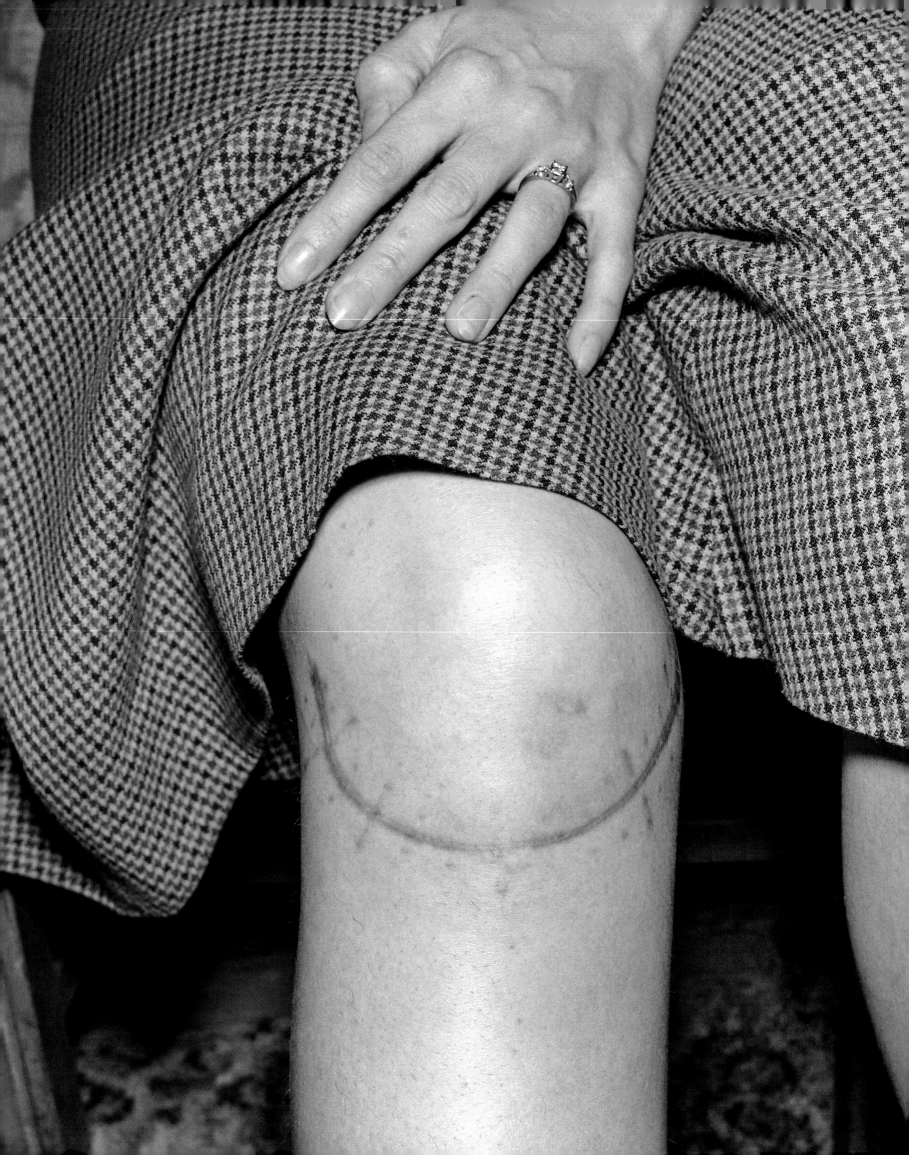

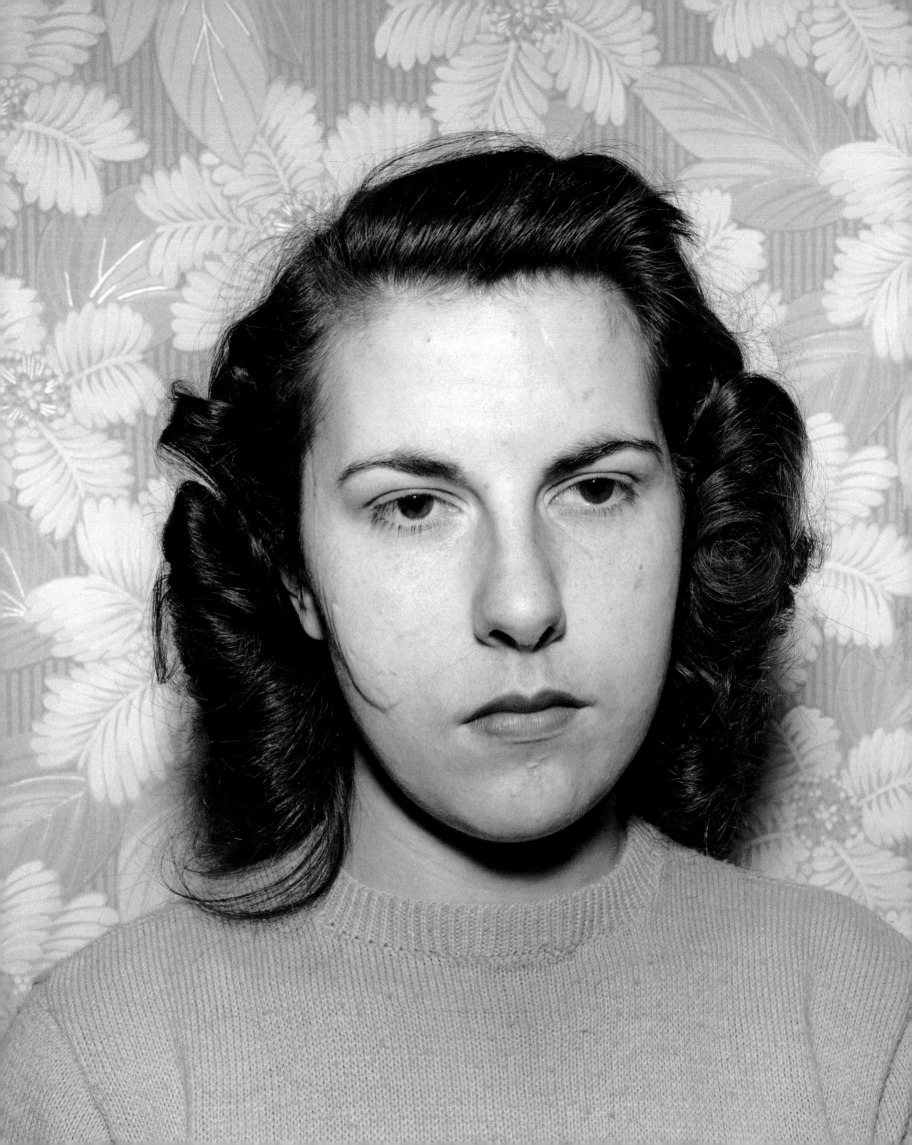

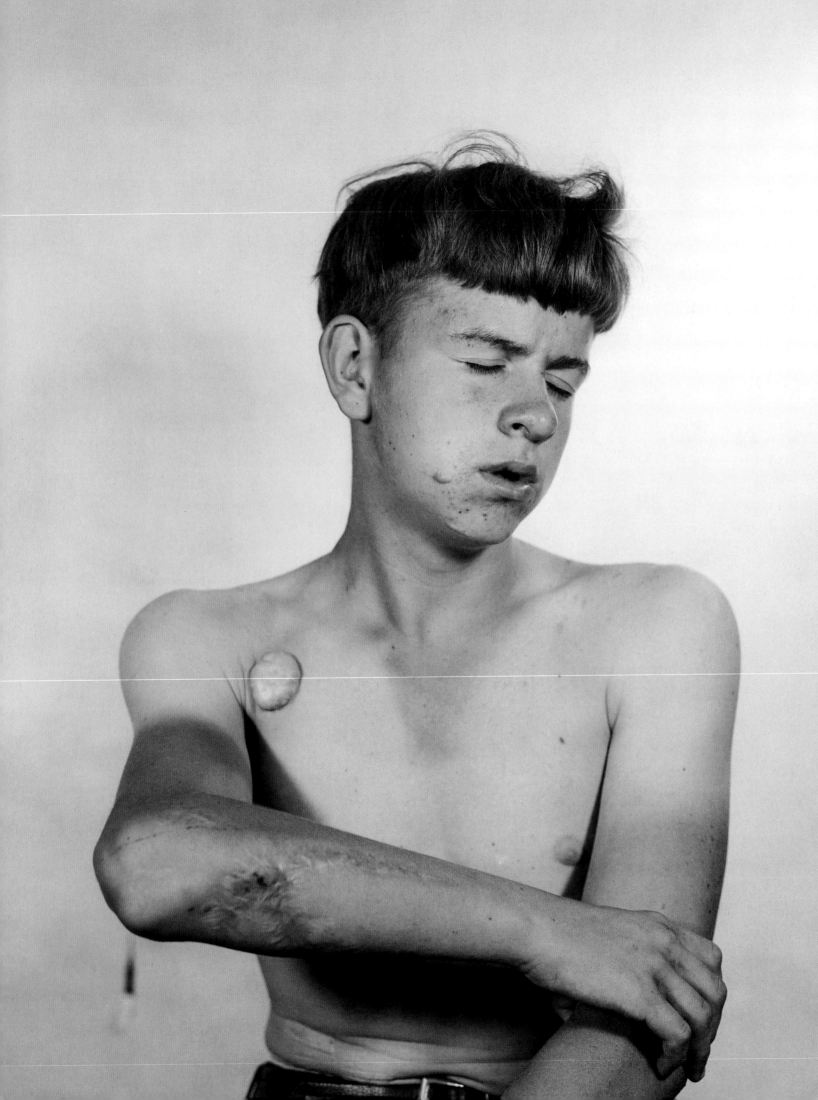

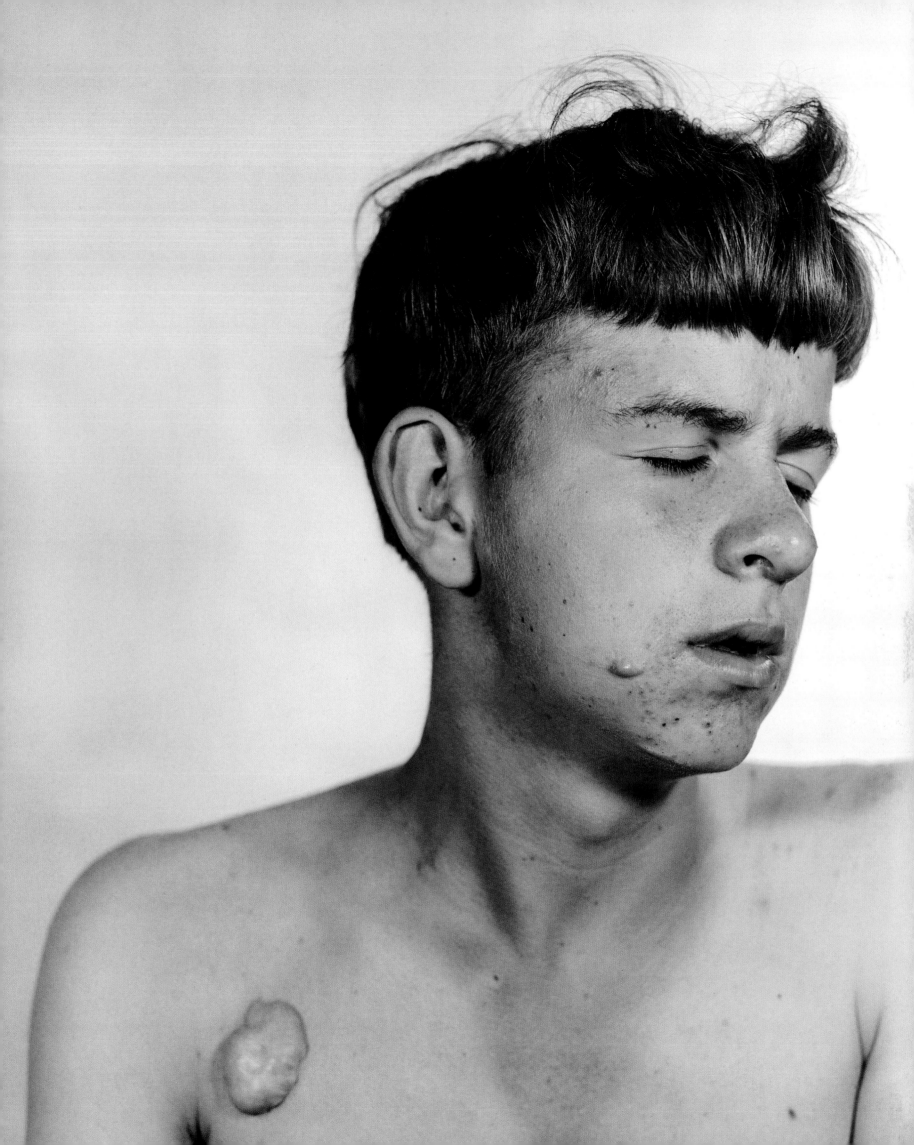

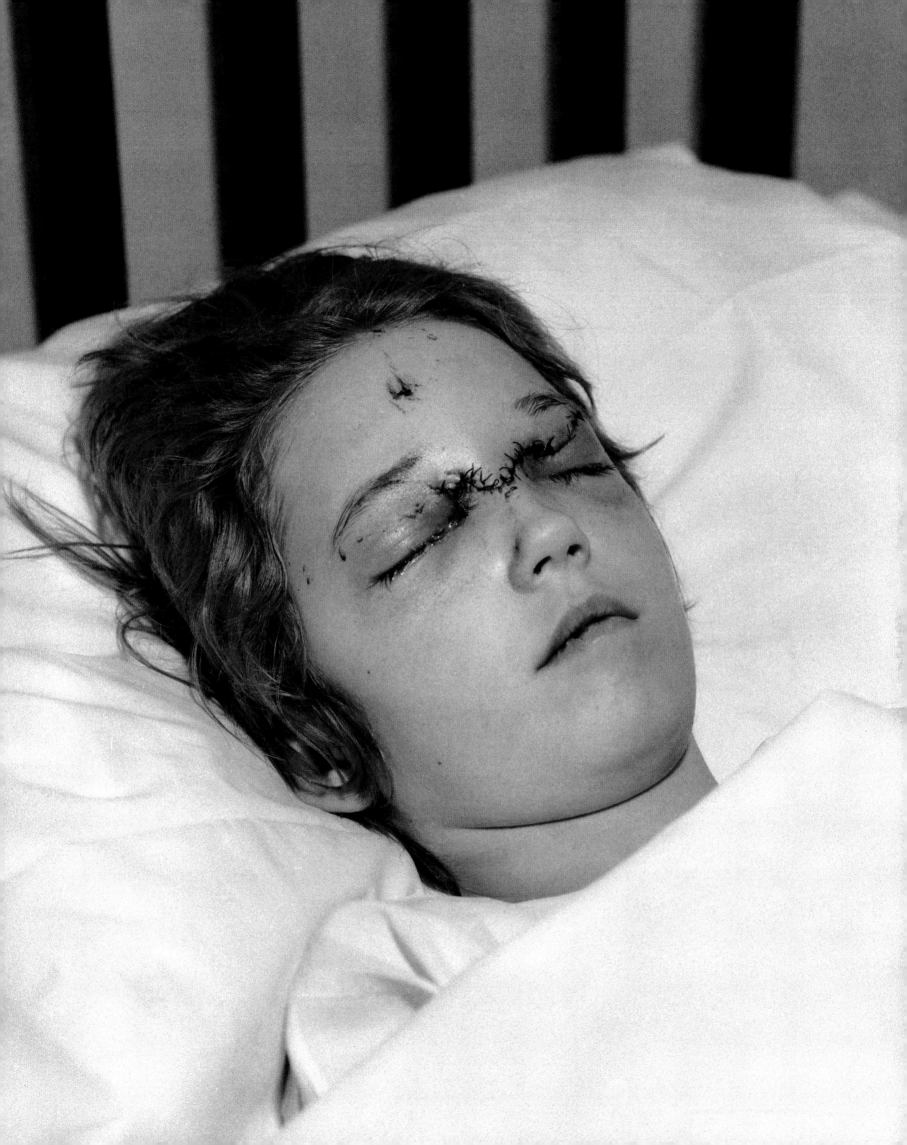

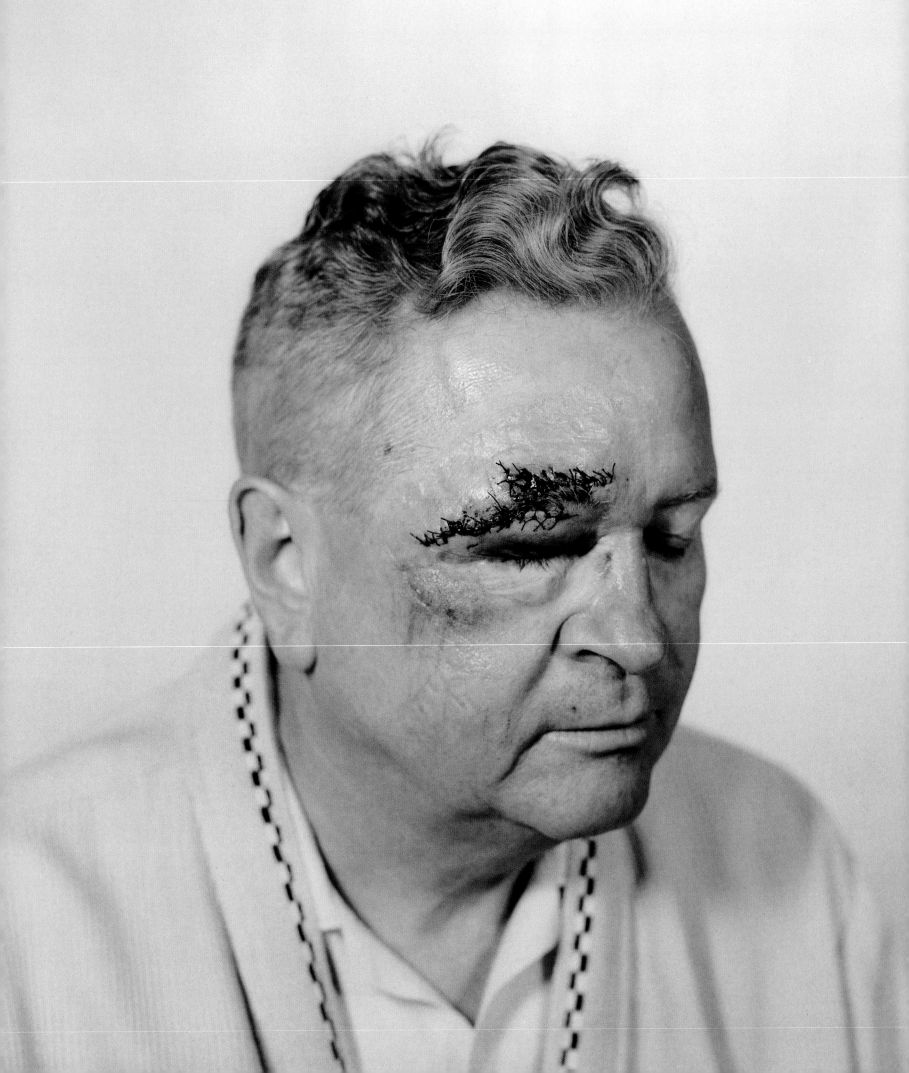

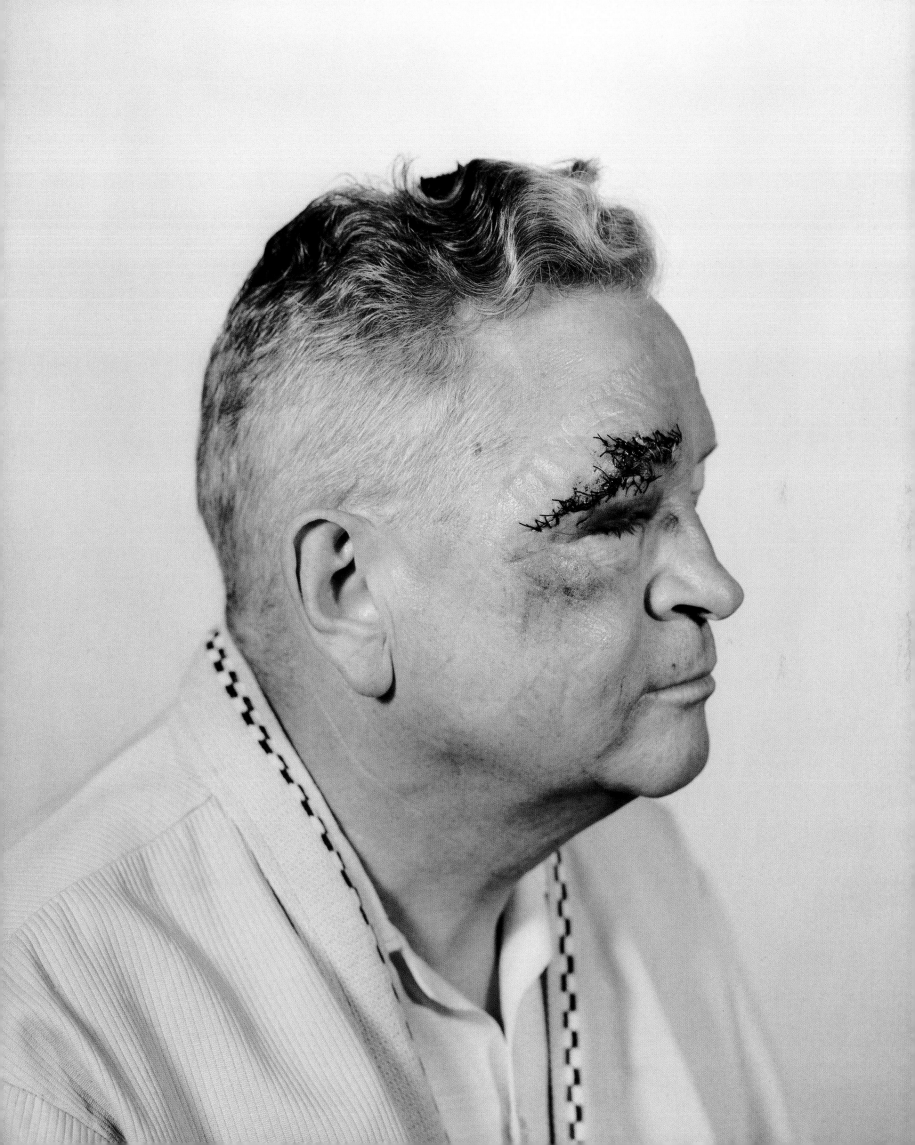

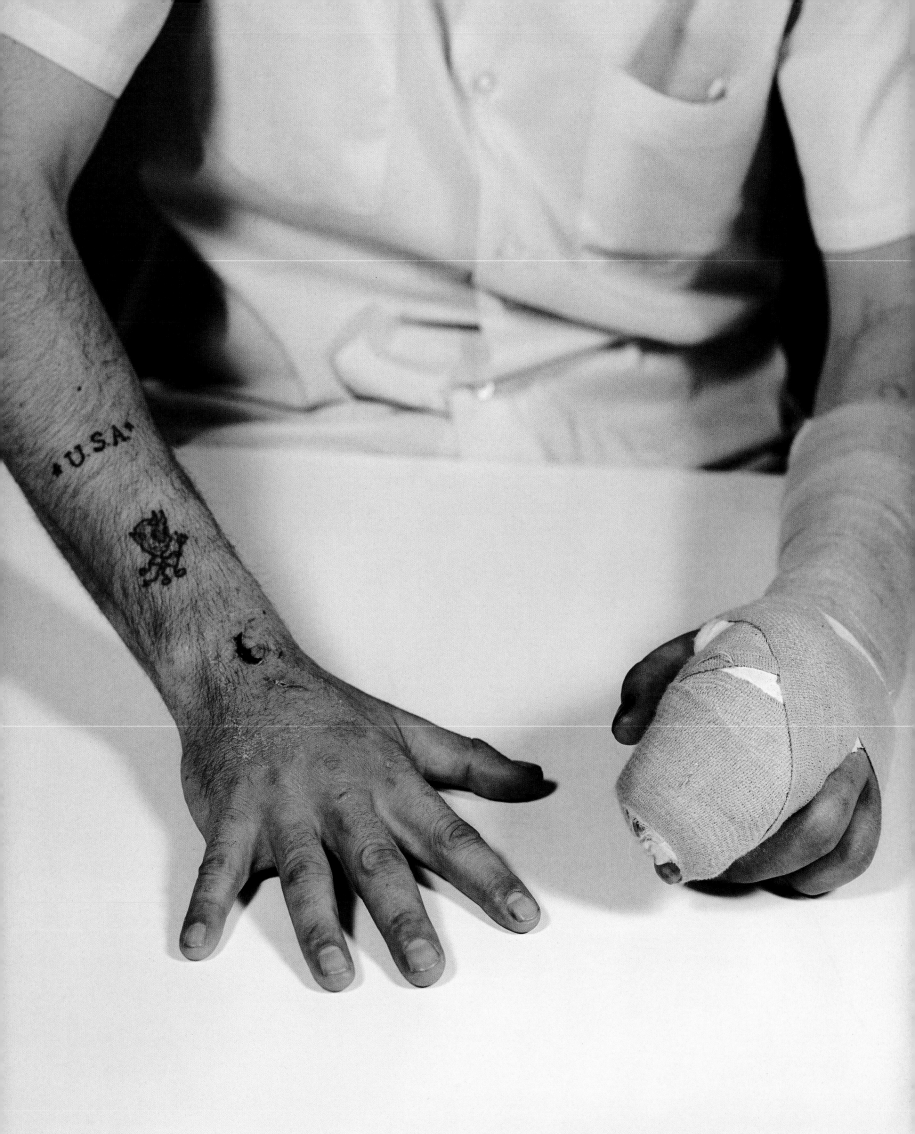

STONE
FACED

I entered the pale room where every white statue had something missing. The warrior was missing a hand. The goddess had a broken shoulder. There was the giant with the missing nose, and a lion with no feet. A world-weary woman was armless as she stood towering nine feet above me. The missing parts seemed to make each one more graceful, more forgiving. Like them, I sometimes feel as if something has been cut out of me. In another room, I found a sea of heads resting on tall pedestals facing a wide window. Their stone eyes looked into the light. It was so startling, I thought they might speak. I remembered looking at a weird book Mom hadn't thrown out when she and Dad moved to Towner Street. *How To Be A Good Nurse* described the way some dying people turn toward the light just before they take their last breath. This was true of my mother Dorothy. She lay in a hospital bed facing the ocean outside her picture window. I leaned over, bent down, and kissed her. Like the statues in the museum, she was looking into the light, peaceful at last.

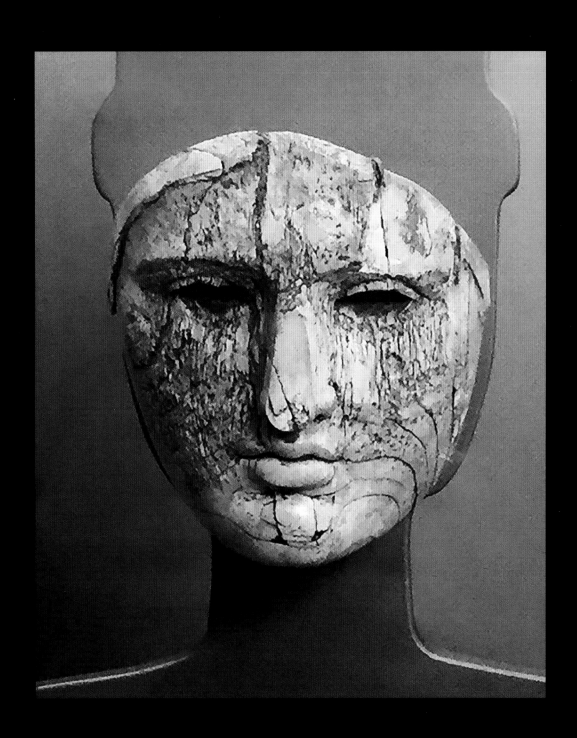

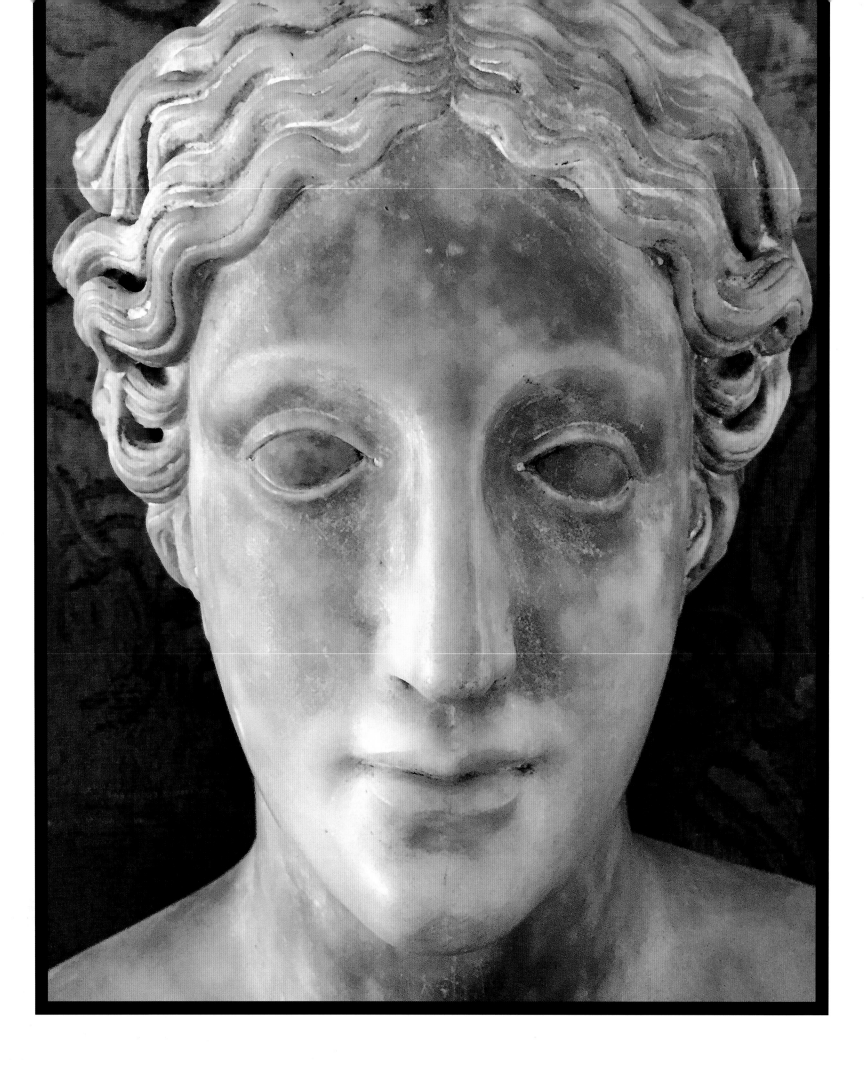

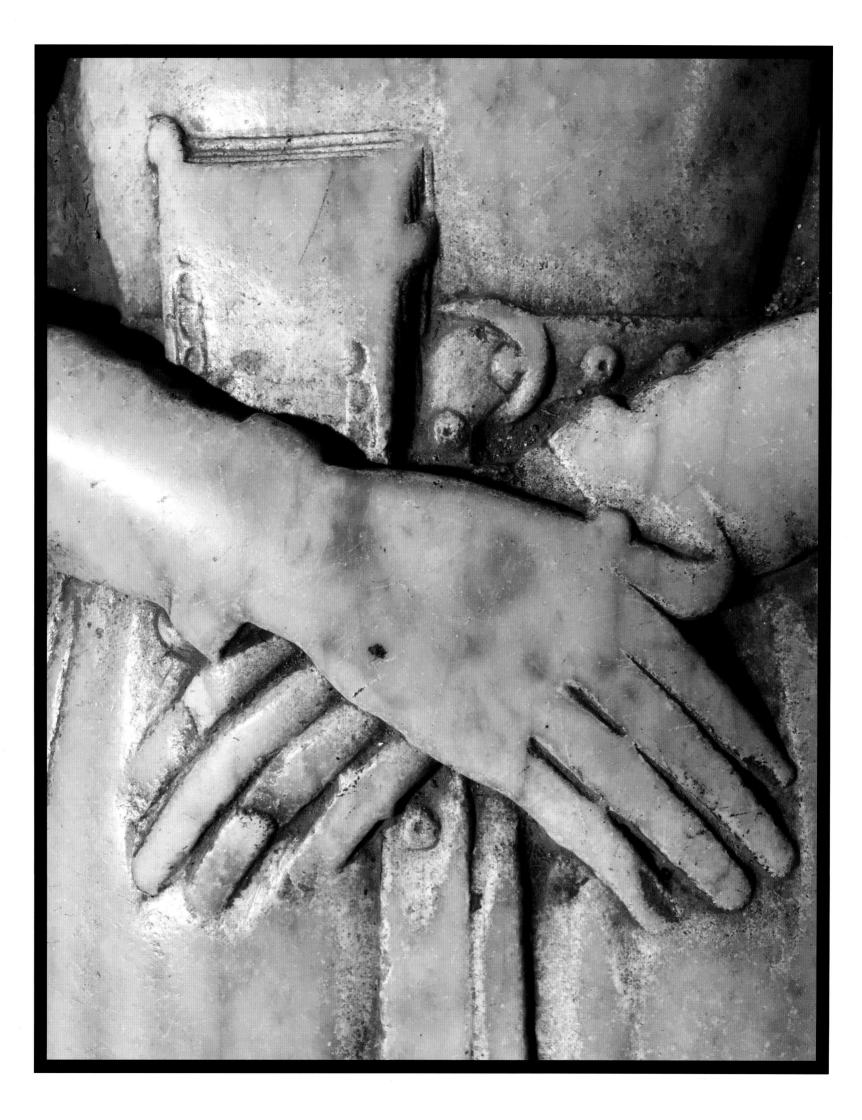

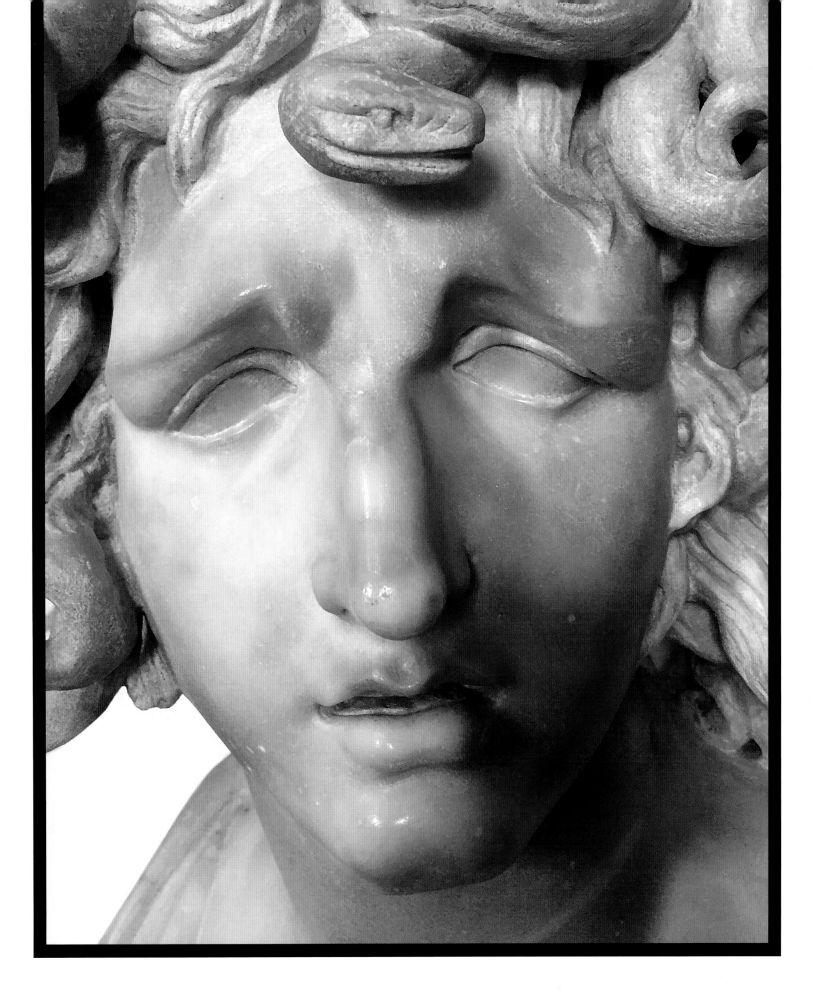

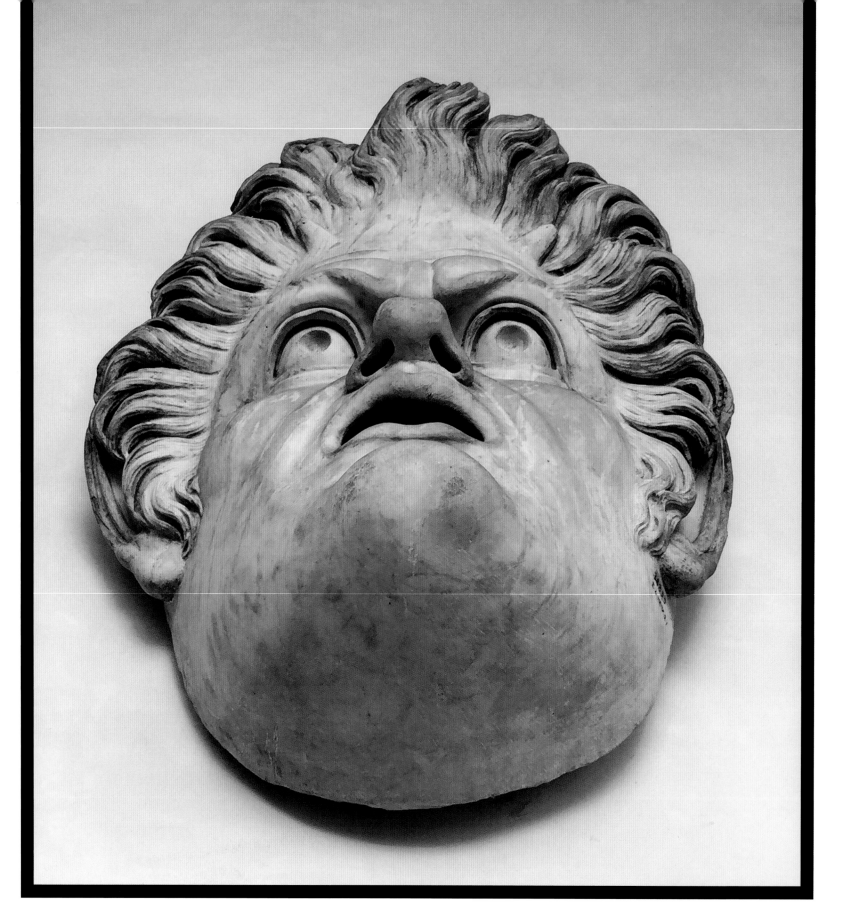

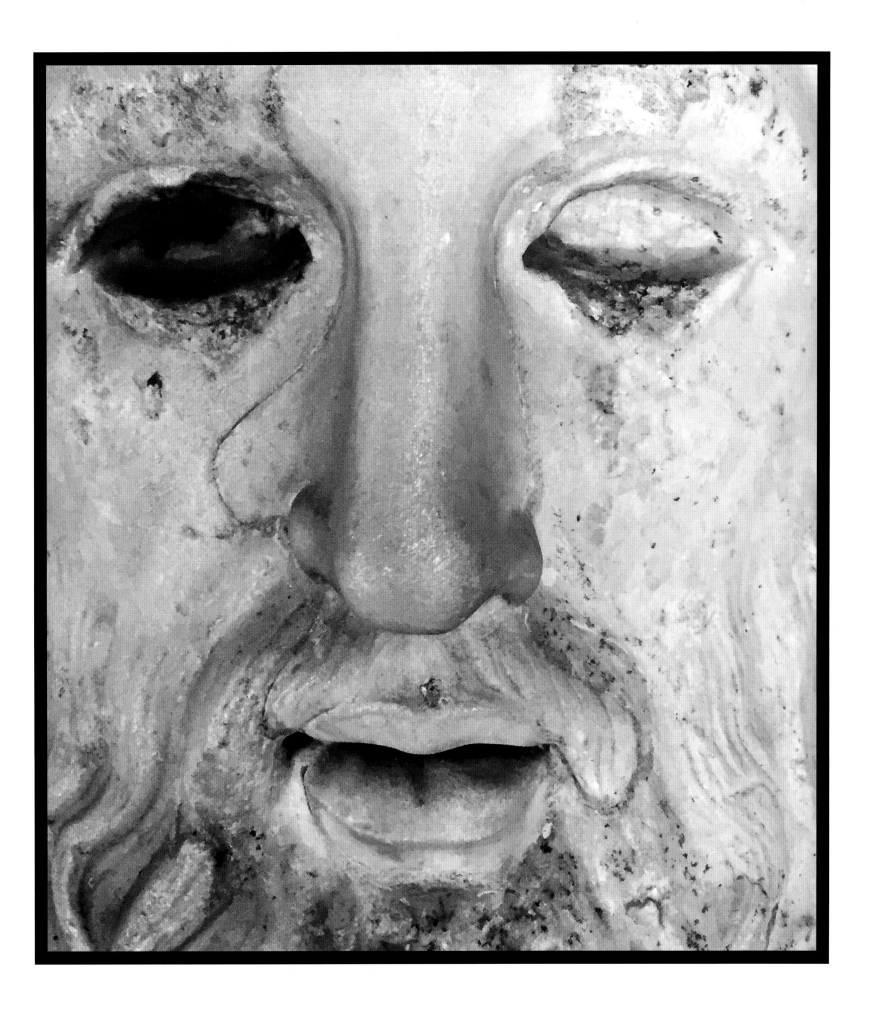

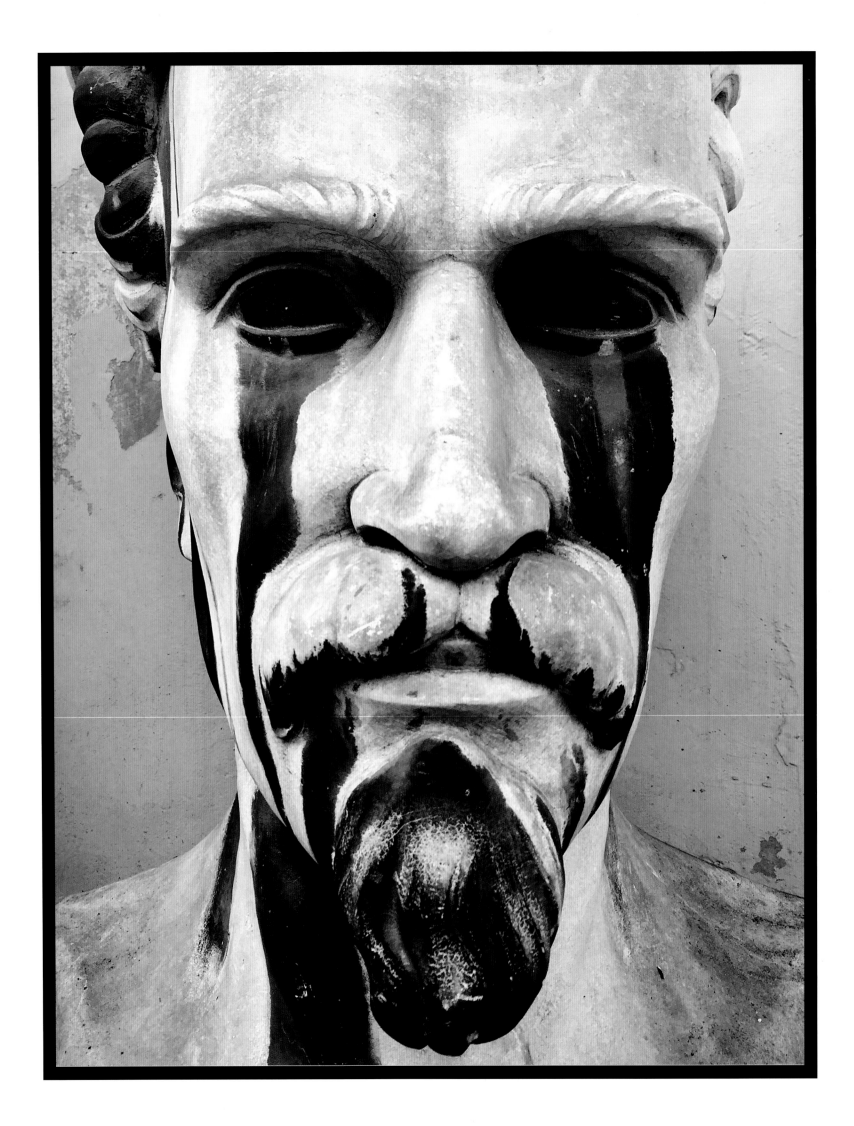

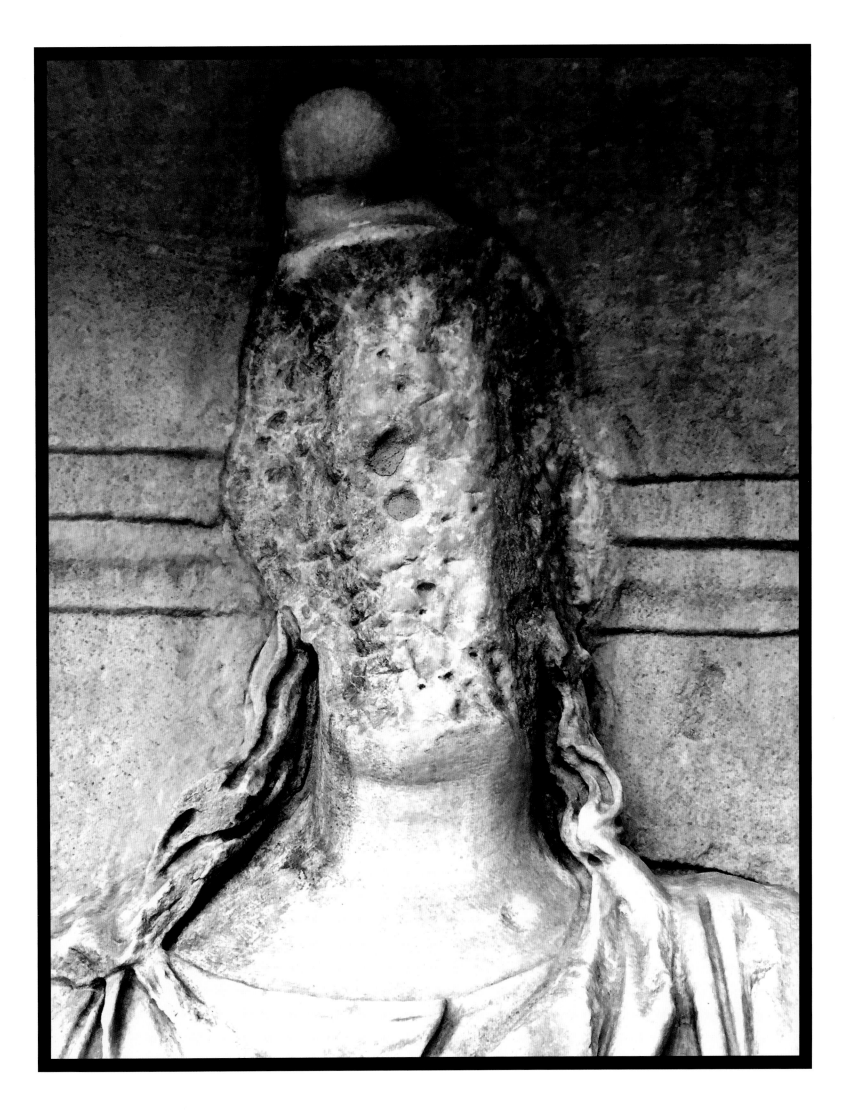

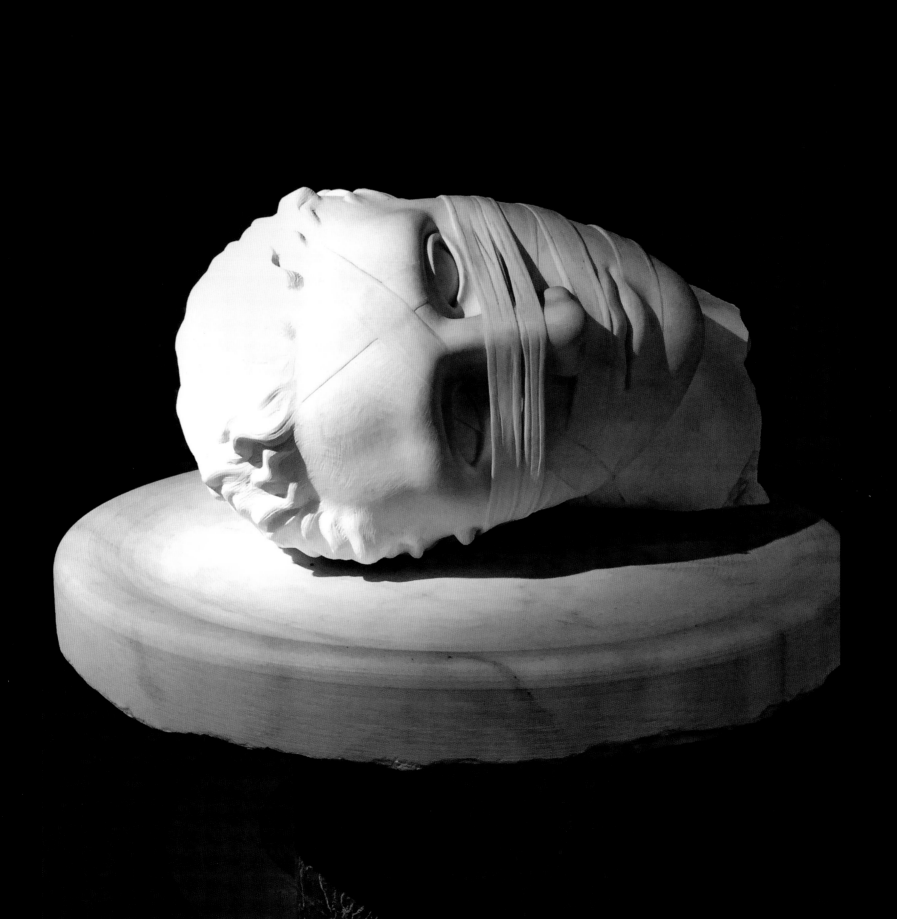

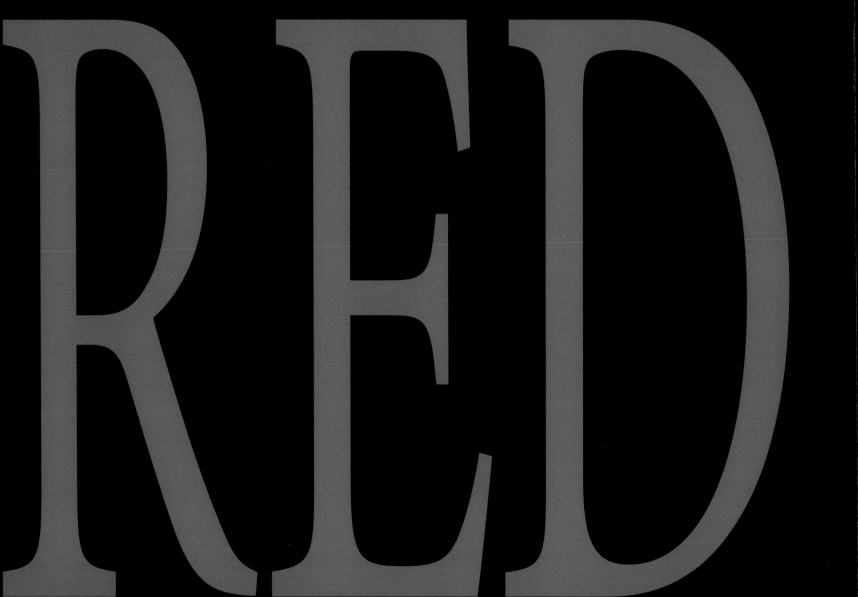

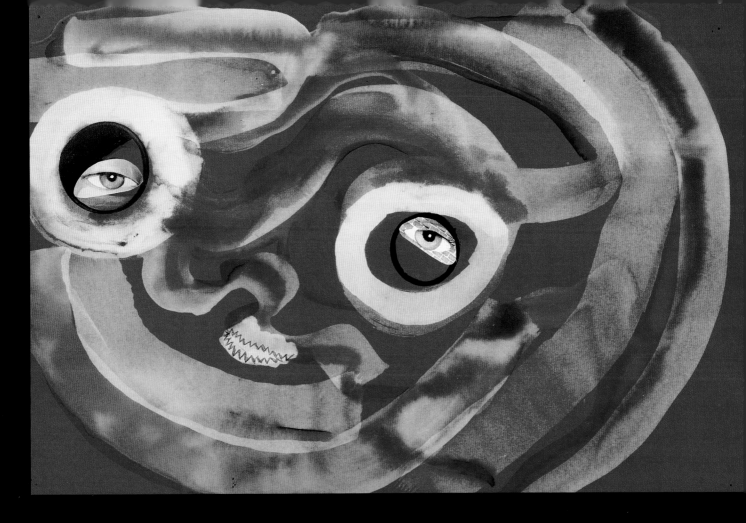

A man in what appears to be a lampshade for a hat looks to the left while wearing a short coat made out of a brick building with a window underneath his chin. Below the coat a woman's legs step forward in a pair of black sandals with straps. You tell me what my brother Randy was going for except the obvious distortion of a world the ordinary do not want to address. Randy took his life's work seriously. While retreating from arduous encounters with people he permanently shut his door, embracing the photograph. The simple act of feeling scissors cutting into a vast panorama of images gave him a steady, if uneven, approach to life. At work with magazines, Randy was the master of rearranging the feminine gender to suit his imagination. Women were ripped up, restructured, torn, cut and thrown into strangely perverse situations. A vivid affection for the color red dominated many of his collages. In one, a woman stands in front of a black painted background, wearing a tight-fitting, long-sleeved dress. Her disproportionately large right arm sweeps down below her knees. Her gaping open red mouth, with claw-like skinny teeth, seems ready for a delicious killing. With a clown nose and heavy black eye makeup, she looks like an evil *Wrinkles The Clown*. On the right side of the page is what appears to be a dreamy circular black platform with a naked mystery woman oozing blue goo. The collage is a study in horror. Randy's life was a mystery spent chronicling thousands of cut-up paper women who adorned the pages of magazines before they became Randy's dream come true.

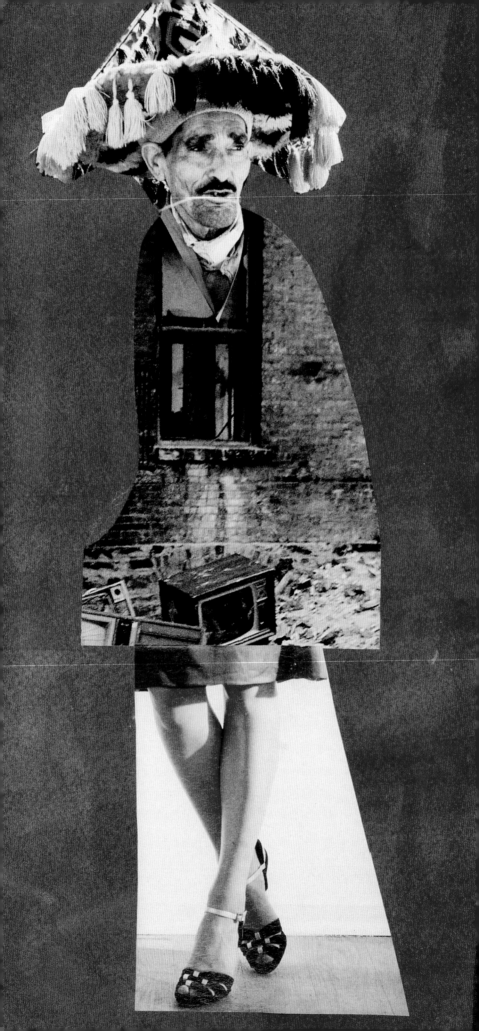

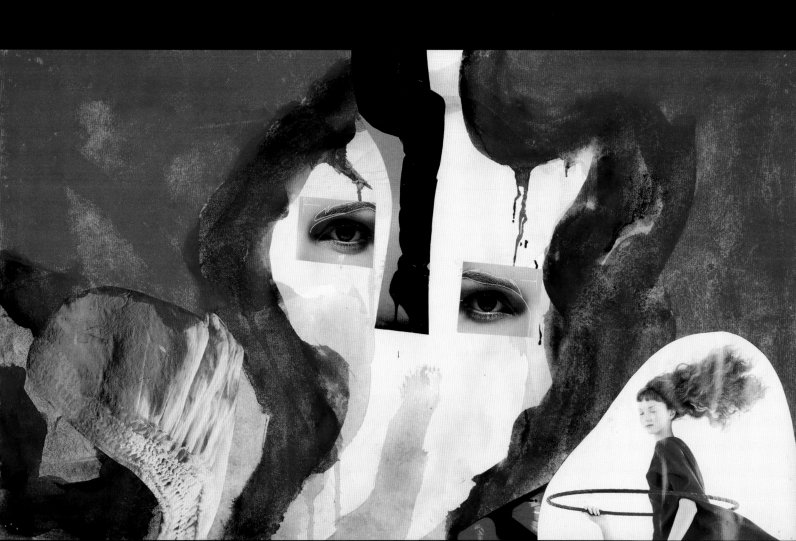

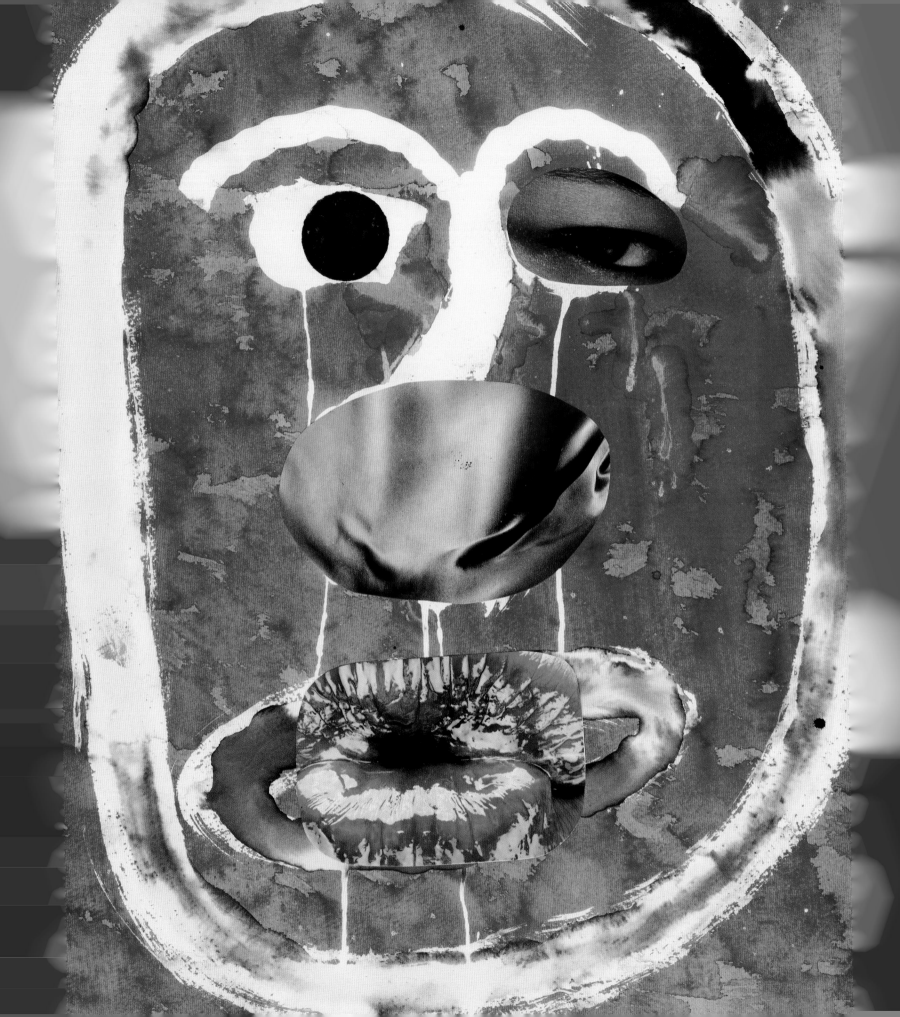

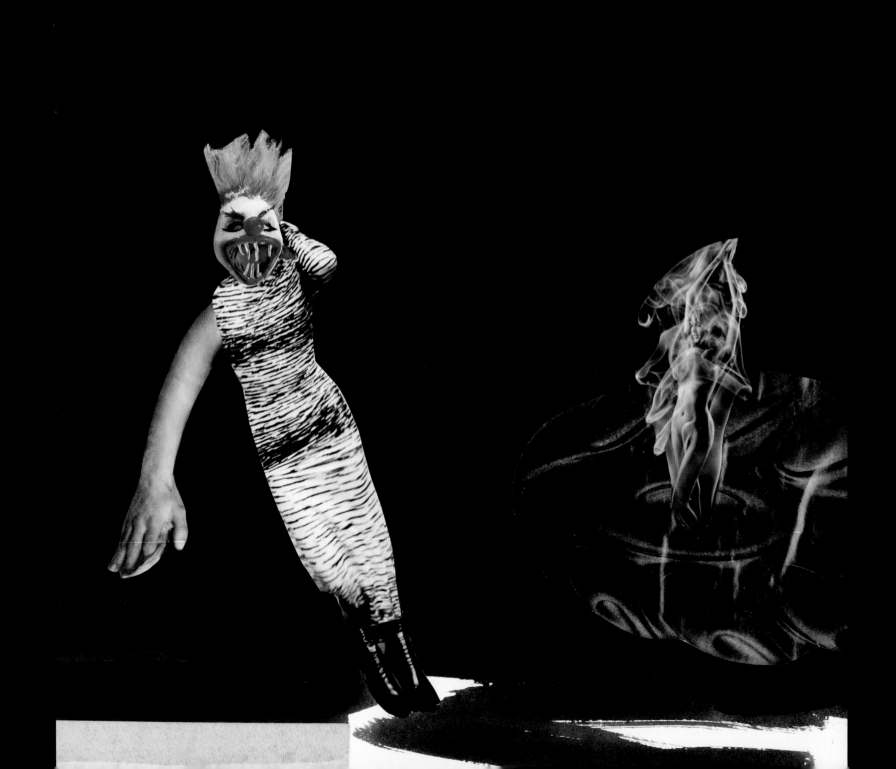

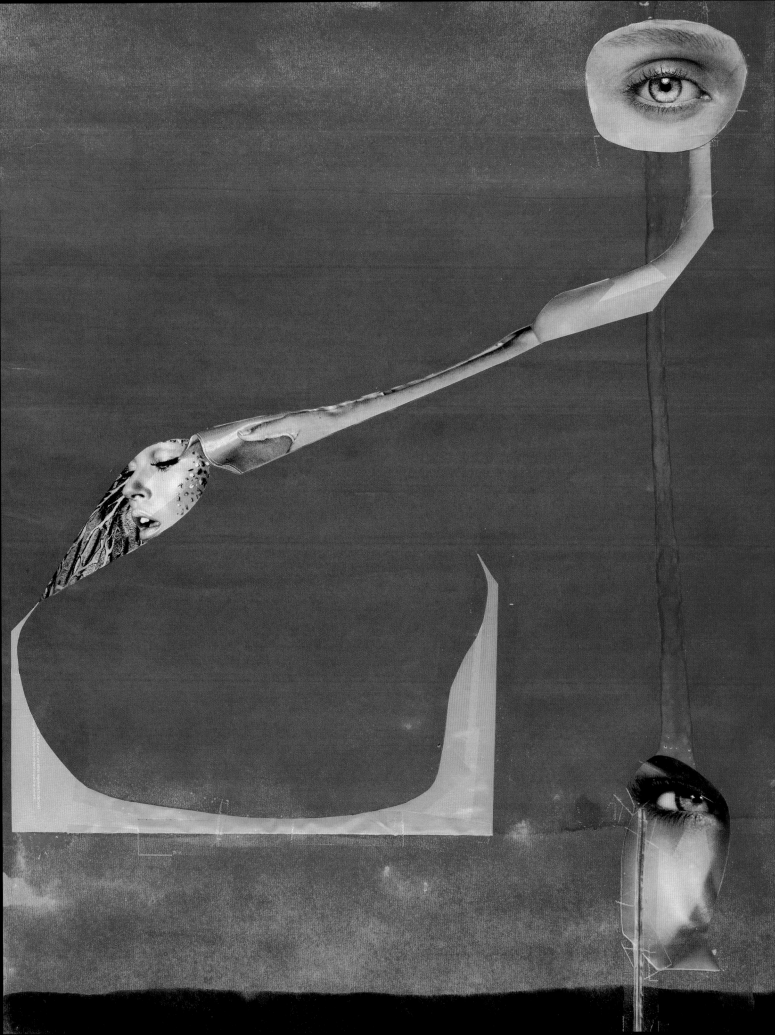

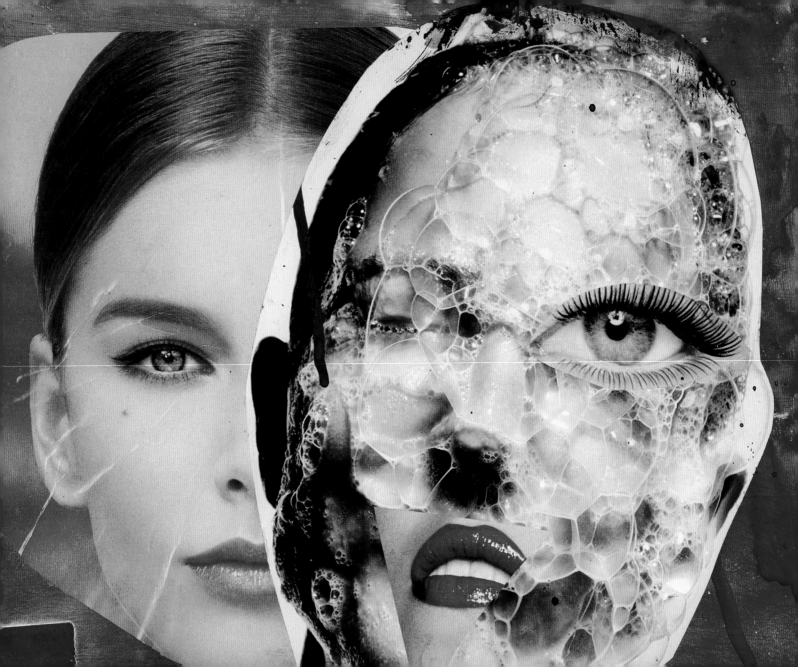

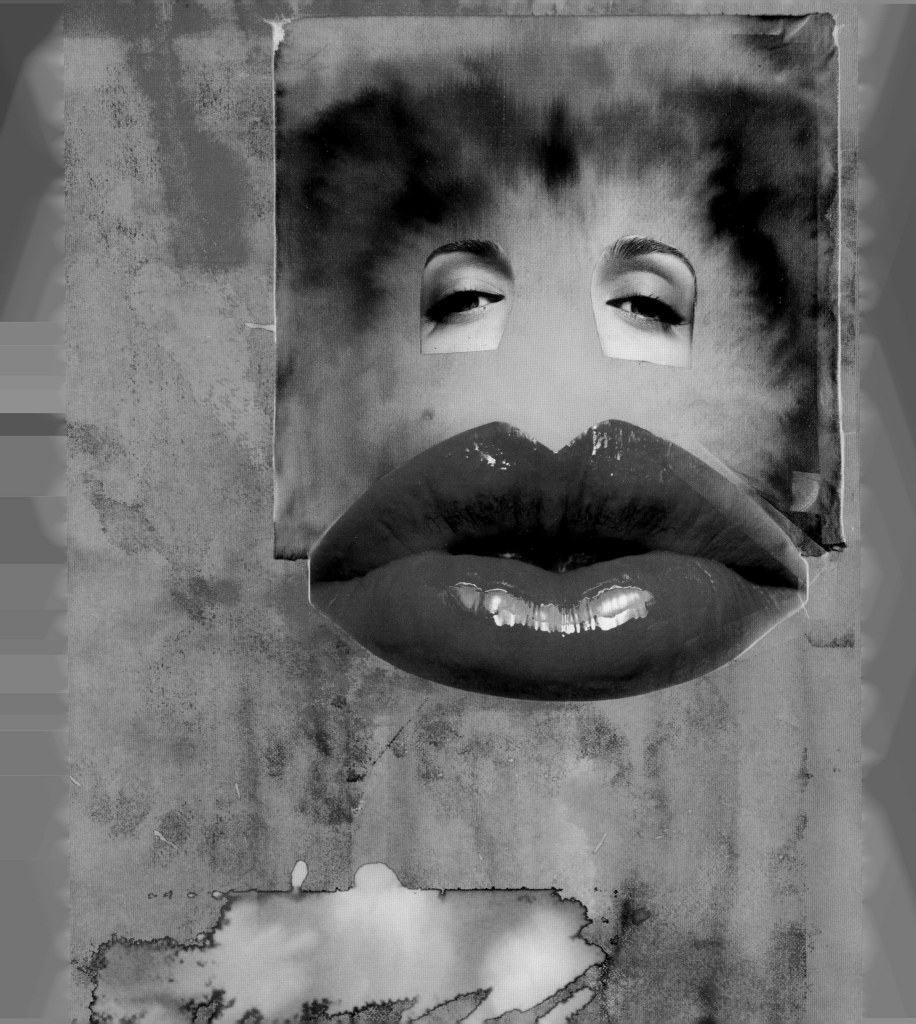

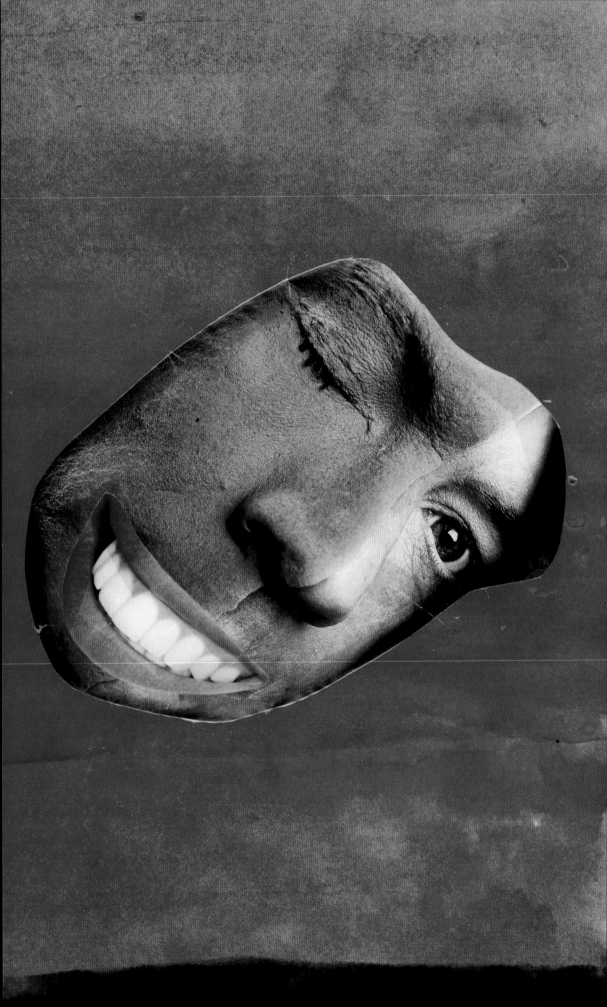

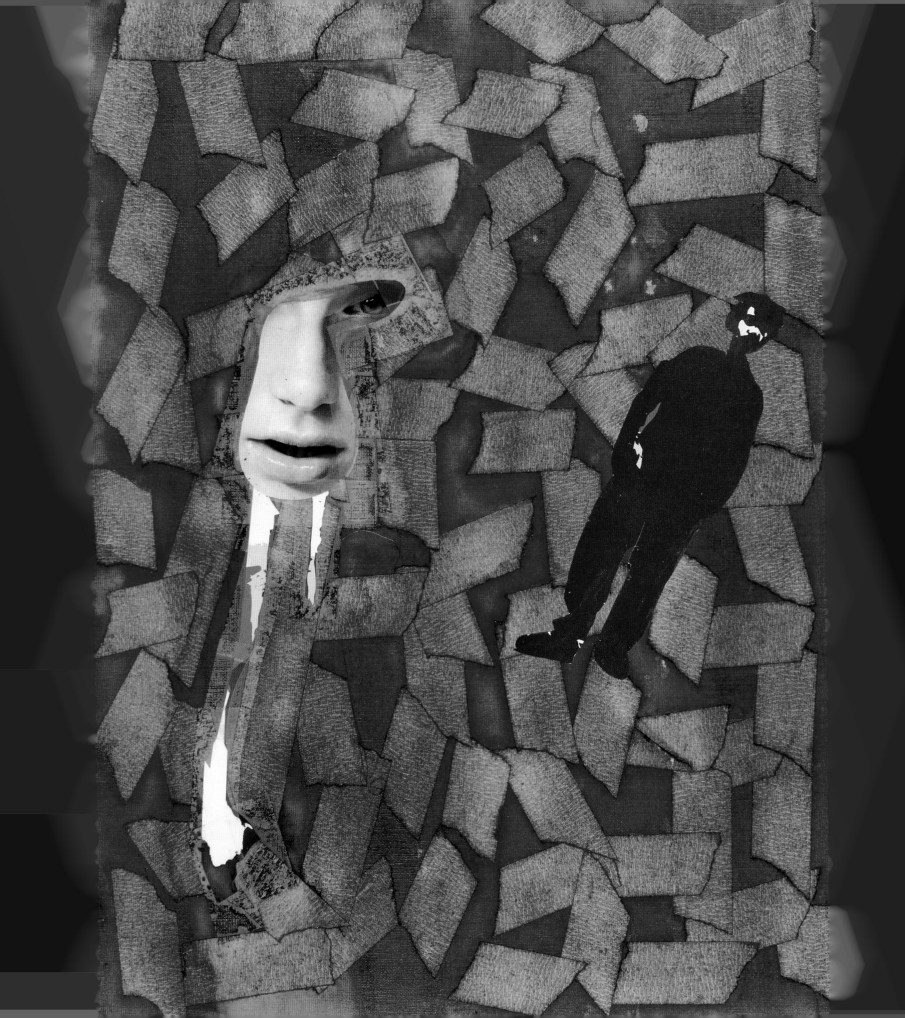

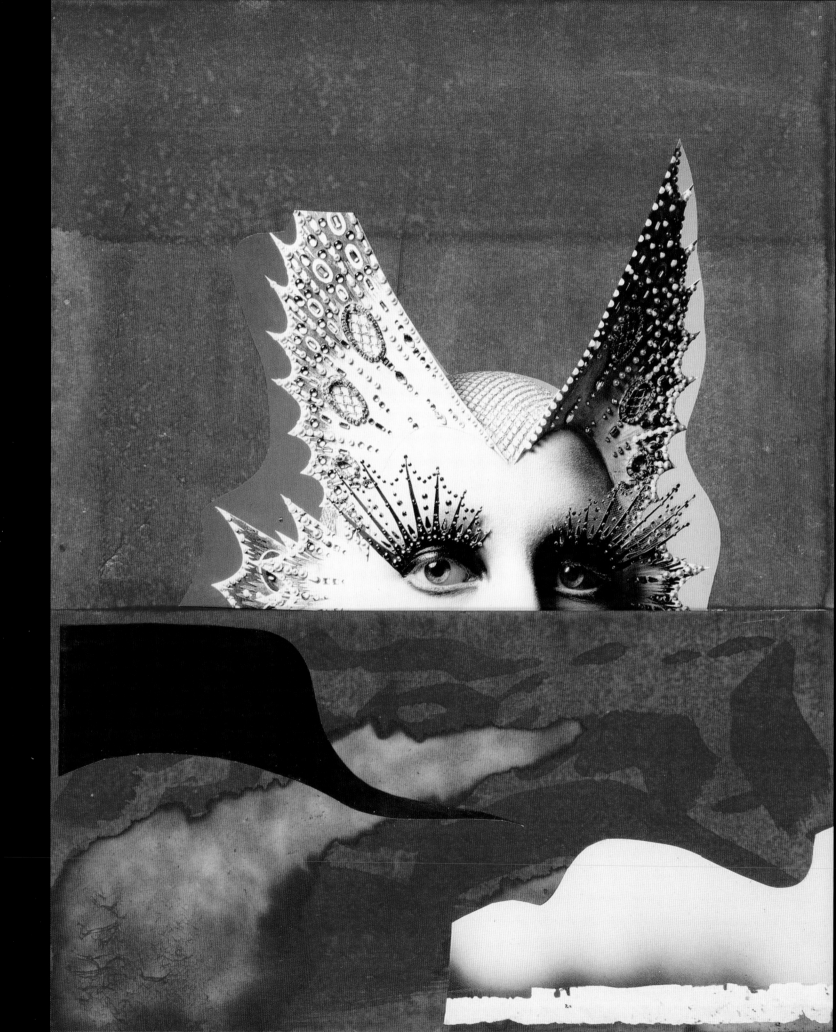

TABLE OF CONTENTS

You are about to turn the page to see my so-called Cherished Treasures. Most will not pass your test. I understand. Small, Undervalued, Medium and Ordinary aren't frequently at the top of anyone's list of fascinating objects. For example, I don't remember buying the tiny gray dolls' couch. I don't remember where I found the yellowing metal ring resting in my jewelry box. Did my sister Dorrie give me the tiny black and white wooden dog she may have named Lucille with the frowning red lips? Inside the antique metal frame resting on my office table is a black and white planet I cut out of an ancient astronomy book I bought at a swap meet forty years ago.

Am I crazy? Not as crazy as I was when I bought a metal First Aid Kit. Yet when I opened it I reminded myself that someone somewhere was taking care of a dangerous, even life-threatening, situation. If I put my large Nautical Antique Warehouse Hook upside down it becomes a question mark. Frames are misunderstood when empty. To me they say look at nothing and reflect on what nothing indicates.

I can't help marvel at the ominous Indian woman who wove a rug illustrating a big mama bear hovering over a tiny baby bear. To this day her artistry still moves me to tears. The collection of objects we live with is a passion filled with memories. Large, small, strange, and especially cherished items help remind us of a world filled with wonder, grace, and most of all, expression. These nonentities continually remind me not to take myself too seriously.

LIFE

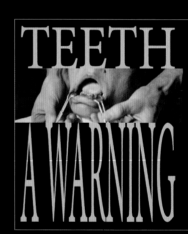

My brother Randy loved horror films. Mom would drop us off at the old movie theater in Orange. In those days you could see two movies for the price of one, but only if you went to the matinee. I liked movies for girls, particularly Gidget starring Sandra Dee. Randy's picks were creepy. There was *Attack of The Puppet People* (1958). Deranged doll maker Mr. Franz is deathly afraid of being left alone, so he creates a machine that can shrink humans down to only a few inches tall. He soon accumulates a troupe of shrunken prisoners whom he forces to perform for him and also keep him company. When he shrinks his secretary Sally and her fiancé Bob, the pair decide to stop spending their days as pint-sized playthings and try to find a way to escape and re-enlarge themselves. To my brother Randy it was sheer genius. And finally, *The Brain That Wouldn't Die*. Dr. Bill Cortner saves a patient who had been pronounced dead, but his senior surgeon, Cortner's father, condemns his son's unorthodox transplant methods. While driving to his family's country house, Cortner and his beautiful fiancée Jan became involved in a car accident that decapitates her. Cortner recovers the severed head and rushes to his basement laboratory and revives the head in a liquid-filled tray. Jan's new customer is agony. She begs Cortner to let her die. He ignores her. Cortner decides to commit murder to obtain a body for Jan. He hunts for a woman in a burlesque nightclub. Meanwhile, Jan begins communicating telepathically with a hideous mutant locked in a laboratory cell. When Kurt, the doctor's assistant, leaves a latch in the cell door unlocked, the monster grabs and tears off Kurt's arm. Kurt dies from his injuries. Cortner lures his old girlfriend Doris to his house, promising to study her scarred face for plastic surgery. He drugs her and carries her to the laboratory. When Cortner goes to quiet the monster, it grabs him and breaks the door from its hinges and sets the laboratory ablaze. The monster, a seven-foot giant with a horribly deformed head, bites a chunk from Cortner's neck. Cortner dies, and the monster carries the unconscious Doris to safety. As the lab goes up in flames, Jan says, "I told you to let me die." The screen goes black, followed by a maniacal cackle. My brother Randy loved these movies. Fifty years later I have to say Randy's choices were bizarre, but in retrospect they were definitely better than Gidget. At least the plots were imaginative bits of insanity.

THE BRAIN THAT WOULDN'T DIE

I have bad teeth, and I've taken bad care of my bad teeth. Many have been removed. Several months ago my temporary bottom left molar fell out. My dentist, Dr. James Robbins, was very good at gluing it back in. Recently, he sat me down, looked me in the eye, and informed me my hard, bony, enamel-coated teeth are in dire straits. I need to have the roots pulled out in two of my upper molars on the right side. As he put it, "There's not enough tooth to stay secure." It's always been a rocky road with regards to my teeth. Several years ago, while strolling with my sister Dorrie at the Rose Bowl swap meet, I came across a large book titled *Clinical Diagnosis of Diseases of the Mouth* written by Louis V. Hayes in 1935. Inside its 461 pages are 322 glossy black-and-white photographs featuring rotten teeth, swollen gums, and an ever-expanding variety of ancillary diseases. A few examples of the chapter headings read, "Cysts of the Jaws," "Correlation of Lesions of the Face," "Tongue Lesions," and don't forget "Lesions of the Gums." Dr. Hayes's choice of imagery is a daunting reminder to take care of your teeth. One photographic illustration displays a carcinoma of the jaw with radium needles in place. Several chapters later, illustration number eighty-five flaunts an infected tongue dangling on the outside of a man's lower lip. Apparently, his wandering rash hadn't cleared up. A middle-aged woman who had a history of seeking help from dentists was informed she not only had mucous patches, but she also was diagnosed with cancer. Look, life can be a grim, irrational, humiliating experience. As for teeth ... teeth can become an island of pain floating on the gums of indifference. Some people toss off responsibility for the care of their teeth. One friend thought he was funny when he said, "Look, Diane ... If you stood into the wind and grinned real wide you could get your teeth sandblasted whiter than white for free." An actor I worked with expressed a desire to grind his teeth into stubs before he reached his declining years so he could subsist on Jell-O, frozen yogurt, and ice cream. Before *Reds* began shooting, Warren Beatty suggested I get rid of my two gold teeth and purchase porcelain jackets so I could properly play the role of Louise Bryant in his epic movie. I did. Like so many other issues with me and my teeth, they didn't last. I doubt Dr. Hayes had a best-seller with *Clinical Diagnosis of Diseases of the Mouth*. Nevertheless, his expertise on the issue of oral treatment, in conjunction with his terrifying photographs, deserves to be applauded. I still wake up in the middle of the night panicked over the pain I suffered under the drill, but even more terrifying, the all-too-real possibility of permanent dentures. In honor of Dr. Hayes, a pioneer in the field of dentistry, I am proud to present the readers with an invaluable cautionary tale, enhanced by photographs that steal the show. At the end of the book, one patient of Dr. Hayes remarked, "I never knew teeth could be so interesting." I agree.

TEETH
A WARNING

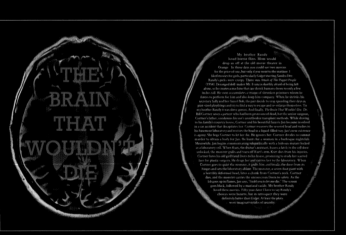

CRACKED

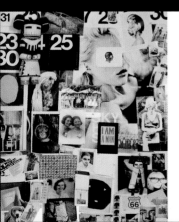

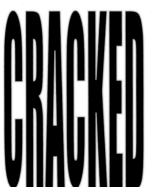

In 1960 I spent most of my time in London playing Louise Bryant opposite Warren Beatty in his movie *Reds*. I'm not sure why I began taking pictures of the pigeons in Trafalgar square. It might have been due to their constant manic swooping down on hundreds of tourists who seemed to enjoy the outrageously close proximity of our so-called feathered friends. They were astonishingly reckless, yet completely in control. I had to admire their willful plunges that occasionally landed on an arm or shoulder of some hysterical teenager or crying baby.

On my weekends off I watched crowds feed the dive-bombing birds. It was almost as if the army of winged invaders knew they were more, much more, than simply "nonentities." I doubt you're aware of the fact that the pigeon has a noble history. It is one of the most loyal and devoted of birds. When raised with love and attention, it can be a faithful, treasured companion. It's said that Charles Darwin owned a diverse flock of adventurial pigeons. Nikola Tesla had one he adored. I loved that pigeon as a man loves a woman and she loved me. When she was ill, I knew and understood. She came to my room and I stayed beside her for days. I nursed her back to health. That pigeon was the joy in my life. If she needed me, nothing else mattered. As long as I had her, there was a purpose in my life.

My friend Woody Allen used to call them rats with wings. Yet pigeons' homing talents helped shape history in both World Wars. One named Cher Ami completed a mission that led to the rescue of 194 stranded US Soldiers. Some pigeons have been trained to distinguish between cubist and impressionist painting. In Project Sea Hunt, a US coast guard search and rescue program in the 1970s and '80s, pigeons were shown to be more effective than humans in spotting shipwreck victims at sea.

The pigeons of Trafalgar Square helped distract me from the challenging duties of playing Louise Bryant, an ambitious feminist, political activist, and journalist who became known for her sympathetic coverage of Russia's political character during the First World War.

Because of my pigeon friends, not only did I print my 20 by 24 inch black and white photographs, I had the joy of appreciating their own special genius. Once you've stood in the rush of their wings ... watch out, you might fall in love.

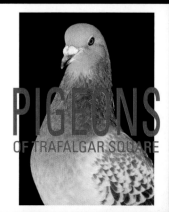

PIGEONS
OF TRAFALGAR SQUARE

PHOTOGRAPHY CREDITS

CHERISHED TREASURES

People see hooks as objects to hold things. Not me. Signs are an unfortunate source of anger. Take my beautiful rusted example: "NO PARKING THIS SIDE." It's helped me stop screaming "Go screw yourself" every time things haven't gone my way while trying to park the car. They help me pause and rethink their meaning. For example, I remember the moment I saw a photo of a pair of endlessly long fingered gloves in a fashion magazine. After I cut it out and glued it onto a piece of paper in my three-holed black binder aptly named "Fashion," I occasionally look inside, see those crazy gloves, and marvel at the person who had the idea to make them a reality. They never fail to make me consider the structure of hands, how they spread, their function, their beauty, their touch. Inside my world, the expression of an object, even something as random as my black hat resting on a table with chains of crosses encircling its perimeters, makes me feel connected to an ever-evolving world of expression. The black silhouette of a man with a large cross sticking out of his face on a small poster is one of my favorite purchases. Why not play with a pure black cross instead of a nose? Let's say some annoying problem is on my mind as I pass by the cross-bearing gentleman. I stop and glance over the artist's unique concept. Where did he even get the idea of a large cross becoming a man's nose? It's pretty damn amazing.

THE NEXT PERFECT HOME

Home was always a dream. There was the Quonset hut Mom and Dad rented when I was two. There was the two-bedroom house dad bought and drove to the vacant lot in Highland Park where we lived until I was seven. There was the ugly tract house in Garden Grove Dad leased until he secured the job of Assistant City Engineer in Santa Ana. I was nine. Our new board and batten tract house had a rock roof and a big garage. All six of us lived in that four-bedroom, two-bath home for ten years. Dad loved real estate. On Sundays he would drive me to model homes for sale. Not only was it his idea of heaven, it also became mine. Even when I was young I collected pictures of houses, mainly from Mom's magazines. I liked to make up stories, not only of the people who lived there, but the houses themselves. How did they weather storms? Were they eventually torn down like our neighbor Ike's house on Mentires Road? How many people lived in them? Were they happy? Were the rich homeowners north of 17th Street happier? A four by six inch photograph of eight people standing in their Sunday best under the porch of an impressive two-story home made me wonder who amongst them owned it. The picture of a woman with a broom in her hand after opening the only door of a random white structure with windows made me sad. On the back of the photograph Mom found in an old scrapbook at the Goodwill, a woman wrote: "Wait till I get some plants around here. It will look better." Another photo details an unusually long, narrow building described as a Moss Hall on stilts with steps leading to the entrance. The peaked roof framing a wood-planked home with four windows on each side includes a hand written note ... "Our home has a brown roof and shutters. It looks barren in the picture because you can't see all the other houses. Every single picture I've saved of a home, and I've saved hundreds, every single one has offered me a long ago, worn away token of the people who lived inside. Their dreams, their longings and losses. I wonder if someone someday will random's chance across old pictures of the Hall family homes, or the many homes I've bought and sold in an adult. Photographer from Brian Vanden Brink put it best. "Our lives go by so quickly. We leave behind the relics of our time here, and what we thought was important. These homes are When I look at these buildings I think nature of life. We frequently move statues, memorializing the transitory building and the next perfect home. too fast, in an effort to erect the next on the value of being content, or These little post cards help us look back at least satisfied with what we have."

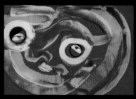

DOGS

I vaguely remember our first dog, Domino. He must have been four or five years old when he showed up at our home in Highland Park. I was not taken with him or with dogs in general. At age fifty I was given a big shepard mix named Josie. She wasn't what I'd had in mind either. The day she took a chunk out of the mailman's leg was not a pleasant experience. Josie had no truck with people. She did not take to my sisters, and they ... they did not take to her. It could be said Josie singlehandedly saved me from the rigors of married life.

In 2005 I brought home a golden retriever pup for my daughter Dexter's birthday. With time Dex became busy with her newfound commitment to girlfriends, boyfriends, and the swim team. Duke, my son, couldn't have cared less about Emma, except when she peed in his bedroom. And so she had little choice but to attack my closet, eat my shoes, steal food from the kitchen countertop, and bark for attention. I considered her a special mistake. I began to take her for her morning walk, and surprisingly, within a year, I fell in love.

This year I received a four-legged gift named Reggie. What little heart I have left is engrossed with a kind of love I never imagined. Without Reggie my life would be a barren desert. I know that sounds extreme, but I don't really care. I kiss her face and don't think of my former complex issues relating to the expression of affection with people. I love grabbing her floppy ears and neck, and then, just for the hell of it, slapping on little bitty baby kisses. I don't have to hide my bad moods or anxiety from Reggie. She doesn't get mad or judge me. Here's to dogs. Here's to my Reggie.

LIGHT OF DAY

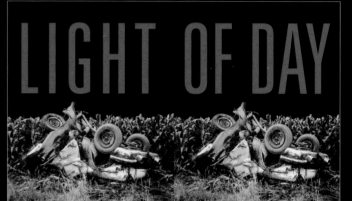

THE OSTENTATIOUS FLASH

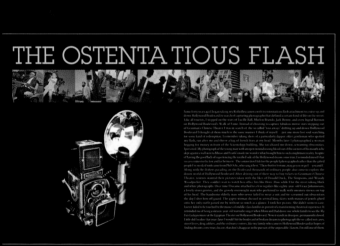

Some forty years ago I began taking my Rolleiflex camera with its ostentatious flash attachment to cruise up and down Hollywood Boulevard in search of capturing photographs that defined a certain kind of life on the street. Like all tourists, I stepped on the stars of Lucille Ball, Marlon Brando, Jack Benny, and even Ingrid Bergman on Hollywood Boulevard's Walk of Fame. Instead of choosing to capture fabulous movie stars stepping out of Grauman's Chinese Theater I was in search of the so called "toss aways" drifting up and down Hollywood Boulevard I thought at them much in the same manner I think of myself ... just one more lost soul searching for some kind of redemption. I remember taking shots of a particularly dapper older gentleman who spotted my flash, ran after me and threw a bag of french fries at my head. Months later I photographed a woman begging for money in front of the Scientology building. She too chased me down, screaming obscenities. I pressed. My photograph of the young man with an open mouthat issuing bleed out of the corner of his mouth as he slept against a wall next to Musso and Frank's made me wonder what brought him to such a nightmare reality. In spite of having the good luck of experiencing the rarified side of the Hollywood dream come true, I reminded myself that no one existed to his end lot between. The camera took little for the people's photographed rather than the gilded people I've worked until a tent from Phil Ochs, who sang their. "There better to train, pay it on or get ... you and I. Along with the drifters parading on the Boulevard thousands of ordinary people also come to explore the diverse world of Hollywood Boulevard. After playing out of there way to buy tickets to Grauman's Chinese Theater, tourists wanted their pictures taken with the likes of Donald Duck, The Simpsons, and Woody Woodpecker. They couldn't wait to watch hot office hits like Home Alone while I hit the street subway, black and white photographs. Over time I became attached to a few regulars like eighty year old Grace Johnstecun, a lonely street greeter, and the grossly overweight man who performed to walk with muumuu stories on top of his head. The handsome elderly man who never failed to wear a suit and tie screamed out obscenities the day I shot him off guard. The gypsy woman dressed in several long, skirts with masses of jewels glued onto her only outfit passed me by without so much as a glance. I took her picture. She didn't seem to care. I never failed to be touched by the masses of middle class families in pursuit of a transforming theatrical experience. It reminded me of being a sixteen year old wannabe singer when Mom and Dad drove our whole family to see the My Fair Lady premiere at the Egyptian Theater on Hollywood Boulevard. Now it stands in disrepair, permanently closed. Little did I realize that years later I would hit the freeks out of brok in dreams to photograph the so-called lost souls, street losers, drug addicts, and the ordinary visitors, like my family who came to Hollywood Boulevard in hopes of finding dreams come true, do cess that don't disappear in the pursuit of the impossible. I'm still one of them.

STONE FACED

I entered the pale room where every white statue had something missing. The warrior was missing a hand. The goddess had a broken shoulder. There was the giant with the missing nose, and a lion with no feet. A world-weary woman was armless as she stood towering nine feet above me. The missing parts seemed to make each one more graceful, more forgiving. Like them, I sometimes feel as if something has been cut out of me. In another room, I found a sea of heads resting on tall pedestals facing a wide window. Their stone eyes looked into the light. It was so startling, I thought they might speak. I remembered looking at a weird book Mom hadn't thrown out when she and Dad moved to Towner Street. *How To Be A Good Nurse* described the way some dying people turn toward the light just before they take their last breath. This was true of my mother Dorothy. She lay in a hospital bed facing the ocean outside her picture window. I leaned over, bent down, and kissed her. Like the statues in the museum, she was looking into the light, peaceful at last.

&

CUT

PASTE

Housewives from the '50s frequently cut up *Life* magazine's pages to paste in their family scrapbooks. My mother Dorothy followed suit. In her footsteps my brother Randy and I grabbed our children's safety scissors and cut out our own choices. Images inside magazines told us stories of people who appeared to have dreamlike, adventurous lives. The pictures we cut out were not saved, but the memory, and Mom's family scrapbooks documented every aspect of our family. In the '60s she took it upon herself to drive all four of us kids across the country, where we went to the 1964 New York World's Fair, and even more amazingly, The Museum of Modern Art. Inside we saw a Joseph Cornell exhibition featuring his collages. One, titled *Allergy of Innocence*, was cut and pasted on printed paper in a wood frame with colored glass. That exhibition was the beginning of what would become Randy's lifelong dedication to cutting and pasting. My collages took shape much later. At first they were tight little concepts focusing on feminine issues like movie stars and fashion, but also the horror of teeth, a personal nightmare that has dogged me all my life. Our love of the picture world was more appealing than the beach, TV, movies, and even our family trips in the Ford station wagon to Death Valley or Doheny Beach, where Dad pitched tents as we rolled down the sandy hills of the desert, or played in the waves. For Randy and me, *Life* magazine offered a much more engaging view of the amazing, complex world around us. You don't have to be a John Stezaker, Joseph Cornell, or Hannah Höch to enjoy cutting and pasting while playing around with the absurdity of real-life images glued into strangely unique situations. Collages are fanciful, dream-ridden escapes. My brother Randy and I picked elation over the scrapbook story of our lives. There was Randy and then there was his brother's dartling, much farther

RED

Chapter 6: Cherished Treasures

Spread One (Chapter Opener): Pair of gloves "Peter"; machine knitted brown and beige wool, by Freddie Robins, UK 1997–1999; © Freddie Robins / Victoria and Albert Museum, London. Spread Two: Photograph © 2021 Giuseppe Pino. Spreads Three through End of Chapter: Photographs by Lisa Romerein; courtesy of the Photographer and the Author.

Chapter 7: Dogs

Spreads One through End of Chapter: Found art/vintage and antique scrapbooks; from the collection of the Author.

Chapter 8: The Ostentatious Flash

Spreads One through End of Chapter: All photographs by Diane Keaton (except Rolleiflex Camera image on Spread One, Photo by C Canon https://www.flickr.com/people/97603721); courtesy of the Author.

Chapter 9: Cut & Paste

Spreads Two through End of Chapter: Collages by Diane Keaton; courtesy of the Author.

Chapter 10: The Next Perfect Home

Spreads One through End of Chapter: Vintage photographs from the collection of the Author.

Chapter 11: Light of Day

Spreads One through End of Chapter: Photographs by Robert Boltz; courtesy of the Author.

Chapter 12: Stone Faced

Spreads Two through End of Chapter: All photographs by Diane Keaton; courtesy of the Author. Spread Two: The ivory head and forearm (not shown) are the only remains of a chryselephantine statue of Athena, made at the time of Emperor Hadrian and placed in a villa in Sabina. They were found in 1824 and were purchased by Pope Gregory XVI in 1832; Vatican City. PHOTO © VATICAN MUSEUMS. ALL RIGHTS RESERVED. Spread Seven: Head of John the Baptist, by Igor Mitoraj; © 2021 Artists Rights Society (ARS), New York / ADAGP, Paris.

Chapter 13: Red

Spreads One through End of Chapter: Artwork by Randy Hall; courtesy of the Author.

First published in the United States of America in 2022 by
RIZZOLI INTERNATIONAL PUBLICATIONS, INC.
300 Park Avenue South, New York, NY 10010
www.rizzoliusa.com

© 2022 Rizzoli International Publications, Inc.
Text © 2022 Diane Keaton
Photography credited on preceding spreads

Publisher: Charles Miers
Editor: Douglas Curran
Production Manager: Colin Hough Trapp
Managing Editor: Lynn Scrabis

Designed by Ethel Seno

Printed and bound in China

2022 2023 2024 2025 2026/ 10 9 8 7 6 5 4 3 2 1

ISBN-13: 978-0-8478-7128-5
Library of Congress Control Number: r: 2021949161

Visit us online:
Facebook.com/RizzoliNewYork
Twitter: @Rizzoli_Books
Instagram.com/RizzoliBooks
Pinterest.com/RizzoliBooks
Youtube.com/user/RizzoliNY
Issuu.com/Rizzoli